W9-DJJ-802

GARLAND STUDIES IN

# AFRICAN AMERICAN HISTORY AND CULTURE

*edited by*

GRAHAM RUSSELL HODGES

A GARLAND SERIES

# UPLIFTING
# THE WOMEN
# AND THE RACE

## THE EDUCATIONAL PHILOSOPHIES
## AND SOCIAL ACTIVISM OF
## ANNA JULIA COOPER AND
## NANNIE HELEN BURROUGHS

KAREN A. JOHNSON

CABRINI COLLEGE LIBRARY
610 King of Prussia Road
Radnor, PA 19087

GARLAND PUBLISHING, INC.
A MEMBER OF THE TAYLOR & FRANCIS GROUP
NEW YORK & LONDON / 2000

#41531762

Published in 2000 by
Garland Publishing, Inc.
A Member of the Taylor & Francis Group
29 West 35th Street
New York, NY 10001

Copyright © 2000 by Karen A. Johnson

All rights reserved. No part of this book may be reprinted or reproduced
or utilized in any form or by any electronic, mechanical, or other means,
now known or hereafter invented, including photocopying and
recording, or  in any information storage or retrieval system, without
permission in writing from the publisher.

10   9   8   7   6   5   4   3

**Library of Congress Cataloging-in-Publication Data**
Johnson, Karen Ann, Ed. D.
     Uplifting the women and the race : the educational
philosophies and social activism of Anna Julia Cooper and Nannie
Helen Burroughs / Karen A. Johnson.
          p.     cm. — (Studies in African American history and culture)
     Includes bibliographical references and index.
     ISBN 0-8153-1477-9 (alk. paper)
     1. Cooper, Anna J. (Anna Julia), 1858–1964.   2. Burroughs, Nannie
Helen, 1879–1961.   3. Educators—United States Biography.   4. Afro-
American women educators Biography.   I. Title.   II. Series.
LA2311.J63     1999 2000
370'.92'2—dc21
     [B]                                                                          99-31681
                                                                                        CIP

Printed on acid-free, 250-year-life paper.
Manufactured in the United States of America

*It is with great pleasure, love and appreciation that I dedicate this book to my first teacher, my mother, Mrs. Sylvia Johnson. Thank you mom for your love, prayers, encouragement and support. Those things gave me the strength and confidence to complete this work.*

# Contents

Preface                                                                          xi
Acknowledgments                                                                  xv
Note on Language Usage                                                           xix

Introduction                                                                     xxi
    The Problem                                              xxi
    Context of the Study                                     xxv
    Significance of the Study                                xxviii
    Notes                                                    xxx

Chapter 1. Theoretical Framework                                                 1
    Section I: Black Feminist Theory                          3
    Section II: Methodological Perspective                    7
    Historical and Biographical Research                      9
    Data Collection                                          9
    Data Analysis                                            11
    Notes                                                    12

Chapter 2. The History of Black Education                                        15
    Black Education: Pre and Post Civil War Years             15
    End of Reconstruction                                     20
    Educational Ideologies in the Post-Reconstruction Era     21
    The Education of African American Women                   22
    The Influence of Booker T. Washington and
        W. E. B. Du Bois on the Education of Black Women    24

Pioneer African American Women Educators   25
Summary and Conclusion   27
Notes   28

Chapter 3. "To Get an Education and to Teach My People":
     Family Background of Anna Julia Cooper   33
Going to School: From the Reconstruction to the Post-
     Reconstruction Era   37
Oberlin Years (1881–1884)   43
Family Background of Nannie Helen Burroughs   47
Going to School: 1883–1896   50
Washington Colored High School   51
Summary and Conclusion   56
Notes   57

Chapter 4. "A Career to Build, a People to Serve, a Purpose
     to Accomplish"   65
Section I: The Professional Careers of Anna Julia Cooper
     and Nannie Helen Burroughs   66
Anna Julia Cooper   66
The Controversy   80
Anna Julia Cooper's Presidency at Frelinghuysen University   86
Nannie Helen Burroughs   91
Ideas about Women's Education: The National Training School   96
Financial Support   99
The Controversy   101
Section II: Anna Julia Cooper's and Nannie Helen Burroughs'
     Educational Philosophies   103
Summary and Conclusion   114
Notes   115

Chapter 5. "Lifting as They Climb"   131
Section I: Defining Black Women's Activism   132
Black Women's Activist Tradition: An Historical Overview   133
In Response to Race and Gender Oppression and
     Economic Subordination   134
Section II: Anna Julia Cooper's and Nannie Helen
     Burroughs' Struggle for Group Survival and
     Institutional Transformation   145
Summary and Conclusion   152
Notes   153

Chapter 6. Conclusion: Lives of Service 159
   Notes 167

Selected Bibliography 169
Index 179

# Preface

Anna Julia Cooper and Nannie Helen Burroughs were among the most outstanding late nineteenth and early twentieth century educators. They lived during an era when the political rights and humanity of African Americans were under systematic assault. It was also a time when women were oppressed politically and economically due to their gender status in society. Despite their triple forms of oppression as African Americans and women from economically poor and humble family backgrounds, Cooper and Burroughs overcame what seemed to be—to use Burroughs' terms, the "wholly impossible."

Imbued with a passion for a life of service, these women dedicated their lives to the education of Black youth and adults, racial uplift, social justice and gender issues. They made noteworthy contributions to American education.

Not limiting themselves or their influences to the school milieu, Cooper and Burroughs played active roles outside the school, working with or creating organizations such as the National Association of Colored Women. Education and social activism became intertwined.

Even though Cooper's and Burroughs' contributions to the field of education were distinctive, their accomplishments, experiences and "voices," have remained ignored and forgotten by educational historians.

The purpose of this study is to recover and reclaim the lived experiences and "voices" of two forgotten but significant educators—Anna Julia Cooper and Nannie Helen Burroughs. The methodological perspective of the study was an historical and biographical investigation. Cooper's and Burroughs' educational philosophies, contributions to the

field of education, and their roles as social and political activists were examined within the socio-historical context in which each woman lived. The lives, works and philosophies of Anna Julia Cooper and Nannie Helen Burroughs were analyzed within the interpretive framework of Black feminist theory. The study focused on identifying and analyzing themes that illuminated Anna Julia Cooper's and Nannie Helen Burroughs' "unique angle of vision on self, community and society," as it related to their distinctive contributions to American education.

The findings of this research have revealed that Anna Julia Cooper and Nannie Helen Burroughs have made pioneering endeavors. They believed that the role of the Black female educator was one of social and moral change agent. Thus, their work as educators, was interrelated with social and political activism. From their perspectives, education was an instrument for "racial uplift." Both women were devoted to the liberation and empowerment of the African American community. They spent their entire adult lives struggling to eradicate race, class, and gender oppression.

Anna Julia Cooper and Nannie Helen Burroughs built institutions and created organizations that not only would ensure the survival of the Black community but would also transform institutional structures that were oppressive. This is the legacy they leave to American education.

## STRUCTURE OF THE BOOK

In my examination of the lives, works and philosophies of Cooper and Burroughs, I explore the themes that illuminate their educational perspectives—themes such as racial, gender and social justice. I also examine the themes of "an ethic of caring" and "teacher as moral and social change agent" as they relate to the issue of teaching for racial uplift and gender and class equality.

The first chapter is the theoretical framework (section I) and methodological perspective (section II). This chapter defines Black feminist theory and makes the argument justifying the need to examine the lives, works, and philosophies of these educators from an alternative paradigm.

Chapter 2 provides a review of the literature on the history of Black education. This review covers four areas which include: (1) the history of Black education prior to Emancipation and after the Civil War; (2) the educational ideologies during the post-Reconstruction years; (3) the educational ideologies of W. E. B. Du Bois and Booker T. Washington and

their impact on the education for African American females; and (4) the development of the education of Black women.

Chapter 3 is a biographical presentation of the early life of Anna Julia Cooper and Nannie Helen Burroughs. Placing the two women in their social historical context, I examine their childhood, family backgrounds, and education, their roles in women's organizations and most importantly, their roles as educators.

Who were Cooper and Burroughs? What were the early educational and cultural influences on these women? Who were their friends and acquaintances? What influence might have they had on their ideological perspectives?

Chapter 4 explores Cooper's and Burroughs lives as educators and attempts to answer the questions: What were Cooper's and Burroughs' educational philosophies? What conditions influenced the development of their philosophies?

Chapter 5 focuses on Cooper's and Burroughs' roles as social and political activists. Typical of African American women educators of their day, Cooper and Burroughs were active outside as well as inside the classroom. They were involved in the Women's Club Movement. Through this and other organizations, they played active roles in education and political campaigns for racial justice and women's suffrage. Thus, this chapter attempts to answer the question: What were Cooper's and Burroughs' major advocacy and ideological commitments, in particular during their involvement in the Women's Club Movement?

Chapter 6 provides a conclusion to the study. Critical reflections on aspects of Cooper's and Burroughs' thoughts and life experiences will be highlighted and summarized. Cooper and Burroughs are remembered first and foremost as devoted educators and social activists, committed to service to their students, women's causes and racial issues. In what respect does the lives, works and philosophies of Anna Julia Cooper and Nannie Helen Burroughs provide a resource that will respond to the plight of the education of African American youth in urban schools today? How can their philosophies inform contemporary educational theories and practices?

# Acknowledgments

I would like to thank my grandmother, Mrs. Viola Dunn. During the years I spent with my maternal grandmother in the Sugar Hill section of Harlem, a strong affectionate bond began to develop. In the warmth of her kitchen, amidst the aromas of mustard greens cooking on the stove, cornbread baking in the oven, and the frying of chicken, she told me stories of what it was like growing up poor, Black and female in Washington, D.C., during the early to mid-1900s. Her stories introduced me to the illustrious Paul Laurence Dunbar High School, to the excellent teachers that taught there—such as Anna Julia Cooper and to students such as Nannie Helen Burroughs. Little did she realize I would grow up and attempt to retell her stories of Black women's experiences in a "scholarly fashion" in this manuscript.

I am especially grateful to the University of California at Los Angeles for the generous financial support I received over the years—the Graduate Division Merit Fellowship Award, the Graduate School of Education and Information Studies (GSE & IS) Dean's Scholarship Award, and the GSE & IS Research Travel Grant Award. These awards provided vital financial assistance for the completing of this study.

I express special recognition to my co-chair Dr. Amy Stuart-Wells for her guidance, support, encouragement, inspiration and assistance during the completion of this research. I would also like to thank Dr. Sandra Harding for taking a keen and sincere interest in my work and for offering invaluable, constructive criticisms, suggestions and advice. Thanks are also extended to Dr. Theodore Mitchell, my co-chair, Dr. Renee Smith-Maddox, and Dr. Peter McLaren for their support and help.

I would also like to thank them all for encouraging me to rewrite this dissertation so that it can be published in book form.

Beyond my committee members, I owe further thanks to the following archivists, librarians and photo-copy assistants for their kind and willing assistance and pleasant personalities: Archivist Robin Van Fleet of Howard University Moorland-Spingarn Research Center (MSRC) Manuscript Division, Archivist Joellen El Bashir of Howard University MSRC Manuscript Division, photo-copy assistant Anthony Hector of Howard University MSRC Manuscript Division , and Susan McElrath of the Mary McLeod Bethune National Black Women's Archives. The librarians of the Library of Congress Manuscript Division were also very helpful in accessing archival materials as well as in providing me with useful information on where to stay in the Washington, D. C. area.

I am deeply grateful and indebted to Dr. Paul Philips Cooke for providing me with invaluable resources and information on Anna Julia Cooper, Nannie Helen Burroughs, M Street High School, and Black women's clubs. The interviews he conducted with Cooper's now deceased niece, former students and colleagues proved to be very significant sources of information for the completion of this project. I appreciate the resources and information I received from Mary E. Hammond—another scholar pursuing doctoral research on Nannie Helen Burroughs. I am also truly grateful to her for introducing me to Dr. Paul Philips Cooke. I look forward to continuing a professional relationship with Mary on future projects relating to the life of Nannie Helen Burroughs.

For the time spared to me by the principal of Nannie Helen Burroughs School, Mrs. Haynes, and by her staff, I am much obliged. The anecdotal stories were very beneficial. I also enjoyed browsing through the items in the Burroughs' museum on the school's campus. My research also brought me into contact with Mr. Sterling Smith and his bright and precocious daughter Shelly Smith—living members of Cooper's family. I appreciated greatly and benefited tremendously from the personal stories about Cooper and her family that they shared. My greatest joy came when the Smiths allowed me to tour and photograph Cooper's home and look through her personal possessions such as books, family photos, personal papers and documents.

I have profited over the years from discussing my work with a number of people. I want to thank in particularly, Nhlakanipho Sizwe for suggesting and encouraging my research on Cooper and Burroughs, for stimulating conversations, spiritual support and for consistently being a true sister friend. Long intellectual, stimulating and challenging conver-

sations with Michelle Knight have also been invaluable. Our conversations have been significant in my intellectual thinking and development about issues relating to the education of African American youth, critical and feminist theories and research. I express my sincere appreciation to my best friend Runoko Rashidi who was loving, supportive, encouraging and had faith in me. Runoko's excellent editing work during the early stages of this research was a labor of love. The stimulating intellectual discourse we engaged in helped me to think in new ways about race, class and gender issues. And most importantly, I want to thank Runoko for purchasing, as a gift to me, the autobiographical book on Anna Julia Cooper by Louise D. Hutchinson, years before I even conceived of conducting this study. He, more than anyone else, understands my love and thirst for Black women's history. Donald A. Logan deserves lots of accolades for his love, affection, financial assistance and for always coming to my rescue in time of need. I would also like to extend thanks to Dennis Formento for editing this manuscript. His labor was truly appreciated.

My immediate and not so immediate family has truly made important contributions to my research. The support they provided was priceless. My sister, Linda Johnson, and niece Kawana, gave me considerable help in collating, typing and making photocopies of portions of my manuscript. My brother, Kenneth Johnson, offered support, made suggestions and came to my rescue when I encountered computer problems. He also provided room and board during the entire time I was researching and writing this project. I want to thank my sweet little niece Zoe, for giving me miscellaneous assistance such as collating and numbering pages and most importantly allowing me to store my books, files and computer in her room.

In conclusion, my heartfelt gratitude is extended to my cousins: Shirley Quick for giving me a tour of the former dormitories of the Nannie Helen Burroughs' school, Kenneth Tolliver for taking me to Burroughs' school, Cooper's house, the Fredrick Douglass museum home, and for allowing me to stay at his condo in Maryland. Soncarare Abdul Latif provided food and shelter for me and took time out her busy schedule and gave me a tour of the Nation's capital. James Morgan also took me to Cooper's home and Burroughs' school and made efforts to put me in contact with Sterling Smith. Ester Morgan, my mom's first cousin, not only provided shelter and food during my stay in D. C., but she also acted as a surrogate mom to me. I also enjoyed our long conversations about the family and her experiences of attending Paul Laurence Dunbar High School during the 1940s.

# Note on Language Usage

For the purposes of this study, the following words will be defined as Colored, Negro, and Black when referring to terms used by Cooper and Burroughs when they refer to African Americans. Thus, when referring to Cooper's and Burroughs' thoughts, I will use those terms. When referring to contemporary ideas, my thoughts and analyses, I will use the terms African American and Black interchangeably. In addition, when the terms "black" and "white" are used to refer to a racial and ethnic group I will capitalize those words. The 1994 edition of the *Publication Manual of the American Psychological Association* has a section in the book titled "Guidelines to Reduce Bias in Language." This section explains why the terms "black" and "white" should be capitalized.

# Introduction

*The history of the black woman's contribution*
*to education during and after Reconstruction*
*remains to be written.*

—GERDA LERNER, 1973[1]

## THE PROBLEM

Historically, "education has persisted as one of the most consistent themes in the life, thought, struggle and protests of African Americans."[2] Indeed it has been viewed as the major liberation tool for the acquisition of racial, gender and class equality.

Although there is a body of research that takes into account the educational experiences of Blacks, there is a scarcity of literature dealing with the history of African American women in America, specifically in education, which would provide a context for analyzing and understanding their overall experiences. As educational historian Linda Perkins notes, this "omission reflects the lack of significance that African Americans in general and African American women in particular, have been accorded in United States history."[3]

Perkins argues that the "unavailability of the traditional primary sources normally utilized in history places severe limitations on researchers investigating the contributions African American women educators have made to American education." Despite their distinctive contributions to American education, their educational philosophies, their struggle for group survival and institutional transformation have been ignored by American educational history. Linda Perkins writes that this "informational void is a reflection of the type of lives that many of these women led, lives that as a whole left little time for the maintenance of diaries and compilation of letters." "Histories that do assess the philosophies of Black education and women's educational history," writes another researcher, "tend to underestimate or ignore issues confronting African American women."[4]

*xxi*

Perkins also notes that

> although Black women have been prominent in most facets of American life, their role in the education of their race has been their most salient contribution. The contributions of nineteenth century and early twentieth century Black women educators have been overshadowed by the emphasis placed in history upon the role of the northern White school marm, benevolent and philanthropic organizations, and the Booker T. Washington industrial educational philosophy. Consequently, the hardships and struggles these women encountered, in obtaining an education and later transmitting their learning to others remains an untold story.[5]

Perkins further contends that their "virtual absence in the historical annals also reflects the prominent racial and gender biases of nineteenth and early twentieth century chroniclers and archivists who neglected to record and document the activities of African American women."[6]

In recent years, there has been an emergence of journals, articles, and monographs and dissertations on Black women's historical experiences.[7]

In order to determine more fully the impact of African American women in education, we must know more about who they were and what they did as well as the issues and movements that characterized the different periods of time during which they lived. Among the notable pioneering African American women educators of the late nineteenth and early twentieth centuries were Anna Julia Cooper and Nannie Helen Burroughs. These women lived and worked during a time when the political rights and humanity of African Americans were under systematic assault. Nineteenth-century America gave rise to numerous White supremacist ideologies. These ideologies, such as the Teutonic theory and Social Darwinism, espoused the theory that racial/ethnic people were inherently inferior. These theories justified the rationale for government-sanctioned segregation of institutions. Indeed, racial oppression was institutionalized in every aspect of American life, which culminated in the passage of de jure segregation. Historian Rayford W. Logan has dubbed this period as the "nadir" of African American history.[8] This era was also a period in which women were oppressed politically and economically because of their gender status in society. As historian Dorothy Sterling notes, "to be a Black woman in nineteenth- and early twentieth-century America was to live in double jeopardy of belonging to the 'infe-

rior' sex of an 'inferior' race."[9] In spite of these repressive obstacles, Cooper and Burroughs embodied a buoyant and audacious spirit that allowed them to achieve what seemed to be the "wholly impossible." Cooper and Burroughs were bold and indefatigable warriors of racial justice and women's suffrage, who dedicated their lives to the education of African American youth and adults. These women challenged the dominant discourse of how African Americans should be educated by offering alternative ways of educating Black youth. As classroom teachers, they were interested not only with the complete development of their students' intellectual growth but also with their social and emotional development. They prepared their students to be life-long learners and social activists.

A glimpse into Cooper's and Burroughs' lives reveals interesting contrasts and connections. Nannie Helen Burroughs was a student of Anna Julia Cooper at the M Street High School in Washington, D. C. Burroughs described Cooper as an excellent role model and teacher. Under the tutelage of this great teacher, Burroughs was inspired to carry on the struggle of empowering and emancipating Black youth.

The themes of racial, gender and social justice are found throughout their works. Present-day critical feminists and social justice educators will find these themes a valuable resource and a useful addition to the literature on historical, curricular and instructional issues concerning urban school youth.

Cooper and Burroughs played distinctive roles, earned enviable reputations and have been widely honored and respected among African Americans. Outside of the Black community, however, and in the literature of education generally, little has been recorded about their contributions and educational ideologies. Indeed, Black women such as Cooper and Burroughs' "records lie buried, unread, infrequently noticed and even more seldom interpreted. Their names and achievements are known to only a few specialists."[10] This omission allowed a major void to exist in the literature on education in America.

The trope of an "archaeology" of subjugated knowledge elucidates the aforementioined point. Philosopher Michel Foucault argues that knowledges and histories that are non-Western have been looked upon with scorn. Uncovering this subjugated knowledge, as Gerda Lerner points out, requires a process of feminist intellectual archaeology.[12]

At present time, there are two biographies on Cooper: one by Louise D. Hutchinson and another by Leona C. Gabel. Each provides an informative detailed account of Cooper's life. A recently published biography

on Burroughs by Opal Valgene Easter tells the story of Burroughs' contribution to adult education, and to leadership development of African American women and girls. My study however, departs from Easter's study and previous biographical accounts of both women by examining their lives, thoughts, and works from a Black feminist and educational perspective. Moreover, my study is the first research that examines these women together. The purpose of studying Cooper and Burroughs together is to compare and contrast their educational ideologies. I am interested in the similarities and differences in Cooper's and Burroughs' educational beliefs and the reasons for each. Each woman closely identified with W. E. B. Du Bois' and Booker T. Washington's educational ideals. In Chapters 2 and 4, I will discuss briefly Du Bois' and Washington's educational beliefs and their impact and influence on African American female education. Within the African American tradition and the greater American society, the debate of the nineteenth century centered on which educational experiences should be deemed appropriate for Blacks—classical education or industrial education? Du Bois was a strong advocate for classical education and Washington positioned himself on the side of industrial education. Cooper's and Burroughs' educational philosophies combined the industrial and classical modes of knowledge; however, Cooper was a strong advocate for classical education and Burroughs was a strong advocate for industrial education.

Anna Julia Cooper was considered the "female Du Bois" and Burroughs was called the "female Washington." However, Cooper and Burroughs were much more than female versions of Du Bois and Washington. Like many Black female educators of their time, Cooper and Burroughs integrated their roles as educators with political activism. They created institutions and participated in various organizations in an effort to educate Blacks, as well as to organize the community for political action.[13] Activism and education became intertwined thereby exemplifying a core theme in Black feminist thought.[14] In Chapter 4, I will discuss the similarities and differences between Cooper's and Burroughs' educational beliefs and the reasons for each. I will also compare and contrast their educational ideals with Du Bois and Washington. I need to stress that this study is not a comparison of Cooper and Burroughs to Du Bois and Washington per se, although, as mentioned earlier, I will do some comparison in an effort to ascertain how Du Bois' and Washington's educational ideals influenced Cooper and Burroughs.

In sum, my book is an essay on the lives, works and educational philosophies of Anna Julia Cooper and Nannies Helen Burroughs. In this

endeavor, I attempt to recover and reclaim the silenced voices of these two outstanding educators within the interpretative framework of Black feminist thought. The critical understanding of the intersection of race, gender and class oppression is fundamental to my research.

## CONTEXT OF THE STUDY

As noted by scholar Hazel Carby, "since Emancipation, African American women had been active within the Black community in the formation of mutual-aid societies, benevolent associations, local literary societies, and the many organizations of the various black churches."[15] Historian Neverdon-Morton's research reveals that "Black women educators in the nineteenth and early twentieth century were often in the vanguard of the establishment of long-lasting educational and social service programs dedicated to improving the general conditions of African American communities. These improvements were made in spite of mounting racial tensions and lack of economic resources."[16]

According to educational historian Linda Perkins, "throughout the nineteenth century, threads that held together the organizational as well as individual pursuits of Black women were those of 'duty' and 'obligation' to the race." The notion of racial obligation was interconnected with the idea of racial uplift and equality.[17]

The careers of Anna Julia Cooper and Nannie Helen Burroughs encompassed the post-Reconstruction era to the middle of the twentieth century. During this time span, these women were confronted with the arduous task of struggling for racial and economic uplift and social equality. The controversial argument regarding industrial and classical education raged among these women educators just as they did between the two famous male counterparts—DuBois and Washington. However, Cooper and Burroughs laid the foundation for a distinctive emphasis in American education. Black feminist sociologist Patricia Hill Collins notes that late nineteenth and early twentieth century Black women educators such as Cooper and Burroughs saw the "activist potential of education and skillfully used this Black female sphere of influence to lay a firm cornerstone of education in Black community development."[18]

Cooper, a major spokeswoman for women's intellectual emancipation, adhered to a philosophy of "education for service." Burroughs advocated education that would "build the fiber of a sturdy, moral, industrious and intellectual woman."

Cooper espoused the belief that from the commencement of their schooling, "Negro girls must be prepared in hand, heart, and head for the duties and responsibilities that await the intelligent wife, the Christian mother, the earnest, virtuous helpful woman at once both the lever and the fulcrum for uplifting the race."[19]

Anna Julia Cooper was born a slave in August 1859 in Raleigh, North Carolina to Hannah Haywood, also a slave, and to George Haywood, Hannah's slave master. As explained by biographer Louise Hutchinson, "from early on Cooper possessed an unbridled passion for learning and a sincere conviction that women were equipped to follow intellectual pursuits." Ultimately, this passion and conviction carried her from St. Augustine's Normal School and Collegiate Institute in Raleigh, North Carolina, to eventually the Sorbonne in Paris.[20] In 1925, at the age of 67, Cooper earned a Ph.D. from the Sorbonne, which made her the fourth Black woman from the United States to earn a doctorate.[21]

Cooper devoted her entire life to the education and empowerment of Americans and women. As an educator and administrator, Cooper initiated and implemented pioneering educational reforms. Cooper also was a feminist, human rights advocate, author, and lecturer.[22] She not only fought for equal education for all, "she was also a pacesetter in the Black women's movement of the latter part of the nineteenth century."[23]

Beverly Guy-Sheftall, the Anna Julia Cooper Professor of English and Women's Studies at Spelman College in Atlanta, Georgia writes:

> Dr. Cooper experienced one of the most difficult yet stunning careers in the history of the struggle for education among African American women. Never wavering from her philosophy of education for service, she overcame every obstacle that the twin evils of racism and sexism put in her path. Her awesome intellect, high standards, unequivocal positions, and tenacity in the face of constant personal attacks . . . make her one of the most memorable figures in the annals of American education. . . . Perhaps Cooper's most significant legacy was her belief in the power of education to liberate and empower women to participate in the transformation of a world sorely in need of transformation.[24]

Although exceptionally brilliant, Anna Julia Cooper was not an isolated phenomenon in the ranks of pioneer African American women educators. Another remarkable Black woman, Burroughs was a school founder, educator, civil rights activist, feminist and religious leader. An early pupil and eventual colleague of Cooper, "Burroughs," stated biog-

rapher Evelyn Higginbotham, "was only twenty-one years old when she became a national leader . . . at the annual conference of the National Baptist Convention (NBC) in Richmond, Virginia in 1900."[25]

Her speech "How the Sisters Are Hindered from Helping" ". . . served as a catalyst for the formation of the Woman's Convention Auxiliary to the National Baptist Convention."[26]

Burroughs was born in Orange, Virginia, May 2, 1879, to John Burroughs and Jenne Poindexter. Her schooling included attendance at the District of Columbia public schools. Burroughs "considered her education at M Street High School to have been a glorious experience." She felt teachers "Mary Church Terrell and Anna Julia Cooper were important role models."[27] Burroughs graduated with honors in 1896, studied business in 1902, and received an honorary M.A. degree from Eckstein-Norton University in Kentucky in 1907.

Burroughs committed her energies to an assortment of social issues. She denounced lynching, segregation, employment discrimination, and the European colonization of Africa. Burroughs was also an active participant in numerous organizations such as the National Association of Colored Women and the National Association of Wage Earners.

Burroughs' struggle to fight against all forms of oppression led to her establishing an industrial school for Black females. On October 19, 1901, the National Training School for Women and Girls opened with Burroughs as president. During the school's first twenty-five years, it provided a junior high school, high school, and junior college level training to more than 2,000 women from the United States, Africa, and the Caribbean. It also provided training for missionaries and Sunday school teachers, bookkeepers, cooks, laundresses, and housemaids. Burroughs believed that Black women needed to be financially independent. Hence her school motto, "We specialize in the wholly impossible," embodied this philosophy. Burroughs' school, which was renamed the Nannie Helen Burroughs School in 1964, remains in existence today as an elementary and junior high school.[28]

Evelyn Brooks Barnett (Higginbotham) writes:

[Burroughs'] efforts to build a school illustrate the camaraderie and cooperation among Black women educators. Through Burroughs' labors and ideas, the voices of women are heard articulating the salient questions of the day—social equality, the franchise, classical versus industrial education, Africa, and economic uplift. . . . [29] Burroughs' life example and . . . teachings, laid a strong foundation upon which to build a more just and equitable America.[30]

## SIGNIFICANCE OF THE STUDY

> *A people do not throw their geniuses away . . . if*
> *they are thrown away, it is our duty as artists,*
> *scholars, and witnesses for the future to collect*
> *them again for the sake of our children . . . if*
> *necessary, bone by bone.*
>
> —ALICE WALKER, 1983[31]

Patricia Hill Collins argues that the

> painstaking process of collecting the ideas and actions of "thrown
> away" Black women like [Cooper and Burroughs] has revealed one
> important discovery: Black women intellectuals have laid a vital ana-
> lytical foundation for a distinctive standpoint on self, community, and
> society, [establishing] in the process a Black women's intellectual tra-
> dition. . . . [in spite of] the shadow obscuring this . . . intellectual tradi-
> tion. . . . [Cooper, Burroughs] and countless other [African American
> women] . . . have used their voices to raise essential issues affecting
> African American women, [Black youth and the Black community as a
> whole].[32]

Black women educators who have made significant contributions to
the development of American education warrant present-day examina-
tion. The experiences of Anna Julia Cooper and Nannie Helen Burroughs
dramatize the triple plight of Black women who struggled against barri-
ers imposed by class, race, and gender discrimination. These bold and
determined women educators entered the field of education as a form of
social and political activism. They saw themselves as contributors to the
"uplifting" of the African American community.

Although each of these women was unique, when they are viewed
together, a number of common themes emerge. One such theme is "the
passion and determination with which each pursued their own education.
Other common themes include their brilliance both as learners and
teachers; the ingenuity that allowed them to overcome personal and pro-
fessional difficulties,"[33] and finally, their staunch commitment to win-
ning the struggle against sexism, classism and institutional racism while
empowering and improving the quality of life for all.[34]

The significance of this study is multiple. First, the study addresses
the issue of who and what images are worth remembering in history. Past

and present sociological and historical ideology on African American women has been discussed and analyzed from a very myopic, erroneous and distorted perspective. The controlling, negative, and stereotypical images of Black women that originated during the slave era attest to the ideological dimension of Black women's oppression.[35] Appearing in scholarly literature as well as popular culture, the images and ideologies of Black women as mammies—the loyal and happy servant; and jezebels—the whore, etc. have taken the form of accepted truths. These images serve to set Black women aside from humanity and in turn justify, support, and rationalize the racial and gender oppression and economic subordination of Black women. In Chapter 5, I will explain further how dominant ideologies, imagery and race, class and gender intersect thereby giving rise to Black women's oppression.

Second, African American women not only have developed distinctive interpretations of Black women's oppression, but have done so by using alternative ways of producing and validating knowledge itself. Analyzing history and ideologies from an African American woman's standpoint reveals a history that "reflects the distinct concerns and values of Black women and their role both as African Americans and women. And our unique status has had an impact on both racial and feminist values."[36] Specifically, analyzing the lives, works and philosophies of two important early Black women educators within the framework of Black feminist theory will illuminate and document their distinctive and collective contributions to Black educational history, women's educational history and American educational history in a way that has never been done before.

Third, Cooper's and Burroughs' "way of knowing" challenges the Western Anglo hegemonic regime of truth, feminist theories, the masculinist hegemony of Black studies, and also scholarship in the realm of educational theory, thereby questioning which ideologies, knowledge and truths are legitimate and valid.

Fourth, the lives and works of Cooper and Burroughs, as elucidated in this study, will serve to remind us that Black women's experiences are complex and often neglected in the interest of racial, gender and class oppression. This study will not merely disclose forms of consciousness that subjugate Black women's subjectivity and personality, but it will attempt to empower and emancipate the subjugated intellectual discourses of Cooper and Burroughs hence offering a valuable perspective for understanding past as well as contemporary educational scholarship of African Americans.

Fifth, without understanding the histories, struggles and ideologies of African Americans, particularly educators, public policy follows the path of social myth. Entering this study into the debate on issues and problems in the education of African American youth, urban education and gender education, offers an opportunity to make those problems central to the debate about education in general and poses important issues for decision makers to consider. Furthermore, this study challenges educators and the field of teacher education to employ educational epistemologies generated by African Americans.

As prominent educator Gloria Ladson-Billings points out, the discourse of Black teachers is the "missing voice" in teacher education programs.[37] This study helps to produce school knowledge that will stimulate a dialogue on the rethinking of schools that are transformative, counterhegemonic and includes the "voices" of African American educational scholars. Such dialogue in the writings on teaching is long overdue.

The lives, works, struggles and educational discourses of Anna Julia Cooper and Nannie Helen Burroughs offer a valuable chapter in the unfolding history of education, women and African Americans.

## NOTES

[1] Gerda Lerner, ed., *Black Women in White America: A Documentary History* (New York: Vintage Books, 1973) p. 622

[2] Bettye Collier-Thomas, "The Impact of Black Women in Education: An Historical Overview," *Journal of Negro Education*, vol. 51, no. 3 (Summer 1982) p. 173

[3] Linda M. Perkins, *Fanny Jackson Coppin and the Institute for Colored Youth 1865-1902* (New York: Garland Publishing Inc., 1987) p. 2

[4] Ibid.; Carol O. Perkins, *Pragmatic Idealism: Industrial Training and Women's Special Needs* (Ph.D. dissertation, Claremont Graduate School and San Diego State University, 1987), p. 2

[5] Perkins, *Fanny Jackson Coppin,* pp. 3-4

[6] Ibid., p. 2

[7] The most major recent documentary works include: J. C. Smith ed., *Notable Black American Women* (London: Gale Research Inc., 1992); D. C. Hine ed., *Black Women in United States History*, vol. 1-16 (Brooklyn, NY: Carlson Publishing Inc., 1990); D. C. Hine ed., *Black Women in America*, vol. 1-2 (Brooklyn, NY: Carlson Publishing Inc., 1993); other works include G. Lerner ed., *Black Women in White America: A Documentary History* (New York: Vintage Books, 1973); D. Sterling ed., *We Are Your Sisters: Black Women in the Nineteenth Century* (London: W. W. Norton & Company Inc., 1984)

[8] Rayford W. Logan, *The Negro in American Life and Thought: The Nadir 1877-1901* (New York: Dial Press, 1954); also see Rayford W. Logan, The Betrayal of the Negro, from Rutherford B. Hayes to Woodrow Wilson (New York: Collier Books, 1965)

[9] Dorothy Sterling, ed., *We Are Your Sisters: Black Women in the Nineteenth Century* (New York: W. W. Norton, 1984) p. ix

[10] Lerner, *Black Women In White America*, pp. xvii-xviii; Jacqueline A Young, *A Study of the Educational Philosophies of Three Black Women* (Ed.D. dissertation, Rutgers State University of New Jersey, 1987), pp. ii–iii.

[11] See Michael Foucault, *The Archaeology of Knowledge and the Discourse on Language* (New York: Pantheon Books, 1972)

[12] See Gerda Lerner, *The Creation of Patriarchy* (New York: Oxford University Press, 1986)

[13] Beverly M. Gordon, "The Fringe Dwellers: African American Women Scholars in the Postmodern Era," in B. Kanpol & P. McLaren *Critical Multiculturalism: Uncommon Voices in a Common Struggle* (London: Bergin & Garvey, 1995) p. 67

[14] See Patricia Hill Collins, *Black Feminist Thought: Knowledge, Consciousness, and the Politics of Empowerment* ( New York: Routledge, 1991)

[15] Hazel V. Carby, *Reconstructing Womanhood: The Emergence of the Afro-American Woman Novelist* (New York: Oxford University Press, 1987) p. 4

[16] Cynthia Neverdon-Morton, (1982) "Self-Help Programs as Educative Activities of Black Women in the South, 1895-1925," *Journal of Negro Education*, vol. 51, no. 3, p. 207

[17] Linda M. Perkins, "Black Women and Racial Uplift Prior to Emancipation," in F. C. Steady, ed., *The Black Woman Cross-Culturally* (Rochester, Vermont: Schenkman, 1981) p. 317

[18] Collins, *Black Feminist Thought*, p. 147

[19] Anna Julia Cooper, *A Voice from the South*, in Schomburg Library of Nineteenth Century Black Women Writers, ed., (1892 reprinted: New York: Oxford University Press, 1988) p. 20

[20] Louise D. Hutchinson, "Anna Julia Cooper," in Darlene Clark Hine, ed., *Black Women in America*, vol. I (Bloomington, Indiana: Indiana University Press, 1993) pp. 275-276

[21] The other African American women who had earned Ph.Ds. before Anna Julia Cooper were Sadie Tanner Mossell Alexander, the first Black woman to earn a Ph.D. in economics from the University of Pennsylvania in 1921; Eva B. Dykes and Georgiana Rose Simpson also each earned their Ph.D. from an American university prior to Cooper.

[22] Hutchinson, "Anna Julia Cooper," p. 275

[23] Ann Allen Shockley, ed., "Anna Julia Haywood Cooper: 1859-1964," in *Afro-American Women Writers, 1746-1933: An Anthology and Critical Guide*, (New York: Meridian Books, 1986) p. 206

[24] Beverly Guy-Sheftall, "Anna Julia Cooper" in M. S. Seller, ed., *Women Educators in the United States, 1820-1993: A Bio-Bibliographical Sourcebook* (London: Green Wood Press, 1994) p. 165

[25] Evelyn B. Higginbotham, "Nannie Helen Burroughs" in D. C. Hine, ed., *Black Women in America: An Historical Encyclopedia*, vol. I (Bloomington: Indiana University Press, 1993) p. 201

[26] Ibid.

[27] Ibid.

[28] Ibid.

[29] Evelyn Brooks Barnett, "Nannie Burroughs and the Education of Black Women," in Harley & Terborg-Penn, ed., *The Afro-American Woman, Struggles and Images* (Port Washington, New York: Kennikat Press, 1978) p. 108

[30] Higginbotham, "Nannie Helen Burroughs," p. 205

[31] Alice Walker, *In Search of Our Mother's Gardens* (New York: Harcourt Brace Jovanovich, 1983) p. 92; also cited in Patricia Hill Collins, *Black Feminist Thought*, p. 5

[32] Collins, *Black Feminist Thought*, p. 5

[33] M. S. Seller, ed., *Women Educators in the United States, 1820-1993: A Bio-Bibliographical Sourcebook* (London: Green Wood Press, 1994) p. xiv

[34] Gordon, "Fringe Dwellers," p. 67

[35] For an analysis of the controlling, negative and stereotypical images of Black women, see Patricia Hill Collins, "Mammies, Matriarchs, and Other Controlling Images" in *Black Feminist Thought: Knowledge, Consciousness, and the Politics of Empowerment* (New York: Routledge, 1991) pp. 67-90

[36] See Paula Giddings, *When and Where I Enter: The Impact of Black Women on Race and Sex in America* (New York: William Morrow, 1984)

[37] See Gloria Ladson-Billings, *The Dreamkeepers: Successful Teachers of African American Children*, (San Francisco: Jossey-Bass Publishers, 1994)

# Theoretical Framework

Feminist educator Maxine Green notes that for more than a century "most histories of [American public] education were written by men and focused largely on what male leaders said and did in the field."[1] Feminist educator Jane R. Martin concurs. She states that even though women have historically

> taught the young and have themselves been educated, they are excluded both as the subjects and objects of educational thought from the standard texts and anthologies: as subjects their philosophical works on education are ignored; as objects in works by men about their education and their role as educators of the young they are largely neglected.[2]

The ideas, writings, intellectual discourses and theorizing produced by African American scholars have also been excluded, ignored and marginalized in the dominant educational literature. As critical educational theorist Beverly Gordon notes, "most of the curriculum fields and indeed educational literature in both the academy and popular cultures are grounded in the Euro-American regime of truth."[3] Gordon argues that while there are prominent African American educational scholars whose research has been published and reviewed in mainstream journals, their ideas, theories, and experiences have not impacted significantly the predominant paradigms in the field of education. She further argues that there is "no absence of discourse and literature" produced by past and present African American scholars such as Carter G. Woodson, Horace

Mann Bond, Anna Julia Cooper, Fanny Jackson Coppin, and W. E. B. Du Bois, just to name a few. "Black people," she explains, "have created a body of cultural knowledge that transcends disciplinary lines in science, education, social theory and other fields. It includes useful theoretical constructs, paradigms, and models of viewing and seeing the world."[4] According to Gordon, this body of scholarship "generated out of and influenced by the African American existential condition . . . could inform educational research and theory and have practical teaching implications."[5]

To give "voice" to Anna Julia Cooper's and Nannie Helen Burroughs' educational philosophies, I use a theoretical perspective grounded in Black feminist epistemology. My study, therefore, proceeds from the assumptions that a reclaiming of the lives, works and subjugated discourses of Cooper and Burroughs requires a critical framework that does not subordinate or marginalize race, class and gender issues, which is the case in traditional frameworks. Epistemology is the study of the philosophical problems in concepts of knowledge and truth. The theoretical framework employed for my study will be informed by Black feminist theory. According to Black feminist sociologist Patricia Hill Collins, Black feminist theory is a "specialized thought that reflects the thematic content of the standpoint of African American women's experiences."[6] Collins maintains that Black feminist thought is subjugated knowledge because Black women have had to battle against Eurocentric masculinist views of the world in order to convey a self-defined standpoint. She further notes that

> the suppression of Black women's efforts to self-definition in traditional sites of knowledge production had led African American women to use alternative sites such as music, literature, daily conversations, and everyday behavior as important locations for articulating the core themes of Black feminist consciousness.[7]

The epistemological basis of this theory provides: (1) an explanation why Western Anglo masculinist thought has excluded and or marginalized the scholarship and intellectual discourse of Black female educators such as Cooper and Burroughs and (2) a conceptual framework that illuminates the contributions and the educational philosophies of the above mentioned educators and places these contributions and philosophies at the center of analysis.

To reclaim the voices and standpoints of Cooper and Burroughs, I use their personal experiences as well as the personal experiences of other

African American women for themes that relate to Black women's experiences. I use this in addition to established bodies of academic research.

## SECTION I: BLACK FEMINIST THEORY

Feminist researcher Beverly Guy-Shettall explains that "Black feminist theory came of age during the 1990s and moved from margin to the center of mainstream feminist discourse."[8] Feminist scholar Patricia Hill Collins analyzes three core themes of Black feminism as the following: (1) the interlocking nature of race, class, and gender oppression in Black women's personal, domestic, and work lives (2) the necessity of internalizing positive self-definitions and rejecting the denigrating, stereotypical, and controlling images of others, both within and without the Black community (3) and the need for active struggle to resist oppression and realize individual and group empowerment.[9]

Black feminist theory was developed as an appropriate epistemological framework for understanding Black women's lives and was one of the responses to the problematic of dominant Western Anglo masculinist assumptions of traditional scientific research. Eurocentric Western science promulgated the idea that knowledge can be universally applicable because all human experiences are generic regardless of race, class and gender differences.

Collins defines Black feminist theory as those experiences and ideas grounded in African American women's lives that provide a "unique angle of vision on self, community and society." It comprises theoretical interpretations of Black women's reality by those who live it. This epistemology consists of "specialized knowledge" created by African American women, which clarifies a standpoint of and for Black women. It employs four dimensions: concrete experiences as a criterion of meaning, the use of dialogue in assessing knowledge claims, an ethic of caring and concern for the totality of the entire Black community and an ethic of personal accountability.[10] The concrete experience relates to the Black woman's "ways of knowing" or validating knowledge claims. One's place or location in a social historical, cultural, political context, gives rise to one assessing knowledge or deconstructing prevailing notions of truths based on one's lived experiences. Patricia Hill Collins argues that concrete experience is both an Afrocentric and a woman's tradition. For dialogue, a primary epistemological assumption underlying dialogue "implies talk between two subjects, not the speech of subject and object. It is humanizing speech, one that challenges and resists domination."[11]

For Black women, "new knowledge claims are rarely worked out in isolation from other individuals and are usually developed through dialogues with other members of a community."[12] In other words, Black women have the "opportunity to deconstruct the specificity of their own experiences and make connections with the collective experiences of others."[13] An ethic of caring also reflects both an African and a woman's tradition. Its components include the "value placed on individual expressiveness, the appropriateness of emotions, and the capacity for empathy most of which pervade the African American culture."[14] The fourth dimension of Black feminist epistemology is an ethic of personal accountability. Its characteristics include a convergence of an Afrocentric value and feminist's value. Moral development and maintaining social relationships are central to the knowledge validation process.[15]

Collins postulates that the "theoretical framework of Black feminist thought, in which the Afrocentric perspective is inherent, sees race, class, and gender as interlocking systems of oppression."[16] She contends that "Black feminist knowledge generates collective consciousness that transform social, political and economic relations." She argues that:

> [Black] feminist thought offers two significant contributions toward furthering our understanding of the important connections among knowledge, consciousness, and the politics of empowerment. First, Black feminist thought fosters a fundamental paradigmatic shift in how we think about oppression. By embracing a paradigm of race, class, and gender as interlocking systems of oppression, Black feminist thought reconceptualizes the social relations of domination and resistance. Second, Black feminist thought addresses ongoing epistemological debates in feminist theory and in the sociology of knowledge concerning ways of assessing 'truth.' Offering subordinate groups new knowledge about their own experiences can be empowering. But revealing new ways of knowing that allow subordinate groups to define their own reality has far greater implications.[17]

Collins maintains that African American scholars use an "outsider-within" standpoint through which they analyze the method of oppression. Certainly this empowers Black women to perceive Western Anglo society and scholarship through an alternative lens. bell hooks too argues that African American women are "outsiders who participate, but do not hold full membership in the Black male community, the White male community or the White feminist community. . . . [Without a doubt,]

"Black women," it is argued, "bear the brunt of sexist, racist, and classist oppression."[18] Collins suggests that any change in this permanent marginal status "requires African American women to reclaim the Black feminist intellectual tradition by discovering, reinterpreting, and analyzing the literary and intellectual works and societal deeds of African American women from a Black feminist standpoint."[19]

Collins proposes that a Black feminist theory reflects elements of epistemologies used by African Americans and women as groups. She explains that

> Africanist analyses of the Black experience generally agree on the fundamental elements of an Afrocentric standpoint. Despite varying histories, Black societies reflect elements of a core African value system that existed prior to and independently of racial oppression. Moreover, as a result of colonialism, imperialism, slavery, apartheid, and other systems of racial domination, Black people share a common experience of oppression.[20]

Collins asserts that these "factors foster shared Afrocentric values that permeate the family structure, religious institutions, culture, and community life of Blacks" in the United States and the Black Diaspora. It is argued that this "Afrocentric consciousness permeates the shared history of people of African descent through the framework of a distinctive Afrocentric epistemology."[21]

Still it is important to note that Black feminism is not a monolithic static theory. As feminist scholar Beverly Guy-Sheftall points out, "there is no one 'Black experience' and no single 'Black woman's experience.' Class and other cultural differences give rise to a diversity of experiences among Black women."[22] Guy-Sheftall further notes that despite this diversity, certain premises are constant. According to Guy-Sheftall, these premises include:

> a) Black women experience a special kind of oppression and suffering in this country which is racist, sexist, and classist because of their dual racial and gender identity and their limited access to economic resources (b) This "triple jeopardy" has meant that the problems, concerns, and needs of Black women are different in many ways from those of both White women and Black men (c) Black women must struggle for Black liberation and gender equality simultaneously (d) There is no inherent contradiction in the struggle to eradicate sexism

and racism as well as the other "isms" which plague the human community, such as classism and heterosexism (e) Black women's commitment to the liberation of Blacks and women is profoundly rooted in their lived experiences.[23]

Collins points out that other feminist scholars have proposed a similar hypothesis by maintaining "that women share a history of gender oppression, primarily through sex/gender hierarchies. These experiences transcend divisions among women created by race, social class . . . [and] sexual orientation, forming the basis of a woman's standpoint . . . and epistemology."[24] According to Collins, "while a Black feminist standpoint reflects elements of epistemologies used by [Blacks] and women . . . , it also paradoxically demonstrates features that may . . . closely resemble Black men; on others White women, and still others may "be unique to the everyday lived experiences of Black women."[25]

Black feminist thought addresses and challenges the hegemony of Western patriarchal ways of assessing "truth." It is a theoretical framework that embodies social change as a change in individual consciousness conjoined with the transformation of societal institutions.[26]

Feminist research grounded in Black feminist theory sheds light on how certain people are ingored, their words discounted, and their place in history overlooked. As explained by feminist scholar Sandra Harding et al., "when the White male experience is taken to be the human experience—the resulting theories, concepts, methodologies, inquiry goals and knowledge claims distort human social life and human thought."[27] Harding et al. argue that

> Human experience differs according to the kinds of activities and social relations in which humans engage. Hence, the experience on which the prevailing claims to social and natural knowledge are founded is only partial human experience and therefore only partially understood.[28]

Thus, researchers must "root out sexist and racist distortions and perversions in epistemology, metaphysics, methodology and the philosophy of science."[29] Black feminist theory challenges the hegemonic notion of truth and provides a valid rationale for the study of African American women.

My epistemological approach grounded in Black feminist thought makes the invisible visible and brings from margin to center the lives,

works, and thoughts of Anna Julia Cooper and Nannie Helen Burroughs. It puts the spotlight on these women as competent educators, theorists, and activists struggling for racial, gender and social class justice. It allows for the understanding of these women as subjects in their own right rather than objects for men. And finally, it allows for the validation of a research methodology based on the standpoint and concrete lived experiences of these women.

## SECTION II:
## METHODOLOGICAL PERSPECTIVE

> *Defining what is in need of scientific explanations only from the perspectives of bourgeois, white men's experiences leads to partial and even perverse understandings of social life. One distinctive feature of feminist research is that it generates its problematic from the perspective of women's experiences. It also uses these experiences as a significant indicator of the "reality" against which hypotheses are tested.*
> —SANDRA HARDING, 1987[30]

In order to reclaim the "voices" of Cooper and Burroughs, and write them into the annals of history, my study is an historical and biographical investigation. My methodological perspective provides a theoretical and epistemological framework grounded in Black feminism. Black feminist theory is the lens through which I interpret my data. My study begins from the position that history has been written from a Western Anglo masculinist perspective—a perspective that has failed to ask those questions that would elicit information about the contributions, experiences and perspectives of women and people of color. Scholarly neglect and racist assumptions have doubly victimized Black women.[31] As Blacks and women we have been historically rendered doubly invisible in American research and scholarship. The burgeoning scholarship on the history of African Americans and women from our perspective and standpoint has enhanced the visibility of both groups and rescued our history from the patronizing or frankly racist attitudes of the mostly White male historians of the period. These works suggest the necessity for a story very different from that told by the hegemonic ideas of Western Anglo

masculinist perspectives. Many African Americans, feminists and members of other marginalized groups in the academy have "rejected the false neutrality of social science inquiry. They put forth the argument that traditional social science begins analysis and inquiry only from the perspectives and experiences of White Western bourgeois men."[32]

Sandra Harding's critique of social science states that

> ... despite the deeply ingrained Western cultural belief in science's intrinsic progressiveness, science today serves primary regressive social tendencies; and that the social structure of science, ... its applications ... technologies, its modes of defining research problems and designing experiments, its way of constructing and conferring meanings are not only sexist but also racist, classist, and culturally coercive.[33]

Patricia Hill Collins makes the point that the exclusion and suppression of Black women's thoughts, ideas and intellectual tradition is neither accidental nor benign. She states that

> ... suppressing the knowledge produced by any oppressed group makes it easier for dominant groups to rule because the seeming absence of an independent consciousness in the oppressed can be taken to mean that subordinate groups willingly collaborate in their victimization ... maintaining the invisibility of Black women and our ideas is critical in structuring patterned relations of race, gender, and class inequalities that pervade the entire social structure.[34]

Many feminist scholars not only argue the importance of challenging Eurocentric patriarchal assumptions of Western science and knowledge, but also the importance of recovering and reclaiming the subjugated knowledge of marginalized groups. Feminist scholar Chandra Mohanty argues:

> The issues of subjectivity represent a realization of the fact that who we are, how we act, what we think, and what stories we tell become more intelligible within an epistemological framework that begins by recognizing existing hegemonic histories ... uncovering and reclaiming of subjugated knowledge is one way to lay claim to alternative histories.[35]

Reclaiming the ideas, knowledge and histories of the traditionally excluded marginalized groups involves discovering, reinterpreting, and

[in] ... "many cases, analyzing for the first time the works of Black women intellectuals who were so extraordinary that they did manage to have their ideas preserved through the mechanisms of mainstream scholarly discourse."[36]

Thus, in my study, I use a framework that not only refutes Western theories, concepts and tools that marginalize the lives and subjugate the intellect of Anna Julia Cooper and Nannie Helen Burroughs, but puts forth an alternative epistemology that illuminates these women's experiences and ideologies.

## HISTORICAL AND BIOGRAPHICAL RESEARCH

According to historical researcher Anthony Brundage, "historical research conceptualizes the past as being in constant dialogue with an ever-advancing present, responding to new questions and revealing fresh patterns to illuminate the human condition."[37] Brundage points out that "historical writing has a narrative structure in which a sequence of connected events occurring within a span of time is deployed by the researcher to create pattern and meaning."[38] It is argued that individual biographies are adequately grasped and understood when referenced to the social historical context during which the individual lived.[39] Historical studies tend to be qualitative or humanistic. This study employs a qualitative design.

This book is an historical and biographical investigation, which begins from an epistemological paradigm. This paradigm reflects the ideas, experiences and standpoints of Anna Julia Cooper and Nannie Helen Burroughs. It is also a narrative biographical story that traces their lives from childhood until death. Although I am not formally trained as an historian, I ventured into this project in order to recover the lives and reclaim the voices of these two extraordinary women.

A deconstruction and reconstruction of the present historical texts was necessary in order to: (a) place at the center of analysis the ideas of Cooper and Burroughs and (b) understand and illuminate Cooper's and Burroughs' particular experiences as they relate to race, class and gender issues in the period under consideration.

## DATA COLLECTION

"Historical research relies on tangible remains of the past, such as written records for source materials."[40] Written records include letters, diaries, memoirs, speeches, newspapers, just to name a few.

These written records are referred to as primary sources. Historical research also depends upon secondary sources (written histories such as books, essays and articles) to learn about and analyze the lives of people in former times. In order to better understand Cooper's and Burroughs' theories of education, I use an historical investigation with an emphasis on biography. This investigation and the reconstruction of the biographical and historical text under consideration proceeded by utilizing primary and secondary source data. The collected papers of Anna Julia Cooper and Nannie Helen Burroughs were examined. The writings of Cooper and Burroughs, including undated documented autobiographies, personal letters and correspondences, scrapbooks and speeches served as the primary sources of information for discussion. The collected papers of Anna Julia Cooper are located in the Moorland-Spingarn Research Center at Howard University in Washington, D. C. The papers of Nannie Helen Burroughs are located in the Library of Congress Manuscript Division. Additional primary sources included newspapers of the era under consideration, and other relevant documents and records. Secondary sources included general histories of the antebellum and postbellum era; the late nineteenth and early twentieth century in the United States; biographies; and critical studies in the field of Black and women's educational history and intellectual thought.

Social researcher K. D. Bailey notes that data collection in an historical investigation is similar to participant observation because of the fact that one is looking at personal documents.[41] The documents I selected were chosen subjectively by me, the researcher, based on my interest rather than being randomly selected. It was based also on the themes I set out to research.

Secondary sources were read first because the "factual grasp of the topic helps one to analyze the primary sources effectively."[42] Due to time constraints on this research project I only extrapolated the selected topics. For example, Nannie Helen Burroughs' collected papers include 135,000 volumes of personal papers, documents and photos. Thus, extrapolating selective examples or facts for analysis were appropriate and less time consuming.

One important way to strengthen a study design is through triangulation. I used data triangulation, which involves using a variety of data sources in a study. Hence, in addition to collecting written records, interviews were conducted as well. I conducted interviews of individuals who personally knew Cooper and Burroughs such as family members, former colleagues, friends and a local Washington, D. C. scholar.

## DATA ANALYSIS

The design of this research study is a basic qualitative approach. Historical research is a subjective science. The analysis is heavily shaped by my theoretical framework within which my study is conducted. I analyzed Cooper's and Burroughs' lives, works and social and political activism and philosophies of education within the framework of Black feminist theories. What emerged from the data of this study was an analysis. Social science researcher Michael Q. Patton makes the point that in qualitative data analysis, there are "few agreed upon canons . . . in the sense of shared ground rules for drawing conclusions and verifying sturdiness. There are no formulas for determining significance. There are no ways of perfectly replicating the researcher's analytical thought processes. There are no straightforward tests for reliability and validity. In short, there are no absolute rules except to do the very best with your full intellect to fairly represent the data and communicate what the data reveal given the purpose of the study."[43]

To illustrate and illuminate Cooper's and Burroughs' educational beliefs, I focused on identifying, interpreting and analyzing themes that reveal alternative ways of conceptualizing education. I also focused on themes that revealed Cooper's and Burroughs' own authentic worldview and perspectives on issues of race, gender, and class oppression. The interactions between the social historical context, the theoretical perspectives, the collected data and the dialogue with each of these, painted a portrait of Cooper's and Burroughs' roles in the enhancement of education for African Americans and their struggle for racial, gender and social justice. A critical investigation of the ideologies and life experiences of Anna Julia Cooper and Nannie Helen Burroughs from the angle and vision provided by an alternative methodological perspective provided for a more objective and comprehensive understanding of these educators.

I collated the data based on themes or topics. I created folders that related to the topics such as biographical or background information; educational thoughts and ideals; organizational and activist work, experiences as educators, and general information on Washington, D.C. and correspondences etc. These topics helped shaped my chapters, and from the data I was able to focus more clearly on the core Black feminist themes.

## NOTES

[1] Maxine Green, "Gender, Multiplicity and Voice." in S. K. Bilken & D. Pollard eds., *Gender and Education* (Chicago: National Society for the Study of Education, 1993) p. 241

[2] Jane Roland Martin, *Changing the Educational Landscape: Philosophy, Women and Curriculum* (New York: Routledge, 1994) p. 35

[3] Beverly Gordon, (1990) "The Necessity of African American Epistemology for Educational Theory and Practice," *Journal of Education*, vol. 172, no. 3, p. 89

[4] Ibid., p. 101

[5] Ibid., p. 90

[6] Patricia Hill Collins, *Black Feminist Thought: Knowledge, Consciousness, and the Politics of Empowerment* (New York: Routledge, 1991) p. 201

[7] Ibid., p. 202

[8] Beverly Guy-Sheftall, *Words of Fire: An Anthology of African American Feminist Thought* (New York: The New Press, 1995) p. 18

[9] Collins, *Black Feminist Thought*, pp. 23, 32, 83-84; also see Guy-Sheftall, *Words of Fire*, pp. 18-19

[10] Collins, *Black Feminist Thought*, pp. 208-217

[11] Ibid., p. 212

[12] Ibid.

[13] Gloria Ladson-Billings, *The Dreamkeepers: Successful Teachers of African American Children* (San Francisco: Jossey-Bass Publishers, 1994) p. 155

[14] Collins, *Black Feminist Thought*, p. 216

[15] Ibid., p. 219

[16] Ibid., p. 213

[17] Ibid., p. 222

[18] See bell hooks, *Feminist Theory: From Margin to Center* (Boston: South End Press, 1984)

[19] See Patricia Hill Collins, "Reclaiming the Feminist Intellectual Tradition," in *Black Feminist Thought: Knowledge, Consciousness, and the Politics of Empowerment* (New York: Routledge, 1991) p. 13-16

[20] Ibid., p. 206

[21] Ibid.

[22] Guy-Sheftall, *Words of Fire*, p. 2

[23] Ibid.

[24] Collins, *Black Feminist Thought*, p. 206

[25] Ibid., pp. 206-207

[26] Ibid.

[27] Sandra Harding & Merrill B. Hintikka, "Introduction" in S. Harding & M. B. Hintikka eds., *Discovering Reality: Feminist Perspectives on Epistemology, Metaphysics, Methodology, and Philosophy of Science* (London: D. Reidel Publishing Company, 1983) p. x

[28] Ibid.

[29] Ibid.

[30] Sandra Harding, ed., "Is there a Feminist Method?," *Feminism & Methodology: Social Science Issues* (Bloomington, Indiana: Indiana University Press, 1987) p. 7

[31] Gerda Lerner, ed., *Black Women in White America: A Documentary History* (New York: Vintage Books, 1972) p. xvii

[32] Harding, p. 7

[33] Sandra Harding, *The Science Question in Feminism* (London: Cornell University Press, 1986) p. 9

[34] Collins, *Black Feminist Thought*, p. 5

[35] Chandra Mohanty, "On Race and Voice Challenges for Liberal Education in the 1990s," in Henry A. Giroux & Peter McLaren eds., *Between Borders: Pedagogy and the Politics of Cultural Studies* (New York: Routledge, 1994) p. 148

[36] Collins, *Black Feminist Thought*, p. 13

[37] Anthony Brundage, *Going to the Sources: A Guide to Historical Research and Writing* (Arlington Heights, Illinois: Harlan Davidson Inc., 1989) p. 2

[38] Ibid., p. 8

[39] Michael R. Hill, *Archival Strategies and Techniques: Qualitative Research Methods Series 31* (Newbury Park, CA: Sage Publications, 1993) p. 3

[40] Brundage, *Going to the Source*, p. 2

[41] K. D. Bailey, *Methods of Social Research* (London: The Free Press, 1994) p. 310

[42] Brundage, *Going to the Source*, p. 2

[43] Michael Q. Patton, *Qualitative Evaluation and Research Methods* (Newbury Park, CA: Sage Publications, 1990) p. 372

# The History of Black Education

Fully to understand and critically analyze the contributions Anna Julia Cooper and Nannie Helen Burroughs made to education requires an examination of the social historical conditions, problems, and issues related to the education of African Americans in general and for Black women in particular. This historical overview will examine the following: (1) the history of Black education prior to Emancipation and after the Civil War; (2) the educational ideologies during the post-Reconstruction years; (3) the educational ideologies of William E. B. Du Bois and Booker T. Washington and their impact or influence on the education for Black females and; (4) the development of education for African American women.

## BLACK EDUCATION: PRE AND POST CIVIL WAR YEARS

Anna Julia Cooper and Nannie Helen Burroughs inherited a tradition through which African Americans associated education with freedom and empowerment.

Beginning in 1619, the African child disembarked on the southern American soil and was forced into a life of enslavement. "For the majority of Africans who were slaves on Southern plantations, life was a process of being conditioned to accept White superiority and Black inferiority. White plantation owners instituted a conditioning process that was intended to make Africans docile, obedient, and compliant."[1]

In order to ensure the success of this "conditioning process," several slave states pressed laws making it illegal to educate Blacks. South Carolina was the first to pass the "compulsory ignorance" law in America, in

1740. This law prohibited the educating of African Americans.[2] The following are examples of laws enacted by slave holding Southern states to prohibit the education of Blacks: In 1817, Missouri barred Blacks from schools; in 1819, Virginia forbade the teaching of reading and writing to Blacks; in 1831, Georgia made it unlawful to teach Blacks to read or write; in 1832 Mississippi made it illegal for five or more Blacks to meet for educational purposes; in 1832, Florida prohibited all meetings of Blacks, except for religious purposes.[3]

Because of the compulsory ignorance law in the slave holding states, the education of the African was primarily by informal means. Some slaves acquired literacy skills depending on the type of task they were required to do. The slave labor force performed tasks that ranged from those of field hands to skilled craftsmen. Some slaves became skilled carpenters, blacksmiths, weavers, and seamstresses; others were proficient bookkeepers, typesetters, and machinists.[4]

The 1848 industrial census of Charleston, South Carolina revealed that free Blacks were employed in all but eight of the fifty occupations composing the skilled group and slaves were employed in all but thirteen. Free Blacks were fairly dominant as carpenters, joiners, barbers, hairdressers, and bankers. Slaves represented between 47 and 67 percent of all such employed workers in the area.[5]

Hosea Easton, a noted nineteenth century African American minister, said in 1830s that the "slaves' narrowly technical education was only a collateral means by which he was rendered a more efficient machine."[6] According to historian Henry Allen Bullock,

> these highly trained slaves were often maintained as status symbols by their owners, who frequently found it necessary to provide some means of holding and supporting them. Out of pressure of circumstances came a "hiring out" of slaves to employers who needed them. The practice of training slaves continued to make the plantation what Booker T. Washington called and "industrial school."[7]

In addition to learning to read and write informally through the tasks they performed, some slaves became literate "accidentally." "Some learned to read as they sorted their masters' newspapers. Some slave children were pupils in "play schools" conducted by their owner's children who . . . taught their students to read. Many . . . read clandestinely. Those who learned . . . taught others. As a result of gaining literacy skills "accidentally," there became a core of literate slaves on the plantations.[8]

Prohibitive legislation, beginning with the 1740 Act of South Car-

olina, sent the education of the African American underground. Educational historian, Carter G. Woodson, notes that clandestine schools "were in operation in most large cities and towns of the South where such law prohibited the enlightenment of the Negroes."[9] In many of the "secret schools," slaves and free Black mingled, thereby making attendance at the schools dangerous.[10]

In her memoirs, *Reminiscences of My Life in Camp with the 33rd U. S. Colored Troops, Late 1st South Carolina Volunteers*, Susie King Taylor poignantly describes an account of secretly receiving an education in a clandestine school:

> We went every day about nine o'clock, with our books wrapped in paper to prevent the police or white persons from seeing them. We went in, one at a time . . . into the yard to L kitchen [sic] which was the schoolroom. . . . The neighbors would see us going in sometimes, but they supposed we were there learning trades. . . . After school we left the same way we entered, one by one, when we would go to a square . . . and wait for each other.[11]

Susie King Taylor's teacher, Mrs. Woodhouse, was a free African American. She and her daughter Mary Jane taught about thirty students at a time.

Educational historian James D. Anderson's research reveals that slaves and free Blacks had already begun making plans for the systematic instruction of their illiterates "before Northern benevolent societies entered the South in 1862, before President Abraham Lincoln issued the Emancipation Proclamation in 1863, and before Congress created the Bureau of Refugees, Freedmen, and Abandoned Lands in 1865."[12] These early schools were established and supported through the efforts and human resources of slaves and free African Americans. "Some of these schools predating the Civil War simply increased their activities after the war commenced."[13] In September 1861, at Fortress Monroe, Virginia, one of the first of these many schools was established and maintained under the leadership of an African American teacher named Mary Peake. A similar institution in Savannah, Georgia had existed unknown to the slave regime from 1833 to 1865. "Its teacher, a Black woman named Deveaux, expanded her literacy campaign during and after the Civil War."[14] Similar scenes were repeated throughout the South. The rapid rise of these "secret schools" reflected the affirmation, and the determination of a fiercely oppressed people struggling for freedom by whatever means necessary. Freedom and schooling became intertwined.

In the free territories, there were more educated Blacks. African American minister-educators opened schools for the instruction of Black youth and adults in conjunction with their religious institutions throughout the antebellum era. The number of educated Blacks increased when slaves who received an education in the South escaped to the North. Few literate Blacks were left on the plantations.[15]

Researcher Opal Easter notes that "by 1830, most Northern Blacks were free men and women and allowed to attend some of the local schools. When they were unable to attend or prohibited from attending local schools, they established schools of their own."[16]

As explained by educational historian Vincent P. Franklin,

> the . . . Black Episcopal Church congregation in the United States is believed to be the [first] African Church—founded in Philadelphia in July 1794. [In addition to providing religious services,] it opened a school in the church building that was available to the entire African American community. . . . [The rector, Absolom] Jones, served as instructor at the school for many years, even after he became the first African American to be ordained to the Episcopal priesthood in 1804.[17]

It was also in Philadelphia in 1794, that Richard Allen founded Bethel Church. Bethel Church (which later became the Mother Church for the African Methodist Episcopal Church) "provided a day school for African American children and adults. The school provided instruction in reading, writing, and arithmetic as well as religion."[18] Franklin notes that

> Jones and Allen were the most influential leaders in the Philadelphia Black community during the early decades of the nineteenth century. Although their prominence stemmed primarily from their positions as pastors of large Black religious congregations, they also saw themselves as educators. They contributed to the community at large through their sponsorship of classes, schools, and educational enterprises.[19]

As noted by Anderson, "in 1863, the enslaved Americans were emancipated whereby they joined the ranks of the nation's free citizens at the very moment that public educational systems were being developed into their modern form."[20] James D. Anderson argues that the ex-slaves' essential concept of the value of literacy and education was clearly revealed in their struggle to "secure schooling for themselves and

their children." According to James D. Anderson's analysis of the research,

> the former slaves were the first among native Southerners to depart from the planters' ideology of education and society and to campaign for universal, state-supported public education. The planters believed that state government had no right to intervene in the education of children and, by extension, in the larger social arrangement. [They felt that the intervention on the part of government] through public education violated the natural evolution of society, threatened familial authority over children, upset reciprocal relations and duties of owners to laborers and usurped the functions of the church.[21]

The ex-slaves understood the need to rally many allies who would aid them in their pursuit of universal schooling. Hence, they were able to gain the support of the Freedmen's Bureau, Northern missionary societies, and the Republican politicians. "With the aid of Republican politicians," explains Anderson, "they seized significant influence in state governments and laid the first foundation for universal public education in the South."[22] In his scholarly research and analysis of the Reconstruction era, W. E. B. Du Bois states that "public education for all at public expense was, in the South, a Negro idea."[23] Anderson notes that "the foundation of the freedmen's education movement was their self-reliance and deep-seated desire to control and sustain schools for themselves and their children.... The values of self-help and self-determination underlay the ex-slaves' educational movements."[24]

In March 1865, Congress created the Bureau of Refugees, Freedmen, Abandoned Lands, as an emergency organization to assist former slaves in adjusting to freedom. Under the leadership of General Oliver Howard, the first commissioner appointed by the President, the Freedmen's Bureau established schools throughout the South. Its program aimed at securing "health, sustenance, and legal rights for refugees" and providing them with the "foundations of education."[25] The commissioner was authorized to cooperate with private benevolent associations in aid to the freedmen. Through this agency great assistance was given to the missionary societies in their work.

Shortly following the Civil War, the White Southern government passed legislation allowing the establishment of White "common" school systems. Educational historian Meyer Weinberg explains that the establishment of "separate school systems on the basis of race to be

financed by corresponding separate taxes" became a common practice throughout the South. Due to the disparities in wealth between Blacks and Whites, Black parents were unable to generate adequate tax renenue that would finance Black schools. Thus, no Black schools were built. Weinberg points out that the "alternative for southern Black children was privately sponsored or federally subsidized education. Schools were established in the South by Northern Whites for Blacks or by Blacks themselves."[26] "The Freedmen's Bureau," writes Weinberg, "supported by the federal government, supplemented these efforts. . . . While the taxes of Black families in some states boost[ed] White education, these families were compelled to organize private self-help efforts to educate their own children."[27]

## END OF RECONSTRUCTION

From the post-Reconstruction era until the end of World War I (1877-1919), progress for African Americans was slow and uneven. Indeed, this period of time has been dubbed by historians as the "nadir" of Black history. Nineteenth century America ushered in an era of racial beliefs and ideologies that reinforced developing and previously held notions of the inherent inferiority of African people and the superiority of Europeans. In the latter half of the nineteenth century, the pseudoscientific theories of Charles Darwin began influencing political theory. His thesis—the process of natural selection, the struggle for existence, the need for adaptation—were applied to human society, principally to justify the political and social subordination of non-Whites. Indeed, the emergence of racial ideologies claiming the inherent inferiority of African people and the superiority of Europeans dominated the racial debates of the nineteenth century.

Deliberate racial discrimination became a pervasive practice throughout the public schools in America. Meyer Weinberg notes that before the American Civil War, every important technique of discrimination was practiced in the North, including the statutory exclusion of Black children from public schools, legally required separate schools, and discriminatory school funding.[28] After the Civil War, separate and unequal education for African Americans was the dominant pattern in the North and the South. In the 1896 Plessy vs. Ferguson decision, the United States Supreme Court upheld the constitutionality of legally segregating the White and Black races in a passenger rail car in Louisiana. The sanctioning of legal racial segregation by the Supreme Court gave rise to numerous public policies that articulated the importance of maintaining a caste system that catered to the political and economic interests

of the White ruling class while at the same time oppressing and exploiting people of color. In terms of its effects on public schooling in the South, the separate-but-equal doctrine contributed to the solidification of a dual system of schools that segregated Blacks and Whites.[29]

## EDUCATIONAL IDEOLOGIES IN THE POST-RECONSTRUCTION ERA

In the post-Reconstruction period, "educational efforts for the education of African Americans were the products of an amalgamation of religious zeal, doctrines of self-help, paternalism, and industrial training."[30] The major burden of educating Blacks fell on the shoulders of private and church-related colleges and the self-help efforts of African Americans. One scholar notes that "the American Missionary Association (AMA) led the effort for Black education during the war years and in the period extending to 1872. This . . . Association . . . was supported by philanthropic aid from church boards and . . . the American Freedmen's Union."[31] The AMA sent teachers, ingrained with the "values" of Protestant moral beliefs to educate newly freed Blacks. In addition to teaching the basic literacy skills, these teachers also taught the values of industriousness, cleanliness, thrift, and punctuality. Northern philanthropists such as George Peabody and John Slater invested financially in the establishment of Black schools. However, as explained by Gutek, because of prevailing social attitudes, "these men defined Black education as practical training for industry rather than a preparation for citizenship or higher education. [Hence] . . . Black education in the South took on the elements of industrial training and paternalism."[32] The AMA also supported the establishment of Black schools. The objectives were "to provide teacher training, 'practical industry' as applied to agriculture and the mechanical arts, and basic academic work."[33] Consequently, a cadre of Black graduates from AMA institutions became teachers.

Support for Black education also came from White Southern businessmen who championed an industrialized South. Gutek's research revealed that

> southern White business spokesmen's formula for Black education was to: (1) provide Black children with a rudimentary education in basic literacy and skills; (2) cultivate values that contribute to order and industry; (3) create a protected but subservient status for Blacks in the South; and (4) detach African Americans from political activist movements and labor organizations.[34]

Gutek notes that the concept of industrial education was emerging by the late 1870s. It would constitute the foundation of the educational ideology the late 1870s and would form the basis of the educational philosophy espoused by Booker T. Washington, "who would become the leading spokesman for African Americans in the United States."[35]

## THE EDUCATION OF AFRICAN AMERICAN WOMEN

The early nineteenth century gave rise to "resurgence of evangelical Protestantism" which proselytized the critical importance of educating women and girls to fulfill their new roles in a changing culture.[36] Educational historians Tyack and Hansot explain that

> advocates of education for girls refuted popular stereotypes about the mental inferiority of women, and sought to convince citizens that practical benefits would flow from the schooling of girls. Proponents of schooling for girls believed that in a republican and Christian United States women had acquired new standing as persons and required a broader education to realize their "ideal feminine" character.[37]

Researchers of early nineteenth-century America often allude to the emergence of the "cult of true womanhood" as forming the basis of schooling for women and girls. The "true woman" ideology prescribed moral guidelines of conduct for the White native-born middle-class female that "essentialized her role as a paragon of feminine virtue and morality."[38] The "ideal woman" exhibited qualities of innocence, modesty, piety, submissiveness and domesticity. She was expected to dedicate her life to her home, husband, and children. As explained by researcher Andolsen, the "true woman was almost certainly the wife of a well-to-do male usually White and native born, whose economic success made it possible for her to reign as queen of the home."[39] It is important to note that the concept of the "true woman" did not apply to Black women. Feminist researcher Beverly Guy-Sheftall notes that the denigration of the Black woman was due to the fact that Black women did not represent the Eurocentric image of the "true woman." She argues that this was "indicative of the degree to which prevailing notions about race and gender interacted in the minds of Whites and resulted in a particular set of attitudes about Black women."[40]

During this time, the major role of a woman was that of a wife, mother, and guardians of the nation's morality. Thus, "female education

was necessary for the molding of the ideal woman."[41] Female seminaries that were established "fostered . . . a curriculum that emphasized religion, music, the three R's and household crafts and management."[42] However, as explained by educational historian Thomas Woody, many of these female seminaries also had academically rigorous courses commonly found in male academies.[43] The purpose and rationale for both a classical and a vocational type of curriculum in the female seminaries were to increase girls' chances of marrying well, to make them better wives and mothers, and to add "systematic knowledge and utilitarian skills to their God-given talents in nurturing children."[44]

During this same time period, the reasons for educating African American females were the following: (1) to make good wives and mothers and (2) to train good domestic servants and agricultural workers.[45] Educational historian Opal Easter notes that the second reason was later expanded to include training "Black women to be teachers, nurses, missionary workers and Sunday School teachers in order to 'uplift the race.' "[46] After the Civil War, many of the White graduates of the northeastern seminaries traveled south to teach the freedmen and women. Historian Audrey McCluskey points out that many of these teachers, who harbored deep-seated racist, sexist, and classist ideologies of Social Darwinism and Teutonic theories commonly propagated during this time, "believed that an indoctrination in morality would prevent Black women from falling prey to their 'natural inclinations.' "[47] "Under their tutelage," explains McCluskey, "Black females were lectured on the tenets of moral redemption that was intended to help them overcome the 'moral laxity' of their slave past."[48] McCluskey notes that both males and females were "ruled by a stiffer standard because of their designated role as change agents who would purify . . . and rescue the Black home"[49]

Research reveals that in the schools for African American females, the Bible was the pivotal point of instruction. The sole purpose was to imbue in Black women the importance of living "virtuous lives and to pass on those values to their children."[50] Indeed, this ideology was taught to women such as Burroughs and Cooper who received their early education in schools that propagandized these Protestant ethics.[51]

One of the early educational institutions for Black females was founded in Washington, D.C., by a White woman from New York named Myrtilla Miner. "She decided that her goal in life would be to devote her time to the moral and intellectual improvement of Negroes."[52] As a result, Myrtilla Miner opened up a school for colored girls in Washington, D.C., in 1851.

In spite of White hostility, the doors of her school remained open, making it possible for a cadre of students to be trained as teachers.[53] These teachers sought employment in the District of Columbia public schools and the surrounding area after emancipation.

The latter half of the nineteenth century gave rise to Black colleges to train Black teachers. Fisk University, Hampton Institute, Tuskegee and several other Black colleges and universities had been established in the post-Civil War South.[54] Most of these institutions admitted women. Scotia Academy, Spelman and Bennett were built exclucively for Black women.

Spelman College was founded in 1881 by Harriet Giles and Sophia Packard. Both were Northern White women who sought to establish an institution of higher learning that would train Black women as teachers for the public schools and Christian workers for evangelical work.[55]

Indeed, for Black women, teaching offered the only viable profession possible other than domestic service. "Black women were excluded not only from male professions, but also from the comparatively restricted areas opened to White women. Being a teacher in the African American community gave rise to visibility that emerged as community leadership."[56] "Teaching became an arena for political activism wherever it occurred."[57]

## THE INFLUENCE OF BOOKER T. WASHINGTON AND W. E. B. DU BOIS ON THE EDUCATION OF BLACK WOMEN

Probably the most important and influential African American spokespersons for the education of Black people during the late nineteenth and early twentieth centuries were Booker Taliaferro Washington (1859-1915) and William Edward Burghardt Du Bois (1868-1963).

Booker T. Washington was born a slave on a plantation in Franklin County, Virginia in 1856. His story is effectively told in his autobiography *Up From Slavery*.[58] In 1872, he was admitted as a student to the Hampton Institute, a school for Blacks founded in 1868 by General Samuel Chapman Armstrong that followed an example of industrial education and agricultural training. The Hampton model of industrial and agricultural training was constructed on the financial backing of White philanthropists who supported the idea of instructing Blacks in manual trades. Hampton was a coeducational school. "Women at Hampton trained as domestic science teachers, elementary school teachers, and nurses."[59]

In 1881, Alabama Governor Rufus Cobb signed legislation provid-

ing for the establishment of a Black normal school at Tuskegee, Alabama, and recommended Booker T. Washington as principal. Under Washington's vigorous leadership and administration, Tuskegee Institute grew from a single building in 1881 to an academic institution of 123 buildings. The curriculum at Tuskegee centered on the development of industrial skills as well as moral ethics and values. In addition to training female students to become domestic laborers, they were also trained as elementary school teachers. A few Tuskegee graduates were employed as administrators at Black industrial institutions throughout the United States. Tuskegee's philosophy was rooted in the social realities of the era. Washington had many critics, in particular Du Bois. Du Bois argued that Washington's educational perspectives failed to equip Blacks for access to higher education and that Washington's ideologies and the Tuskegee Institute circumscribed Blacks to positions of subservience. The Black woman's place in Du Bois' view was "in [her] role in the [African American] home and in [her] role as school teacher."[60]

William Edward Burghardt Du Bois was born February 1868 in Great Barrington, Massachusetts. In 1896, he became the first African American to receive a Ph.D. from Harvard University. After teaching Latin, Greek, German, and English at Wilberforce University in Ohio, Dr. Du Bois went on to establish the first department of sociology in the United States at Atlanta University.

Unlike Washington, Du Bois embraced the concept of combining industrial education with a classical education. He believed that the combination of the two would allow for the development of one's "full capabilities and 'God-given' human potentials."[61] However, Du Bois also believed strongly that a classical education was the key to the development of a cadre of the "Talented Tenth" who would be scholars, intellectuals, and leaders of the Black race.[62]

## PIONEER AFRICAN AMERICAN WOMEN EDUCATORS

Black women were also pioneers in the establishment of important educational institutions during this period. Black women educators established schools that provided vocational and liberal arts curriculum. These educators believed that "vocational training had its role in all forms of female education."[63] Researcher Carol Perkins' analysis of the literature on Black women educators revealed that the vocational training of African American females was founded on the philosophy of "pragmatic idealism." It was

pragmatic in that it offered scientific methods of raising the living standards of Black families by providing training in the basics of sanitation and family health care, including food preparation, basic nursing skills, and infant child care, as well as manual skills related to household tasks, and vocational skills such as laundry work and school teaching.[64]

According to Perkins,

idealism arose from the expectation that the educated woman held the key to race uplift on two fronts: one, as the "intelligent wife, the Christian mother," she was "both the lever and the fulcrum for uplifting the race," and, as school teacher, fitted by nature to her task of teaching the young, she held the key to "the salvation of the race."[65]

Cooper and Burroughs, like many educated Black women of their era, "viewed their role as social and moral change agents."[66] This perspective led many of the African American women educators to start schools of their own.

The school Burroughs founded and the schools Cooper taught at or provided leadership for, were paragons of high moral ethics and service to the race. "Cooper believed strongly that the future of the race was in the hands of Black women and that the more enlightened ones must assume the major responsbility for providing the leadership for the difficult struggle ahead."[67] McCluskey notes that

Burroughs viewed her mission as "uplifting the race" by preparing Black women to lead their people out of the despairing conditions of the period. . . . [She] believed her school would promote self-esteem and address the multiple burdens facing Black women—which were economic and social as well as racial and sexual.[68]

According to Perkins,

among educated Black women, the concept of the "ideal" Black woman differed from the majority culture's ideal woman "whose responsibilities seem to end at her own front door. [Cooper and Burroughs as well as other Black women educators] felt that they could not afford the luxury of being concerned only about their own households when the race as well as society in general suffered from a vast array of problems.[69]

Black women educators such as Cooper and Burroughs personally perceived the challenge of a teaching career as their duty to and role in race uplift through education. Working for race uplift and education became intertwined. In addition, these women "did not limit their vision of women's role in race uplift to the public role of teacher."[70] Cooper and Burroughs were active outside the classroom working with or creating organizations such as the National Association of Colored Women (NACW). They viewed their work and goals as, in part, interrelated with the social activism and advancement of the community at large. Cooper and Burroughs and many Black women educators played an active role in educational and political campaigns for racial justice, temperance, peace, and women's suffrage.

## SUMMARY AND CONCLUSION

The review of the literature reveals that Black education developed within a context of political and economic oppression. Since its earliest beginnings, there were systematic efforts on the part of the White slavocracy and later the planters to destroy Black schools and undermine the Black educational movement. Nonetheless, the newly liberated Blacks, echoing similar sentiments as those of Frederick Douglass, realized that "knowledge unfits a child to be a slave."[71] The newly freed men and women perceived education as a tool for emancipation, self-determination and empowerment. They saw it as a means of "uplifting" and improving the life conditions and circumstances of the Black community. And their battle for an education would be pursued by any means necessary.

The freed men and women urged, welcomed and embraced the efforts of White Northern, religious and philanthropic organizations to establish schools for African Americans. Numerous White Northern female teachers journeyed to southern states to teach for the Freedmen's Bureau. Many of these women, filled with missionary zeal, felt it was their moral obligation to bring literacy and morality to their Black students. As cultural critic Angela Davis points out, White female teachers "involved in the education for Black women, understood Black women needed to acquire knowledge—a lamp unto their people's feet and a light unto the path of freedom."[72]

The review of the literature also revealed another story—one often ignored and suppressed by historians. Historical evidence and documentation disclose a story of the struggle and the self-help efforts that African Americans engaged in, in order to obtain schooling for themselves. And in this struggle, African American women played a signifi-

cant and visible role. Like White women educators, Cooper and Burroughs long realized that illiteracy doomed Black people powerless. Liked White women educators, Black women educators believed that it was their moral and social obligations as educated women to educate the poor and unlettered African American student. Like Black men educators, Cooper and Burroughs and other Black women educators perceived teaching as a form of service around racial uplift. However, what made Cooper and Burroughs and other Black women educators distinct from Black male educators and White female educators was that teaching took them beyond the classroom milieu and into the community. Education became a form of social and political activism that contributed to the goal of group survival and institutional transformation. These educators strongly believed that education meant economic, political and social improvement for the entire Black community. And they were committed to fighting for a just and equitable society. In Chapter 5, I will explore this issue in depth.

This chapter attempted to put into context the issues surrounding the education of African American women and their emergence on the scene as outstanding and dedicated educators. In the next chapter, I will examine Cooper's and Burroughs' early lives including their schooling and the cultural influences that impacted their life experiences.

## NOTES

[1] See Vincent Harding, *There is a River: The Black Struggle for Freedom in America* (New York: Harcourt Brace Jovanovich, 1981)

[2] Carter G. Woodson, *The Education of The Negro Prior to 1861* (New York: Arno Press, 1968) pp. 159-67

[3] Ibid.

[4] See Henry Allen Bullock, *A History of Negro Education in the South from 1619 to the Present* (Cambridge, Massachusetts: Harvard University Press, 1967)

[5] Ibid., p. 7

[6] Hosea Easton quoted in Meyer Weinberg, *A Chance to Learn: The History of Race and Education in the United States* (London: Cambridge University Press, 1977) p. 2

[7] Booker T. Washington quoted in Henry Allen Bullock, *A History of Negro Education in the South from 1619 to Present* (Cambridge, Massachusetts: Harvard University Press, 1967) p. 7

[8] Gerald Gutek, ed. "The Civil War, Reconstruction, and the Education of Black Americans," in *Education in the United States* (Englewood Cliffs, New Jersey: Prentice Hall, 1986), p. 151

[9] Carter G. Woodson, cited in Meyer Weinberg, *A Chance to Learn: The History of Race and Education in the United States* (London: Cambridge University Press, 1977) p. 13

[10] Ibid.

[11] Susie King Taylor, *Reminiscences of My Life in Camp with the 33rd U. S. Colored Troops, Late 1st South Carolina Volunteers: A Black Woman's Civil War Memoirs,* (Reprinted New York: Markus Wiener Publishing, 1902/1988) pp. 29-30; also cited in Weinberg, *A Chance to Learn,* p. 13-14

[12] James D. Anderson, *The Education of Blacks in the South* (Chapel Hill, North Carolina: The University of North Carolina Press, 1988) p. 7

[13] Ibid.

[14] Ibid.

[15] Jeanne Noble, *The Negro College Woman's Education* (Washington, D. C.: Ransdell, 1956) p. 22

[16] Opal Easter, *Nannie Helen Burroughs and Her Contributions to the Adult Education of African-American Women* (Ed.D. dissertation, Northern Illinois University, 1992) p. 7

[17] Vincent P. Franklin, (1990) "They Rose and Fell Together, African American Educators and Community Leadership, 1795-1954" *Journal of Education,* vol. 172, no. 3, p. 41

[18] Ibid.

[19] Ibid.

[20] Anderson, *The Education of Blacks,* p. 2

[21] Ibid., p. 4

[22] Ibid.

[23] William E. B. Du Bois, *Black Reconstruction in America:1860-1880* (Cleveland: World Publishing Co., 1962) pp. 641-649

[24] Anderson, *The Education of Blacks,* p. 5

[25] See Henry Allen Bullock, *A History of Negro Education,* 1967

[26] Weinberg, *A Chance to Learn,* pp. 40-41

[27] Ibid.

[28] Ibid.

[29] Ibid.

[30] Gerald Gutek, ed., "The Civil War, Reconstruction, and the Education of Black Americans," in *Education in the United States: A Historical Perspective* (Englewood Cliffs: Prentice Hall,1986) pp. 150-172

[31] Carol Perkins, *Pragmatic Idealism: Industrial Training, Liberal Education, Women's Special Needs: Conflict and Continuity in the Experience of Mary McLeod Bethune and Other Black Women Educators, 1900-1930* (Ph.D. dissertation, Claremont Graduate School and San Diego State University, 1986) p. 7

[32] Gutek, "The Civil War," pp. 160

[33] Perkins, *Pragmatic Idealism*, p. 7

[34] Gutek, "The Civil War," p. 161

[35] Ibid.

[36] David Tyack & Elisabeth Hansot, *Learning Together: A History of Coeducation in American Public Schools* (New York: Russell Sage Foundation, 1992) p. 28

[37] Ibid.

[38] Audrey T. McCluskey, (1993) "The Historical Context of the Single-Sex Schooling Debate Among African Americans," *The Western Journal of Black Studies,* vol. 17, no. 4, p. 194

[39] B. H. Andolsen, *Daughters of Jefferson, Daughters of Bootblacks?: Racism and American Feminism* (Macon, Georgia: Mercer University Press, 1986) p. 45

[40] Beverly Guy-Sheftall, *Daughters of Sorrow: Attitudes Towards Black Women, 1880-1920* (Brooklyn, New York: Carlson Publishing, 1990) p. 40

[41] Linda M. Perkins, (1983) "The Impact of the Cult of True Womanhood on the Education on the Black Woman," *Journal of Social Issues*, vol. 39, no. 3, p 18

[42] McCluskey, "The Historical Context," p. 194

[43] For discussion on seminary training for girls, see Thomas Woody, *A History of Women's Education in the United States*, vol. I (New York: The Science Press, 1929) pp. 280-281

[44] See Tyack & Hansot, "Why Educate Girls," in *Learning Together*, pp. 28-45

[45] Easter, *Nannie Helen Burroughs*, p. 22

[46] Ibid.

[47] McCluskey, "The Historical Context," p. 194

[48] Ibid.

[49] Ibid.

[50] Ibid.

[51] Ibid.

[52] Carter G. Woodson, *The Education of the Negro Prior to 1861* (New York: Arno Press, 1968) p. 266

[53] Dorothy Sterling, *We Are Your Sisters: Black Women in the 19th Century* (New York: W. W. Norton Press, 1984) p. 190

[54] Angela Davis, *Women, Race and Class* (New York: Random House, 1981) p. 109

[55] Noble, *The Negro College*, p. 22

[56] See Cynthia Neverdon-Morton, (1982) "Self-help Programs as Educative Activities of Black Women in the South, 1895-1925," *Journal of Negro Education,* vol. 51, no. 3, pp. 207-221

[57] See Patricia Hill Collins, *Black Feminist Thought: Knowledge, Consciousness, and the Politics of Empowerment* (New York: Routledge, 1991)

[58] For an autobiographical account on the life of Booker T. Washington, see *Up From Slavery* (New York: Penguin Books, 1967)

[59] Easter, *Nannie Helen Burroughs*, p. 25-26

[60] Perkins, *Pragmatic Idealism*, p. 14

[61] See W. E. B. Du Bois, *The Education of Black People* (Amherst, Massachusetts: University of Massachusetts Press, 1963)

[62] Ibid.

[63] Perkins, *Pragmatic Idealism*, p. 10

[64] Ibid.

[65] Ibid.

[66] McCluskey, "The Historical Context," pp. 194-195

[67] Guy-Sheftall, *Daughters of Sorrow*, p. 34

[68] McCluskey, "The Historical Context," p. 194

[69] Perkins, *Pragmatic Idealism*, p. 17

[70] Ibid.

[71] Fredrick Douglass is quoted in Angela Davis, *Women, Race and Class* (New York: Random House, 1981) p. 100

[72] Angela Davis, *Women, Race and Class*, p. 105

# "To Get an Education and to Teach My People"

## Family Background of Anna Julia Cooper

> *To be a slave. To be owned by another person,*
> *as a car, house, or table is owned. To live as a*
> *piece of property that could be sold—A child*
> *sold from its mother, a wife from her husband.*
> *To be considered not human, but a "thing" that*
> *plowed the fields. . . . To be a slave. To know,*
> *despite the suffering, deprivation, that you were*
> *human, more human than he who said you were*
> *not human.*
>
> —JULIUS LESTER, 1968[1]

> *De nigger woman is de mule uh de world so fur*
> *as Ah can see. . . . Ah was born back der in*
> *slavery so it wasn't for me to fulfill my dreams*
> *of what a woman oughta be and to do. . . . Ah*
> *didn't want to be used for a work-ox and a*
> *brood-sex. . . . Ah wanted to preach a great*
> *sermon about colored women sittin' on high, but*
> *they wasn't no pulpit for me.*
>
> —ZORA NEALE HURSTON, 1937[2]

This chapter is a biographical sketch. The biographical approach in this chapter sets the context for exploring and understanding the emergence of Cooper's and Burroughs' educational philosophies. In this chapter, each educator will be analyzed in the context of the following question: What were the cultural and educational influences that shaped Cooper's and Burroughs' race, class and gender consciousness and in turn gave rise to their educational philosophies?

Born in 1859 prior to the start of the Civil War, in Raleigh, North Carolina, Cooper experienced first hand what it meant to be a slave. "Annie," as she was affectionately called by family and friends, was the

youngest child of Hannah Stanley Haywood, her slave mother. Annie's father, George Washington Haywood, was her mother's slave master. He was a man whom Annie held in strong contempt and bitterness. She writes: "Presumably my father was her master, if so I owe him not a sou [sic]. She was always too modest & [sic] shamefaced ever to mention him."[3] In her introduction to a reprinted edition of Cooper's *A Voice From the South: by A Black Woman of the South*, literary critic Mary Helen Washington writes that Cooper received confirmation that George Haywood was her father in 1934. At that time, she requested information about her family history from Haywood's nephew. The nephew wrote back that "Wash [George] Haywood, was a prominent and successful lawyer in Raleigh until the Civil War, . . . had one child by his slave Hannah without benefit of clergy."[4]

Historian Darlene Clark Hine notes that female slaves suffered a dual form of oppression. "In addition to economc exploitation, they were oppressed sexually as well."[5] "The slave codes drew no distinction between the slaves' sexual autonomy and the master's property rights. Slave women were often subject to rape and forced liaisons that both satisfied their master's sexual desires and increased their capital accumulation."[6] In the slave holding states, state legislatures adopted the principle of "partus sequitir ventrem"—the child follows the condition of the mother. Offspring of slave women by White men were slaves, according to the law. Hence, Annie inherited the slave status of her mother. Annie, her mother and two older brothers, Rufus and Andrew, were the property of the prosperous and prominent Haywood family of Raleigh, North Carolina.

Jacob Stanley Haywood, Cooper's maternal grandfather, also a slave, was a skilled carpenter, who "took part in the planning & construction of the [North Carolina] State Capitol."[7] Cooper makes the point that expert economists of that time period were impressed with Jacob's talent as a carpenter. Rufus and Andrew were also skilled carpenters and bricklayers respectively. Later in their life, during their years as free men, each was able to earn a living in their respective vocations. In addition to being skilled craftsmen, Rufus and Andrew, who were 22 and 10 years older than Annie respectively, were also musicians of the "Stanley's Band." At the time of Annie's birth, the thirty-nine year old Hannah was hired out as a nursemaid for Charles Busbee, who later became a prominent attorney. Hannah's baby girl was named after Charles' mother Annie.[8]

Unlike her mother and two brothers, Annie's experience of slavery was short lived. Cooper wrote few comments or reflections concerning

her childhood years during the slave era. In the absence of a detailed narrative describing her early life, one is left to conjecture about what effects did the daily dehumanization of slavery had on Cooper's developing sense of freedom and equality? What values, hopes, dreams and cultural ethos were Hannah and the community of slaves able to impart to young Annie? And what did family life mean to a slave?

Slave narratives and other historical research are replete with examples of total commitment bonds that existed between mother and child. The family during slavery, with all its modifications, was a strong unit in that parents were able oftentimes to impart certain values and cultural ethos to their offspring.[9] According to historian Deborah Gray White, "slave women in their role as mothers were the central figures in the nuclear slave family. Mothers helped supplement the family diet, and they served as the critical information link when fathers were sold or ran away."[10] White explains that slave mothers did what American pioneer women did on the frontier: "they mustered their reserves, persevered, and helped others survive. These women made themselves a real bulwark against the destruction of the slave family's integrity."[11] Historian Darlene Clark Hine contends that part of the requirements for survival on the slave plantation dictated that Black women "reconfigure and re-image families, communities, and themselves. Survival mandated that they develop private identities and inner worlds known only to their own."[12]

Black feminist analysis of Black women and motherhood reveals that Black mothers of daughters [faced] a troubling dilemma.[13] According to feminist scholar Patricia Hill Collins,

> to ensure their daughters' physical survival, mothers [had] to teach them how to survive in the interlocking structures of race, class, and gender oppression while rejecting and transcending those same structures. In order to develop these skills in their daughters, mothers demonstrate [d] varying combinations of behaviors devoted to ensuring their daughters' survival—such as providing them with basic necessities and protecting them in dangerous environments—to help their daughters go further than the mothers were allowed to go.[14]

During slavery, those mothers who raised daughters as slaves "prepared them to resist dehumanization and to survive their experience."[15] "Slave mothers taught their daughters survival methods during their early childhood years through children's stories, religious lessons, and by example."[16] Historian Brenda Stevenson notes that

slave mothers tended to combine their emphasis on discipline and obe-
dience with words of encouragement and support. Many taught their
daughters to turn to God in times of trouble and to pray for divine pro-
tection. Slave mothers hoped to teach their girls how to survive as indi-
viduals in a slave society; the importance of the slave family and
community; and each slave's responsibility to help other slaves.[17]

The lessons Cooper apparently learned from her mother were com-
mitment to family and to others in the community; strategies to resist
race, class and gender oppression; and her strong religious belief in
God's benevolence. These beliefs remained throughout her life and were
evident in her work. They gave her the strength and resiliency to struggle
for social justice. These lessons were manifested in her actions and
deeds. Family solidarity and commitment obviously existed between
Cooper and her older brothers. Later in her life, Cooper took on the re-
sponsibility of raising the grandchildren of Andrew, "with the hope and
determination of nurturing their growth into useful and creditable Amer-
ican citizens."[18] Cooper also later became the guardian of two orphaned
North Carolina teenagers, John and Emma Love.[19]

Black feminist analysis reveals that "Black women's experiences as
'othermothers' or fictive kin provide a foundation for Black women's po-
litical activism."[20] Patricia Hill Collins explains that "nurturing children
in African American extended family networks or fictive kin networks
stimulates a more generalized ethic of caring and personal accountability
among Black women who often feel accountable to all the Black com-
munity's children."[21] Cooper, the dedicated educator, feminist, humanist
and social activist, sincerely felt accountable to Black youth and Black
women. This accountability resulted in her actively partaking in the
struggle to bring liberty, justice and equality to the Black community.

The love and bond between Annie and her mother Hannah must
have been strong. When referring to her mother, Cooper expressed
wholehearted adoration, compassion and gratitude for the sacrifices
Hannah made on her behalf. As Cooper wrote about her mother, "my
mother was a slave and the finest woman I have ever known . . . [her] . . .
self-sacrificing toil to give me advantages that she had never enjoyed her-
self is worthy [of] the highest praise & undying gratitude."[22] Years later,
as President of Frelinghuysen University, Cooper named one of the
school's departments after her mother. It became the Hannah Stanley
Opportunity School. This act, she stated, was "the only private and per-
sonal right and privilege to honor my mother by giving her name to this

[school] . . . dedicated to the educational and social advancement of her race."[23]

Cooper's early years were spent during a time of tremendous upheaval in the South. "The War," writes biographer Leona Gabel, "left the South in a state of saturated destruction and disrupted its life pattern. North Carolina, Cooper's home state, suffered widespread devastation in nearly a dozen battles and more than seventy skirmishes fought on its soil."[24] Its losses were the largest of any Confederate state. Researcher Karen Baker-Fletcher notes that hope for freedom seemed to characterize Cooper's memory of her earliest years because she wrote with respect of the longing for freedom in the slave community. She recalled stories of that period: "During the Civil War, [I] served many an anxious slave's superstition to wake up the baby & ask directly "Which side is goin to win de war? Will de Yankees beat de Rebs & will Linkum free de niggers."[25] Freedom came to little Annie and the slaves of this nation when Abraham Lincoln signed the Emancipation Proclamation in 1863. Emancipation officially brought to a close an era of legalized enslavement for approximately four million African Americans in the United States. Cooper was approximately six or seven years old when the War came to an end. Within this social historical context of devastation and despair, Anna Julia Haywood's early childhood years were spent.

## GOING TO SCHOOL: FROM THE RECONSTRUCTION TO THE POST-RECONSTRUCTION ERA

"When freedom came, folks left home, out in the streets, crying, praying, singing, shouting, yelling and knocking down everything."[26] And how they thanked God! They sang his praises profusely and joyously! "A great human sob shrieked in the wind, and tossed its tears upon the sea—free, free, free."[27]

The devastation and destruction of the War-torn Southern states were reported in the following account:

> the countryside looked for many miles like a broad black streak of ruin and desolation—the fences all gone; lonesome smoke stacks surrounded by dark heaps of ashes and cinders, marking the spots where human habitations had stood; the fields along the road wildly overgrown by weeds, with here and there a sickly patch of cotton or corn cultivated by Negro squatters.[28]

In their autobiography *Having Our Say*, Sadie and Bessie Delany wrote that "most of the slaves, when they were freed, wandered about the countryside like shell-shocked soldiers. . . . Everywhere you went, it seemed you saw Negroes asking, begging for something . . . It was a pitiful sight.[29]

The aftermath of the Civil War brought on numerous political, economic and social upheavals across the land. Newly freed slaves found themselves homeless, jobless, illiterate, and in poor health. In 1865, the freedmen and women organized themselves around a variety of political and social issues. According to Hutchinson, a "Convention of the Colored Citizens of North Carolina" counseled the delegates "to be assertive in future relationships with their government and in all matters pertaining to their full manhood and citizenship rights."[30]

After 250 years of slavery, African Americans were finally free to own their person, their labor, and to assert their rights for the first time. Blacks in North Carolina, as elsewhere, strongly believed that acquiring an education was a revolutionary step toward their total liberation. "For the freedmen, . . . schooling was a matter of personal liberation and a necessary function of a free society."[31] An education would remove the vestiges of slavery, illiteracy, joblessness, and political and economic powerlessness. Without a doubt education was seen as a political necessity—the key to full rights to citizenship. Cultural critic and feminist bell hooks makes the point that without the capacity to read and write, to think critically and analytically, the liberated slave would remain forever bound, dependent on the will of the oppressor. She argues that "no aspect of the Black liberation struggle in the United States has been as charged with revolutionary fervor as the effort to gain access to education at all levels."[32]

Anna Julia Haywood's social location in this milieu of social, political, and economic upheaval was multiple. She was an ex-slave living in the rural South during Reconstruction; Black, poor and female. It is no doubt that this climate of social change profoundly affected her life and shaped her race, class and gender consciousness.

Annie formally entered the doors of educational opportunity in 1868 when The Saint Augustine's Normal School and Collegiate Institute (now College), founded under the auspices of the Protestant Episcopal Church, officially opened. This institution's mission was to "educate teachers of both sexes [as well as to provide] a Training School for the preparation of Colored men for the sacred ministry."[33]

On the other side of town, Saint Mary's, also an Episcopalian Insti-

tution was established for White students.[34] According to the research conducted by Cooper's biographer, Louise Hutchinson, St. Augustine's was built on 110 acres of land owned by the Haywood family of Raleigh. "Contributions and gifts from the Freedmen's Bureau, and the estate of Charles Avery of Pittsburgh, made . . . the erection of the school building possible."[35]

The original incorporators of the school were clerics of the Protestant Episcopal Church.[36] Saint Augustine's opened with four students, a shortage of teachers and Reverend J. Brinton Smith as its first principal. Within the first few months of operation, the school was "unfinished inside, with no plastering, but comfortable chairs, and desks, and with maps and blackboards covering the wall."[37]

According to Sadie and Bessie Delany's autobiographical accounts of St. Augustine's, the farm on the campus provided food for the staff and students and it gave the poorest students, who worked in the fields, "a way to pay their tuition."[38] Annie, who was close to ten years old, was awarded a scholarship to attend the school and was among its first group of students. The school awarded her a scholarship, which required that she be enrolled as a "pupil teacher." Thus, at the tender age of nine or ten, she began teaching. (Cooper stated she was eight years old when she began teaching). Annie truly enjoyed her role as a teacher. One of her happiest childhood memories was explaining to her illiterate mother, "the subtle differences, between q's & g's or b's & l's."[39]

Cooper's biographer, Leona Gabel, explains that the shortage of teachers left the school administrators few options when it came to hiring teachers. Not only were students of every age level hired to teach, the school also hired individuals from the community, who had skills in sewing to teach sewing to the students.[40] At St. Augustine's, the primary level classes were taught by teachers in training.[41]

According to an account by the Delany sisters, in reference to the type of students attending classes at the school, they observed that:

> often there were people in the classes who were grown men and women who lived nearby who wanted to learn to read and write . . . There were people of every age studying together . . . I never saw people try harder to improve themselves than these grown men and women wanting to learn to read and write. This was the only chance most of them had ever had to get an education, and they were eager to take advantage of it. These folks, along with many of the neighborhood children who attended our school were very poor.[42]

Annie left no account of the educational background, professional experiences or racial/ethnic make up of her instructors. She also recorded very little of her social life and informal relationships she may have forged with her schoolmates or instructors. Thus, we do not know which, if any, teachers or classmates were sources of stimulation and inspiration to her. What was the communal ethos of this institution, especially given the times in which Annie Haywood lived? Were the students involved in any political or civic activities on and off campus, or were they isolated in their "Ivory Tower," encapsulated by their privileged lifestyle of reading, writing, thinking and learning?

Gabel notes that St. Augustine's had a "firm policy of non-involvement in the violent political agitation which engulfed the state as elsewhere in the South."[43] In their autobiography, Sadie and Bessie Delany delineates a personal account into the campus life of St. Augustine's during the time Cooper was there. The parents of the Delany sisters, Henry B. Delany and Nancy Logan Delany, were students as well as instructors at the school. Cooper and Nancy Delany formed life-long friendships. They maintained contact over the years through letter correspondences. In response to "The Negro College Graduate Questionnaire," Cooper identified Nancy Logan as a close associate from her childhood past.[44] Henry Delany, Nancy's husband, was Bishop of the School's church and Vice Principal of the school. Nancy named one of her daughters Annie Elizabeth (a.k.a. Bessie) after Cooper. The entire Delany clan lived on the campus. From the accounts of the Delany sisters, we learn that this school provided an atmosphere where students felt safe, protected, and free to read, write, and think. The residents of the surrounding community were freedmen and women who lived in abject poverty.

Saint Augustine's was a religious institution. Before the start of classes, the chapel bells would chime signaling the start of morning prayer services.[45] Cooper was introduced to the Episcopalian religion at this school. While a student at St. Augustine's, Cooper considered herself a "bigoted church woman" because she did not believed in institutionalized religion. Later in her life, strict adherence to religious convictions would give her the strength and guidance to face many challenges and conquer many obstacles.[46]

Annie undoubtedly loved, enjoyed and cherished her experience at St. Augustine's School. Her education seemed to have been an enabling experience that stimulated her desires to seek out additional educational

pursuits. It enhanced her capacity to be free—and to dream of a world of possibilities—one that would not limit her life chances due to her race, class and gender status. In an undated privately written document she recalled of those years:

> . . . that school was my world during the formative period, the most critical in any girl's life. Its nurture & admonition gave not only shelter & protection from the many pitfalls that beset the unwary. . . . The whole atmosphere contributed [to] growth & nourishment beyond the power of words to estimate.[47]

Annie stayed for fourteen years at the school, pursuing basic "classical" courses. She completed her course of study in 1877. From 1871 to 1881, Annie was a teacher and supervisor for the female students enrolled at St. Augustine's. She taught Latin, Greek and mathematics. Although St. Augustine's was an environment where Annie's intellect was nurtured, it also was a place that attempted to limit her intellectual pursuits simply due to her sex. Female students were excluded from taking Greek classes, which were only opened to male theology students.

This act of discrimination awakened in Annie a feminist consciousness, sensitive to the need that higher educational opportunities between the sexes must be equal. Her displeasure and anger in the preferential treatment accorded to the male theology students at St. Augustine's is noted in the following personal account:

> . . . My inspiring preceptor informed me that Greek had never been taught in the school, but that he was going to form a class for the candidates for the ministry, and if I liked I might join in. I replied . . . that I would like very much to study Greek . . . A boy however meager his equipment and shallow his pretensions, had only to declare a floating intention to study theology and he could get all the support, encouragement and stimulus he needed, be absolved from work and invested beforehand with all the dignity of his far away office. While a self-supporting girl had to struggle on by teaching in the summer and working after school hours to keep up with her board bills, and actually to fight her way against positive discouragements to higher education; till one such girl one day flared out and told the principal the only mission open before a girl in his school was to marry one of those candidates.[48]

Annie was finally granted permission to enroll in Greek classes after challenging discriminatory practices of the school. Her challenge cleared the way for other female students, such as Sadie Delany, to be given the opportunity to take Greek classes. As fate would have it, Annie did marry a male theology candidate named George Christopher Cooper. Reverend Cooper, a native of Nassau, British West Indies, had begun ministerial studies at St. Augustine's in 1873, was teaching Greek classes in 1874, and 1876 became an ordained Episcopalian minister.

On June 21, 1877, Annie and George were married. They both continued to study and teach at St. Augustine's until "hard work and exposure" took the life of Reverend Cooper on September 27, 1879.[49]

Annie, a widow at the age of twenty-one, never remarried. Single once again, childless and educated, Cooper had the freedom and luxury to seek the answers to that "thumping within," to use her words. Widowhood was a magical space for women during that time period because marriage stifled their educational and professional opportunities. In July, 1881 Cooper had written to President Fairchild of Oberlin College in Oberlin, Ohio, requesting admission, a scholarship and housing. She was admitted into the sophomore class due to her impressive credentials and academic preparation received at St. Augustine's. Cooper's academic course of study at St. Augustine's included . . . "besides the English branches & Latin: Caesar, seven books; Virgil's Aeneid, six books; Sallust's Cataline and Jugurtha; and a few orations of Cicero—Greek: White's first lessons; Goodwin's Greek Reader, containing selections from Xenophon, Plato, Herodotus and Thucydides; and five or six books of the Iliad—Mathematics: Algebra and Geometry."[50]

In the fall of 1881, Cooper left St. Augustine's College, her beloved family, and the South to attend a school in the North—famous for its Underground Railroad and liberal attitudes toward educating women and African Americans. St. Augustine's conducted no graduation ceremonies and did not confer any degrees or diplomas. Cooper left the school somewhat pleased with the academic preparation she received in classical education. As Cooper left on her journey to begin a new life, she carried in her heart the eternal love for Reverend George Christopher Cooper as well as her undying devotion and compassion for her family. She carried in her thoughts, a race, class and gender consciousness committed to the struggle for equitable educational experiences for women and African Americans, and to use her term, "the underprivileged."[51]

## OBERLIN YEARS (1881–1884)

Oberlin College, located in the Midwestern agricultural community of Oberlin, Ohio, was founded in 1833 by John J. Shipherd and Philip P. Stewart, a minister and missionary respectively and both of the Congregationist denomination. "This institution was very active in the anti-slavery movement and served as an important stop on the Underground Railroad."[52] James Harris Fairchild, the president of Oberlin during the time Cooper was a student at the College, wrote that "... the two founders were both [Christian] reformers, strongly impressed with the conviction that the Church as well as the world needed to be lifted up to a higher plane of life and action."[53]

Shipherd's and Stewart's objective was to create a Christian colony of higher educational learning that would furnish the Mississippi Valley with well-trained gospel ministers and pious school teachers.

When the school opened on December 3, 1833, students of both sexes were admitted. Two years later, African Americans were admitted into this institution. According to the research conducted by William E. Biggleston, African American students were admitted as part of an agreement that would bring desperately needed funds to the struggling institution. According to the agreement, Oberlin would receive an anti-slavery group of students from Cincinnati's Lane Seminary, and New York revivalist Charles Finney would join the Oberlin faculty. The financial support was to come from the philanthropists, Arthur and Lewis Tappan.[54]

Oberlin College was the center of Oberlin's anti-slavery movement. The city of Oberlin was also a place where the majority of the colonists were anti-slavery activists. Consequently, Oberlin College became a major place of anti-slavery agitation as well as a refuge for escaping slaves on their way to Canada. It is estimated that 3,000 escaped slaves passed through Oberlin before the end of the Civil War.[55] The Oberlin Anti-Slavery Society was formed later the year Blacks were admitted at Oberlin. "Students from the college traveled . . . to Kentucky to guide escaped slaves to freedom. The anti-slavery activities at the College were so . . . successful that the state legislature, in the control of pro-slavery Democrats, sought to revoke the College's charter.[56]

The inclusion of women and African Americans into the Oberlin milieu of higher learning differentiated this institution from other colleges and universities during that period. The integration of the races at a collegiate institution was rare in the North, as well as in the South. In addition, Robert Fletcher, a researcher of Oberlin College's history, wrote

that the education of both sexes at colleges and universities was an entirely new and shocking departure from societal norms.[57] Thus the notion of a racially integrated, coeducational institution was contrary to the prevailing ideology of separate race and gender collegiate institutions—thereby making Oberlin College an anomaly.

"During the period between the end of the Civil War and the beginning of World War II, Black students were treated differently from White students at Oberlin."[58] During this time, Oberlin was under the leadership of three presidents: James Harris Fairchild (1866-1889), Henry Churchill King (1902-27) and Ernest Hatch Wilkins (1927-46). Bigglestone observes that the fair or unfair treatment of African American students at Oberlin College was contingent upon the personal views of the above mentioned presidents and the times in which their administration occurred.[59] President Fairchild's administration was during the post-Reconstruction years—"before the shadows cast by Jim Crow's wings reached their greatest length."[60] In reference to the treatment of Blacks under Fairchild's presidency, Fairchild wrote the following in 1883:

> Every student was left to determine for himself whether he would recognize his colored fellow pupil. Nothing in this respect was required of him. He was not permitted to abuse him and that was the limit of the obligation imposed. Classes were never seated alphabetically in the recitation room or in the chapel, hence no one was required to sit next to a colored student. He must consent to be in the same class with him or forego the opportunities of the school.[61]

Fairchild also noted that to his recollection no particular disciplinary problems resulted from this "arrangement." It is within this environment that Cooper entered to pursue her dreams in higher education. The year she entered was 1881. James H. Fairchild was president of the college.

Despite the liberal Christian tradition of Oberlin College, the school never admitted many African Americans.[62] The year Cooper entered Oberlin College, African Americans made up between "four and six percent of the student population."[63] Two Black women, Mary Church (Terrell) and Ida A. Gibbs (Hunt) were Cooper's classmates, and later members of her 1884 graduating class. These three women were among a "very small select group of Black women to earn Bachelor's of Arts degrees from an American college or university."[64] History records Mary Jane Patterson as the first African American female to earn a B. A. degree

from an American college. She received her degree from Oberlin in 1862, followed by Francis (Fanny) Jackson Coppin in 1865.[65]

Cooper, along with Terrell and Hunt, took the four-year "gentlemen's course" which was a classical course of study which led to a B. A. degree. Most women took the two year "Ladies' Course" of study which led to a certificate.[66] Cooper's decision to pursue the "gentlemen's classical course" of study was definitely reflective of her concern for the equality of women in the higher educational arena. "It also reflected her belief that women and African Americans' abilities were intellectually equal to White males. The Ladies' Course, in Cooper's viewpoint, was 'inferior in scope and aim' as compared to the classical course of study."[67] One scholar notes that Cooper's, Terrell's, Hunt's, Patterson's, and Jackson's "success in the 'gentlemen's' course did more than disprove race and gender stereotypes, they also bent the gender specificity of classical education."[68]

Oberlin policies illustrated the prevailing attitudes toward higher education for women. Research has revealed that this collegiate institution was founded to prepare men to enter the ministry. The courses designated for women did not require Latin, Greek, or higher mathematics.[69] One scholar's research reveals that female students were admitted into Oberlin to be trained as virtuous, pious, and obedient wives to the future male ministers.[70] In addition to pursuing their studies, the female students were expected to take care of the domestic needs of the male students, such as washing and repairing clothes and cleaning the male student's rooms. As God-fearing and obedient women they were also there to help counteract "morbid fantasies" men have about women.

Thus while Oberlin on the surface appeared to have been liberal because it admitted women and African Americans in 1833 and 1835 respectively, a close examination of the school's policies for the admittance of the aforementioned groups reveals a hidden agenda underpinning their policies.

One is left to speculate whether or not Cooper experienced racial and gender discrimination at Oberlin—her outspoken voice is muted on that issue. Mary Church Terrell however does write about her experience at Oberlin. Terrell was very happy at Oberlin. She records in her autobiography *A Colored Woman in a White World*, that she "had dear and intimate friends among the white girls," and as an on campus student, she did not feel discriminated against.[71] However, she does record an incident where she felt her race played a part, when a White male student was elected poet for exercises to be held by the junior class. According to

"Molly," (as she was called), this student had never written poetry before whereas she was recognized as having been prolific in her poetry writing. Nonetheless, she felt that racial discrimination was involved in her not being elected. She does not mention that gender discrimination might have played a significant role in this incident as well.

Annie was a serious and mature student who lived off campus. Her life on campus was limited to attending and teaching classes and her involvement in a few on campus extra curricular activities. "Cooper resided in the home of her professor, Charles Henry Churchill. Home life with the Churchill family was described as pleasant and intellectually stimulating."[72] Cooper remained a close friend with the Churchill family throughout her life. In response to question number 31 in the 1931 "Negro College Graduates" questionnaire, Cooper identified Churchill, Tutor and Fairchild as stimulating faculty members. Years later, she writes the following on the dedication page of her book, *Le Pelerinage de Charlemage*:

> . . . to three great teachers who more than any other Americans have inspired my faith, encourage my hope, deepened my love in and privilege of a life of service.[73]

Cooper involved herself in a number of school activities including membership in the prestigious Young Ladies Literary Society (LLS), participation in "Thursdays' Lectures," and a series called "General X for Women."[74] According to Cooper, the Thursdays' Lectures were very important because they gave her direction in her life. From the LLS Cooper gained experiences in poetry reading, essay writing and public speaking. Her occasional participation in the oratory and debating class shaped her skills as a debater. Later in life, Cooper would become a well-sought after speaker at various churches and conferences.

Religious exposure at Oberlin College helped "broaden her understanding of Christianity beyond the myopic faith of a 'bigoted' churchwoman entrenched in denominational doctrines."[75] She regularly attended the Episcopal Church on the school's campus and found the "friendly contacts & [sic] wider study" to be "humanizing."[76]

At Oberlin, Cooper studied the "classics," such as mathematics, literature, science, philosophy and both dead and modern European languages.[77] Cooper enjoyed her "classical" studies courses. She often requested special permission to take "four courses instead of the prescribed number of three."[78] She also enjoyed studying the European lan-

guages. "She was so fluent in French that she often used it as her native language."[79] In addition, Cooper took piano lessons and studied secular and sacred music under the guidance of President Henry Churchill King at the Oberlin Conservatory Music, established in 1865.[80]

Oberlin had a custom of employing students in the Collegiate Department to teach classes in the Preparatory Program. Thus, from 1882-1884, Cooper taught Advanced Algebra courses in the Oberlin Academy. She stated that her students were White.[81]

Cooper did extremely well at Oberlin. She won the respect of her instructors and classmates. Hutchinson contends that Cooper's "interaction with faculty members and peers, whose sound scholarship and intelligence reinforced her own views, helped her prepare for her lifelong work."[82] Cooper writes that Oberlin College had been "the college of so many happy memories."[83] It had also been one of the most influential institutions in the development of Cooper's philosophy on life, race, gender, and class issues. Fairchild, one of her favorite professors, believed that:

> Each student belongs still to the world, not isolated from sympathies and obligations and activities. The ends he pursues are such as appeal to men in general, the reputation he desires is the same that will serve him in work of life, and the motives to excellence are the natural motives which operates on men at large ... The college is a place for education, not merely for the acquisition of learning. ... The great object is such a discipline as is qualified for service in the world.[84]

Armed with her bachelor's degree, conferred upon her in 1884, "Cooper felt ready to address the inequities and indignities that Black women like her mother had experienced in slavery and in the post-Civil War South."[85] She was ready to commit her life "for service in the world." When Cooper departed Oberlin in 1884, she headed for the historically black school of Wilberforce University in Ohio. She was offered a position as professor of modern languages and literature.

## FAMILY BACKGROUND OF NANNIE HELEN BURROUGHS

Burroughs was born two years after Reconstruction officially ended in 1877, when the newly elected Republican president, Rutherford B. Hayes, withdrew federal military forces from the South.[86] She would come of age in the post-Reconstruction era (which expanded from 1877

to 1919). During this time span, progress for African Americans was slow and uneven. The social and political events of this era would greatly effect Burroughs' race, class and gender consciousness.

Dr. Earl L. Harrison, biographer and close colleague of Nannie Helen Burroughs, notes that not much is known about the early life of Burroughs . . . "like a tree she is better known by her fruit. She is so full of ideas and so imbued with the passion for service that she had no time to talk about Nannie."[87]

Nannie Helen Burroughs was born on May 2, 1879 in Orange, Virginia to John Burroughs and Jennie Poindexter Burroughs. She was the elder of two children. Nannie's baby sister, Maggie, died in infancy. Burroughs' parents were born into slavery and were young children at the close of the Civil War. Her father attended the Richmond Institute (renamed Virginia Union University) and became an itinerant Baptist preacher.[88] Burroughs described her mother as an independent woman. In later years, her mother worked as a domestic laborer in Washington, D. C.[89]

Nannie's paternal grandfather was freed from slavery prior to the Civil War and lived comfortably off of a sizeable farm purchased after the War.[90] Her maternal grandfather bought his freedom from slavery and made his living as a carpenter.[91]

When Nannie was five years old, Jennie brought her to Washington, D. C. They resided with Jennie's older sister, Cordelia Mercer.[92] There are various accounts as to why Jennie came to the District of Columbia, one being that she left her husband due to marital problems. Another is that she left Orange, Virginia soon after the death of her husband. Whatever the reasons for the move, Jennie was obviously conscious of the fact that she and Nannie faced a life of limitations living in rural Virginia during the post-Reconstruction era.

During this era, the federal government moved away from its policy of promoting the civil and educational rights of Blacks. Researcher Angel Davis argues that once the "northern industrial capitalists established their hegemony in the South, the elected Republican Party—which represented the capitalists' interest, participated in the systematic disenfranchisement of Black people."[93] Lynching, mob violence, and literary attacks on Black women's morality were on the rise. Segregation became a legalized form of institutional discrimination; the Ku Klux Klan had increased its terrorist activities; and the economic peonage of the sharecropping system all worked together to ensure the continued social and political dehumanization, exploitation, and subordination of the African American.[94]

The post-Reconstruction era also gave rise to racist images and social Darwinist ideologies. These ideologies promulgated racist notions that Blacks were innately inferior. Pseudoscientific theories were increasingly used to "justify the domination of the White majority over the Black minority."[95] It was also during this era that "all women in America were encumbered by a cultural tradition of inferiority and a social condition of second class citizenship."[96] The "cult of true womanhood," discussed in Chapter 2, came into existence at this time and as womanist theologian Emilie M. Townes observes, it had a "tremendous impact on the lives of Black women. The effects of slavery, . . . racism, [and] . . . an emerging class structure, combined with the 'cult of true womanhood' ideology placed Black women in a narrowly defined sphere in nineteenth century culture."[97]

The sexual exploitation of Black women during slavery gave rise to the nineteenth century controlling images of Black women as sexually depraved, immoral and loose women.[98] And "like all sexually assaulted victims in a patriarchal society," explains feminist bell hooks, [Black women] "were seen as having lost value and worth as a result of the humiliation they endured."[99]

Research conducted by historian Paula Giddings revealed that a popular periodical of the nineteenth century called *The Independent*, typified the following prevailing attitudes toward African American women: "Black women had the brains of a child, the passions of a woman," but unlike Whites, Black women were "steeped in centuries of ignorance and savagery, and wrapped about with immoral vices."[100]

Additional images of Black women included the: "mammy"—the obedient, faithful servant who protects and nurtures the White family; "sapphire"—bad mother who works at a period when women were suppose to be domestic, thereby emasculating Black men; "jezebel"— whore, sexually aggressive, this image justified the widespread assault on Black women by White men during slavery and into the nineteenth century. The image of Blacks as less than human, or "Other," provided the "ideological justification for the racial oppression, the politics of gender subordination, and the economic exploitation inherent in the [industrialized patriarchal] capitalist economy."[101]

Hence, the intersection of being Black, poor, female and living in the rural South consigned Black women to a new form of slavery. Access to jobs other than laundry work, sharecropping or domestic labor was denied to Jennie and many other Black women.[102]

Jennie adhered to the philosophy that an education was the key to

social and economic freedom. Educational opportunities were not as great or plentiful in Orange, Virginia as they were in Washington, D.C. She no doubt believed that the schools in the nation's capital, although segregated, offered much more for African Americans. "The number and quality of educational institutions in Washington made the city a national center of Black education."[103] Howard University, an elite institution, was sometimes known as the "National Negro University."

The story of Jennie uprooting herself in order to secure better schooling for Nannie is not an unusual one. The literature is replete with stories of African American families, of various class backgrounds, moving to Washington for the purpose of educating their children in the District's public schools.[104] Jennie wanted the best for her only daughter. A life limited to domestic or agricultural servitude would not be an option for Nannie. Thus, Jennie packed up her belongings and headed to the larger metropolitan town in hopes of a better life for her and Nannie.

## GOING TO SCHOOL: 1883–1896

In 1862, twenty-one years prior to Burroughs arrival in Washington, D.C., the public school education for African American children began in the District of Columbia. However, the first public school did not open until 1864. Funding for the District of Columbia's 'Colored schools' "were placed upon the federal statutes."[105] Elementary public schools were the first schools opened for African Americans. These institutions were separate and segregated educational experiences for both Black and White children. In 1872, Massachusetts's Senator Charles Sumner proclaimed that "the separate school is not equivalent." He introduced a legislated bill that prohibited racial discrimination in hiring teachers and admitting students in the District of Columbia's schools. This bill was defeated, and as a result the nation's capital maintained two separate school systems for eighty-two years.[106]

The segregated school system "had a Black superintendent and a White superintendent until the reorganization of 1901, at which time the administrative head of the Black schools became an assistant superintendent subordinate to the White superintendent."[107] The District's schools also employed African American school board members who were effective advocates of better schools for the Black student population when the school boards were separate.[108] George F. T. Cook, the Black superintendent, was a graduate of Oberlin College. He attended Oberlin from 1853 to 1860. In 1868 he was appointed superintendent of the Colored public schools in the District, a post he held until 1900.[109]

By the time five-year old Nannie arrived in Washington, D.C. in 1883, the "Colored" elementary schools were eight-year institutions. Grades one to four were known as primary grades. Grades five to eight were considered grammar grades.[110] Language Arts, penmanship, grammar, arithmetic, algebra, geography, history, physiology, physical science, nature study, music and moral training constituted the course of study at the "Colored" elementary schools.[111] Presumably, these were the courses Nannie took during her elementary school years. As noted by researcher Lillian G. Dabney, the quality of the "Colored" elementary schools was somewhat inferior to the White schools.

Soon after Burroughs moved to Washington, she became seriously ill with typhoid fever. This illness rendered her incapable of attending school for two years.[112] Upon returning to school, the young, bright and ambitious Nannie pursued her studies seriously and was able to make up for the two years she lost.[113] Upon the completion of her elementary schooling, Burroughs enrolled in the only high school in existence for African Americans in the District of Columbia in 1892. This school was the Washington Colored High School, commonly called M Street High School. M Street (later called Paul Laurence Dunbar High School) was known "nationwide as the foremost illustrious high school for African Americans."[114]

## WASHINGTON COLORED HIGH SCHOOL

Very "few public high schools acquired reputations for academic excellence. Among these was the M Street school in Washington, D.C."[115] In September 1891, M Street was a new school built to replace the Washington Preparatory High School. The Preparatory High School was the first and only high school established for African Americans in 1870, nine years before the establishment of a high school for White students in the nation's capital. The Preparatory High School for Negro youth was established in the memory of Myrtilla Miner. It had been organized in the basement of the Fifteen Street Presbyterian Church, then moved to the Charles Sumner elementary school building near M Street, then eventually to the Myrtilla Miner Building in the North West section of Washington. The Miner Fund helped finance the school.[116] By the time the Preparatory High School (later Washington Colored High School) moved from M Street into its newly built brick building, the name "M Street" became attached to the high school.[117]

The newly built M Street school housed the classrooms on the top story of the building. The recreational and physical education programs

were conducted in large spacious rooms located in the basement.[118] The school also included a "well-appointed office [space] for the principal and a combination conference room for the teachers."[119] Still the new school was lacking in certain physical facilities and equipment. "It did not have a gym or lockers for physical education, no pool or track field, nor a yard or grass outside."[120] Despite these limitations, this District's segregated high school provided an excellent educational experience for its Black youth.

Between September 1891 and September 1916 the M Street High School graduated a multitude of students who would achieve prominence in the local Washington community as well as in the national and international communities. Others would obtain the "distinction of being the first African American to obtain eminence in their respective professions."[121] The high school also had a long history of attracting highly educated and qualified African American teachers and administrators. Social and political activist and former teacher of M Street, Mary Church Terrell, wrote in 1917 the following about M Street:

> . . . at the head of no school in the United States have there been teachers who have availed themselves of better educational advantages than have the principals of the high school for the education of Negroes in the District of Columbia . . . of the ten [Black] principals who have guided and molded the school, two held degrees from Harvard University, three from Oberlin College, one from Dartmouth, one from Amherst, one from Western Reserve University, and one was educated in the University of Glasgow in Scotland.[122]

Terrell also notes that "however well-trained and strong the principal of a school may be, it is impossible for him to accomplish as much as he might, if his teachers also are not efficient and conscientious in the discharge of their duties . . . this high school has been greatly blessed . . . The teachers . . . not only enjoyed superior educational advantages, but have faithfully discharged their duties."[123]

The impressive faculty credentials combined with visionary distinguished principals who adhered to a high standard of academic excellence gave rise to an outstanding high school—successful in educating the majority of the students.

In 1892, Burroughs became a student at M Street High School. At the time of her enrollment, students were admitted on the basis of qualifications and performance. As mentioned above, M Street was the only

high school for African Americans in the District, thus the "school attracted students from neighboring jurisdictions and from several states where there were no high schools for Black students."[124]

During the time Burroughs was a student at M Street, the talented and highly educated Francis Lewis Cardozo was the principal. Minister, politician and educator, Cardozo (1836-1903) was born free in antebellum South Carolina. He was educated at the University of Glasgow in Scotland during "Sessions 1858-59 and 1859-60."[125] At the University of Glasgow, Cardozo won two scholarships in Latin and Greek. He also studied theology in Edinburgh and at the London School of Theology in England.[126]

In 1864, Cardozo became pastor of the Temple Street Presbyterian Church in New Haven, Connecticut. The following year, the American Missionary Association sent Cardozo to Charleston, South Carolina to undertake missionary work.[127] During his stay in Charleston, Cardozo founded the Avery Institute and served as its principal. The multi-talented Cardozo was also a politician. In 1868 he was elected Secretary of State of South Carolina and in 1872 and 1876 Cardozo served as Treasurer of the State of South Carolina.[128]

Cardozo became the principal of M Street High School in 1884 and served in that capacity until 1896. Under his administration, the high school provided a college preparatory classical arts curriculum. The high school also was extended from three years to four years. The vast majority of M Street graduates went on to pursue higher education.[129] In addition to the classical curriculum, Cardozo developed the District's first trade and business curricula.[130] Cardozo's trade and business curricula "ultimately led to the founding of the Armstrong Manual Training High School in 1902 and the Cardozo Vocational High School" in 1928.[131] Armstrong and Cardozo High Schools were part of the District's public schools for Colored youth.

As noted by researcher Louise Hutchinson, the vocational courses at M Street were designed to give students an alternative choice to a classical education. She writes that "the principal and teaching staff were pragmatists and realized that not all their students . . . would want or be able to go on to college."[132] The faculty espoused the educational belief that those who would enter the vocational courses "should be 'educated,' not just become skilled hands."[133] Superintendent Cook viewed the trade and business courses as having a "practical usefulness" because they better prepared students for the business life. He believed these courses to be "the great end of intellectual discipline."[134]

M Street curriculum, however, was dominated by the classical courses. A classical curriculum in a school for African Americans was rare due to the fact that the prevailing viewpoint of dominant society promulgated the philosophy that an industrial education provided the best and appropriate model of educating Black students.[135] An industrial education was a way of keeping Blacks in a place of economic subordination. M Street's College preparatory program would later prove to become problematic and would come under attack by the District's school board; Anna J. Cooper would be in the middle of this controversy. I will discuss this in Chapter 4.

While at M Street, Burroughs' major area of study was business and domestic science. She also took elective classes in the classical education program. As a motivated and ambitious student, she took advantage of the opportunities and activities the school had to offer. In addition, she organized the Harriet Beecher Stowe Literary Society. This club provided students an outlet for "both literary and oratorical expression."[136] Burroughs was gifted with oratorical abilities. The club she formed allowed her to cultivate her talents in public speaking. Later in her adult life, she became in great demand for speeches in churches and various group gatherings.[137] Burroughs truly enjoyed her experience at the Washington Colored High School. Her teachers, Mary Church Terrell and Anna Julia Cooper, were great influences on her "during her formative years."[138]

In her historical research on Washington, D. C., Constance Green revealed that at M Street High School a dedicated, stimulating and college-educated faculty fostered students' intellectual ambitions.[139] Students were encouraged to reason and think critically about issues rather than depend upon memory. In an exam given to all of the District of Columbia's high school students in 1899, M Street students scored higher than the District's white high schools.[140] Green's findings also revealed that M Street teaching and administrative staff possessed far more college degrees that the staff of the white high schools in the nation's capital.[141]

In this de jure segregated system, Nannie emerged highly educated. Her dreams, interests and intellectual pursuits were cultivated and nurtured by caring and sensitive teachers. She received an education, which was either on par or superior to the students in the neighboring white high school. Her education prepared her for a life of leadership in women's education, Christian education and socio-political work. Her major in business and domestic science, with a minor in classical studies allowed Burroughs to fulfill her dream and her mother's dream to be more than just a "skilled hand" or de mule uh de world."

In 1896, the year segregation was legalized and sanctioned by the federal government, Burroughs graduated from Washington Colored High School. She graduated with honors and consequently was elected the class valedictorian.

After graduation, Burroughs applied for an assistant teaching position at Tuskegee Institute in Alabama. She was not offered a position. Burrough also attempted to secure employment in the District's "Colored" public schools, as a teacher's assistant of domestic science. She was unsuccessful in her attempts to get this position also. The job went to "another girl" who had "pull" with those in charge of hiring.[142] Historian Evelyn Higginbotham notes that it was suggested to Burroughs that her "dark skin color and her lack of social pull had thwarted her being chosen."[143] There were ongoing complaints in the Black community about favoritism in teaching appointments on the part of Superintendent George F. T. Cook.[144] "Cook was for many years superintendent of African American schools, and various members of his family held administrative and faculty posts."[145] As explained by historian Willard B. Gatewood, "Washington's black school system had a national reputation for excellence and provided respectable employment for well-educated Blacks; the competition for jobs was fierce and the struggles between rival factions were often bitter."[146] The following scenario illustrates the aforementioned point:

> In 1894, a Black resident asked, "Why so many members of certain families are employed in lucrative positions in the public schools to the exclusion of others who are not so high on the social scale?" In responding to criticism about the appointment of his sister-in-law to a faculty position, Dr. John R. Francis, Washington's leading Black physician and member of the Board of Education, maintained that a teacher "who moves in the best society" was far preferable to one whose parents "live in alleys."[147]

Gatewood aptly observes that "such statements lent credence to suspicions that the separate public school system was the preserve of [the District's] 'Old families' who represented light-skinned members of the Black aristocracy."[148]

Although her training qualified her for the teaching assistant position, Burroughs' dark skin, poor and humble background and no ties to the "old families" of the District, deemed her inappropriate for the job. The African American newspaper, the *Washington Bee*, poignantly states that the administrators and teachers of the District's Colored schools

"constituted a self-conscious elite that held itself aloof from Negroes outside its charmed circle."[149]

Burroughs' biographer, Earl Harrison, wrote that Burroughs was very wounded and disappointed. She told him,

> It broke me up at first. I had my life all planned out to settle down in Washington with my mother, do that pleasant work, draw a good salary and be comfortable the rest of my life. . . . An idea struck out of the suffering of that disappointment that I would some day have a school here in Washington and that school politics had nothing to do with and that would give all sorts of girls a fair chance, without political pull, to help them overcome whatever handicaps they might have. It came to me like a flash of light, and I knew I was to do that thing when the time came.[150]

This incident transformed Burroughs' life and led her on a career path "imbued with a passion for a life of service." The National Trade and Professional School for Women and Girls was conceived out of her disappointment. As biographer Aurelia Downey aptly observes, "Nannie's disappointment became God's appointment for her life."[151]

It would take eleven years before Burroughs was able to build her dream school in the District of Columbia. During the interim she moved to Philadelphia and worked as an associate editor for a Baptist newpaper, *The Christian Banner*.[152] Burroughs remained in Philadelphia a short period of time. Later, she moved to Louisville, Kentucky and worked as a bookkeeper and editorial secretary of the Foreign Mission Board headed by Reverend L. G. Jordan, a mentor, friend and confidant.[153]

## SUMMARY AND CONCLUSION

Hope for freedom—social, political and economic—seemed to have been the theme throughout the Reconstruction period within the African American community. Educational institutions were constructed, offering the newly emancipated men, women and children an opportunity to gain literacy skills—one of the keys to their liberation. Cooper, a child of this era, was one of the fortunate few to be given a "chance to learn." In contrast, Burroughs came of age and was educated during the post-Reconstruction period—the "nadir" of the African American experience. It was a time of oppressive racism, which permeated every facet of the American economic, political and social order.

Raised by mothers who were former slaves, Cooper and Burroughs were encouraged to go farther than their mothers themselves were allowed to go. Their mother's "self-sacrificing toil to give [them] the advantages [Hannah and Jennie] never enjoyed," enabled Cooper and Burroughs to be relieved of the experience of being "de mule uh de world"—relieved of the physical, psychic and economic abuses of domestic and agricultural labor. Their mothers' sacrifices gave them the tools to survive as well as resist the interlocking structures of race, class and gender oppression.

Cooper and Burroughs enjoyed their schooling experiences. They encountered dedicated teachers who were inspiring and stimulating. These teachers instilled in them a commitment to a life of service.

The social climate Anna Julia Cooper and Nannie Helen Burroughs grew up in intersected with their family background and their educational experiences, helped shape Cooper's and Burroughs' race, class and gender consciousness and influenced their particular educational perspectives. In Chapter 4, I will discuss Cooper's and Burroughs' careers as educators and the development of their educational philosophies.

## NOTES

[1] Julius Lester, *To Be a Slave* (New York: The Dial Press, 1968) p. 28

[2] Zora Neale Hurston, *Their Eyes Were Watching God* (Greenwich, CT: Fawcett, 1937/1969) pp. 16-17

[3] Undated autobiographical document, Anna Julia Cooper, Anna Julia Cooper papers, courtesy of the Moorland-Spingard Research Center, Howard University, (Hereafter cited as AJC papers courtesy of MSRC); also reproduced in Louise D. Hutchinson, *Anna J. Cooper: A Voice from the South* (Washington, D. C.: Smithsonian Institute Press, 1981) p. 4

[4] Mary Helen Washington, Introduction to Anna Julia Cooper's *A Voice from the South* in The Schomburg Library of Nineteenth Century Black Women Writers, eds., (New York: Oxford University Press, 1988) p. xxxi

[5] Darlene Clark Hine & Kate Wittenstein, "Female Slave Resistance: The Economics of Sex," in Filomina C. Steady, eds., *The Black Woman Cross-Culturally* (Rochester, Vermont: Schenkman Books, Inc., 1981) p. 289

[6] Valerie Smith, Introduction to Harriet Jacobs' *Incidents in the Life of a Slave Girl* in The Schomburg Library of Nineteenth Century Black Women Writers, eds., (New York: Oxford University Press, 1988) p. xxxi

[7] Undated autobiographical document, Anna Julia Cooper, AJC papers, courtesy of MSRC

[8] Letter from Charles Busbee to the Board of Education of the District of Columbia, September 11, 1905. Busbee wrote a letter to the Board in an effort to speak to Cooper's qualifications and moral character. While principal of "M Street" High School, Cooper was in the process of being fired from her job due to alleged insubordination and immoral conduct. I will discuss this issue in detail in Chapter 4. However, in this letter Busbee writes that Cooper was named after his mother Annie.

[9] For extensive research and discussion on the family life of slaves during and after slavery see Herbert Gutman, *The Black Family in Slavery and Freedom: 1750-1925* (New York: Pantheon Books, 1976)

[10] Deborah Gray White, *Ar'n't I a Woman?: Female Slaves in the Plantation South* (New York: W. W. & Norton Company, 1985) p. 159

[11] Ibid., pp. 159-160

[12] Darlene Clark Hine, *Speak Truth to Power: Black Professional Class in United States History* (Brooklyn, New York: Carlson Publishing, Inc., 1996) p. 37

[13] Patricia Hill Collins, *Black Feminist Thought: Knowledge, Consciousness, and the Politics of Empowerment* (New York: Routledge, 1991) p. 123

[14] Ibid., p. 124

[15] Brenda Stevenson, "Slavery," in Darlene Clark Hine, eds., *Black Women in America: An Historical Encyclopedia*, vol. II (Bloomington, Indiana: Indiana University Press, 1993) p. 1058

[16] Ibid.

[17] Ibid., p. 1059

[18] Anna Julia Cooper, *The Third Step* Autobiographical Booklet. (Privately Printed, 1950) pp. 4-5

[19] Paul Philips Cooke, (1981). "Anna J. Cooper." Unpublished paper lent to this author courtesy of Dr. Paul Philips Cooke (Private Collection) p. 1

[20] Patricia Hill Collins, *Black Feminist Thought*, p. 129

[21] Ibid.

[22] Undated autobiographical document, Anna Julia Cooper AJC papers, courtesy of MSRC

[23] Louise D. Hutchinson, *Anna J. Cooper, A Voice From the South* (Washington, D. C.: Smithsonian Institute Press, 1981) p. 166

[24] Leona Gabel, *From Slavery to the Sorbonne and Beyond: The Life and Writings of Anna J. Cooper* (Northampton, Massachusetts: Smith College Studies in History, 1982) p. 11

[25] Undated autobiographical document, Anna Julia Cooper, AJC papers, courtesy of MSRC; Karen Baker-Fletcher, *A Singing Something: Womanist Reflections on Anna Julia Cooper* (New York: Crossroad, 1994) p. 36

[26] Dorothy Sterling, *We Are Your Sisters: Black Women in the Nineteenth Century* (New York: W. W. Norton, 1984) p. 309

[27] William E. B. Du Bois, *Black Reconstruction in America: 1860-1880* (New York: Harcourt, Brace, 1975) p. 124

[28] Carl Schurz is quoted in John Hope Franklin, *Reconstruction After the Civil War* (Chicago: University of Chicago Press, 1994) p. 2

[29] Sadie and Elizabeth Delany & Amy Hearth, *Having Our Say: The Delany Sisters' First 100 Years* (New York: Kodansha International, 1993) p. 25

[30] Reverend James Hood quoted in Louise D. Hutchinson, *Anna J. Cooper, A Voice*, pp. 20-21

[31] James D. Anderson, *The Education of Blacks in the South, 1860-1935* (Chapel Hill, North Carolina: University of North Carolina Press, 1988) p. 18

[32] bell hooks, *Talking Back: Thinking Feminist, Thinking Black* (Boston: South End Press, 1989) p. 98

[33] C. D. Halliburton, *A History of St. Augustine's College, 1867-1931* (Raleigh, North Carolina: St. Augustine's College Press, 1937) pp. 1, 73

[34] Delany & Hearth, *Having Our Say*, p. 42

[35] Hutchinson, *Anna J. Cooper, A Voice*, p. 24

[36] Ibid.

[37] Halliburton, *A History of St. Augustine's*, pp. 1, 5, 6, 10

[38] Delany & Hearth, *Having Our Say*, p. 44

[39] Hutchinson, *Ann J. Cooper, A Voice*, p. 4

[40] Delany & Hearth, *Having Our Say*, pp. 43-33

[41] Ibid., pp. 50-51

[42] Ibid.

[43] Gabel, *From Slavery to the Sorbonne*, p. 14

[44] "Negro College Graduates' Questionnaire," question # 19, AJC papers, courtesy of MSRC

[45] Delany & Hearth, *Having Our Say*, p. 50

[46] See Karen Baker-Fletcher, Chapter 2, pp. 63-85 and Chapter 3, pp. 86-101

[47] Undated autobiographical document, Anna Julia Cooper, AJC papers, courtesy of MSRC

[48] Anna Julia Cooper, *A Voice From the South* in Schomburg Library of Nineteenth Century Black Women Writers, eds., (New York: Oxford University Press, 1988) p. 77

[49] Undated document, Anna Julia Cooper, AJC papers, courtesy of MSRC

[50] Gabel, *From Slavery to the Sorbonne*, p. 18

[51] "Negro College Graduates' Questionnaire," question #58, AJC papers, courtesy of MSRC

[52] Linda M. Perkins, *Fanny Jackson Coppin and the Institute for Colored Youth 1865-1902* (New York: Garland Publishing, 1987) p. 21

[53] James Harris Fairchild, *Oberlin: The Colony and the College: 1833-1883* (Oberlin, Ohio: E. J. Goodrich, 1883) p. 14

[54] William E. Biggleston, *Oberlin From War to Jubilee: 1866-1883* (Oberlin, Ohio: Grady Publishing Co) 1983, p. xi

[55] Robert B. Slater, (Autumn, 1995) "American Colleges that Led the Abolition Movement," *Journal of Blacks in Higher Education*, no. 9, pp. 95-97

[56] Ibid., p. 97

[57] See Robert S. Fletcher, *A History of Oberlin College: From its Foundation Through the Civil War* vol. 2, (Oberlin, Ohio: Oberlin College, 1943)

[58] William E. Biggleston, (1971) "Oberlin College and the Negro Student, 1865-1940," *Journal of Negro History* vol. 56, p. 198

[59] Ibid.

[60] Ibid.

[61] Fairchild, *Oberlin*, p. 113

[62] Biggleston, "Oberlin College," p.198

[63] Ibid.

[64] Dorothy Sterling, *We Are Your Sisters*, p. 202

[65] Ibid.

[66] Ibid., p. 202

[67] Cooper, *A Voice from the South*, p. 50

[68] Shelley P. Haley, Introduction to Fanny J. Coppin's *Reminiscences of School Life and Hints on Teaching*, in Henry Louis Gates, ed., African American Women Writers, 1910-1940 (New York: G. K. & Co, 1995) p. xxvi

[69] R. W. Hogeland, (1972-73) "Coeducation of the Sexes at Oberlin: A Study of Social Ideas in Mid-Nineteenth Century America," *Journal of Social History*, no. 6, pp. 160-76

[70] Ibid.

[71] Mary Church Terrell, *A Colored Woman in a White World* (Salem, New Hampshire, Ayer Publishers, Inc., 1940) pp.43-45

[72] Hutchinson, *Anna J. Cooper, A Voice*, p. 37

[73] Anna Julia Cooper, *Le Pelerinage de Charlemagne* (Paris: A. Lahure Imprimeur Editeur, 1925) no page

[74] Beverly Guy-Sheftall, "Anna Julia Cooper," in M. S. Seller, eds., *Women Educators in the United States, 1820-1993: A Bio-Bibliographical Sourcebook* (London: Green Wood Press, 1994) p. 163

[75] Karen Baker-Fletcher, *A Singing Something*, p. 43

[76] "Negro College Graduates' Questionnaire," question # 37, AJC papers, courtesy of MSRC

[77] Gabel, *From Slavery to the Sorbonne*, p. 19

[78] Ibid.

[79] Frances R. Keller, *Slavery and the French Revolutionists, 1788-1805 by Anna Julia Cooper*, (Lewiston, New York: The Edwin Mellen Press, 1988) p. 3

[80] Cooper, *The Third Step*, p. 18

[81] "Negro College Graduates' Questionnaire," question #34, AJC papers, courtesy of MSRC

[82] Hutchinson, *Anna J. Cooper, A Voice*, p. 277

[83] Cooper, *The Third Step*, p. 3

[84] Fairchild, *Oberlin*, n. p.

[85] Hutchinson, "Ann Julia Cooper," in Darlene Clark Hine, eds, *Black Women in America*, vol. I (Bloomington, Indiana: Indiana University, 1993) p. 277

[86] Gerald L. Gutek, ed., "The Civil War, Reconstruction, and the Education of Black Americans," in *Education in the United States: A Historical Perspective* (Englewood Cliffs: Prentice Hall, 1986) p. 159

[87] Earl L. Harris, *The Dream and the Dreamer: An Abbreviated Story of the Life of Dr. Nannie Helen Burroughs and Nannie Helen Burroughs School* (Washington, D. C.: Nannie H. Burroughs Literature Foundation Publisher, 1956) p. 8

[88] Evelyn Higginbotham, "Nannie Helen Burroughs," in Darlene Clark Hine, eds., *Black Women in America: An Historical Encyclopedia* (Bloomington, Indiana: Indiana University, 1993) p. 201

[89] Ibid.

[90] B. Sicherman & C. H. Green, *Notable American Women, The Modern Period: A Biographical Dictionary* (Cambridge, Massachusetts: Harvard University Press, 1980) p. 125

[91] Higginbotham, "Nannie Helen Burroughs," p. 201

[92] Ibid.

[93] Angela Davis, *Women, Race and Class* (New York: Random House, 1983) pp. 85-86

[94] See Angela Davis, "Rape, Racism and the Myth of the Black Rapist," in *Women, Race and Class* (New York: Random House, 1983) pp. 172-201; also see Rayford Logan, *The Negro in American Life and Thought: The Nadir 1877-1901* (New York: Dial Press, 1954)

[95] See Gutek, "The Civil War,"

[96] Bert Loewenberg & Ruth Bogin, *Black Women in Nineteenth Century American Life: Their Words, Their Thoughts, Their Feelings* (University Park: Pennsylvania State University Press, 1976) p. 2

[97] Emilie M. Townes, *Womanist Justice, Womanist Hope* (Atlanta, Georigia: Scholars Press, 1993) p. 85

[98] bell hooks, *Ain't I A Woman: Black Women and Feminism* (Boston: South End Press, 1981) p. 53; See Patricia Hill Collins, "Mammie, Matriarchs, and other Controlling Images," in *Black Feminist Thought: Knowledge, Consciousness, and the Politics of Empowerment* (New York: Routledge, 1991) pp. 67-90; Angela Davis, *Women, Race and Class* (New York: Random House, 1983) p. 176; For an historical account on the origins of the myth of the black rapist as a political weapon, see Paula Giddings' *When and Where I Enter: The Impact of Black Women on Race and Sex in America* (New York: William Morrow, 1984) page 27

[99] hooks, *Ain't I A Woman*, p. 53

[100] Paula Giddings, *When and Where I Enter: The Impact of Black Women on Race and Sex in America* (New York: William Morrow, 1984) p. 82

[101] Patricia Hill Collins, *Black Feminist Thought*, p. 78

[102] For detail research and discussion on Black women's work after the Civil War and up to the early to mid twentieth century see Sharon Harley's, "For the Good of the Family and Race: Gender, Work, and Domestic Roles in The Black Community, 1880-1930," in M. Malson, eds., *Black Women in America: Social Science Perspectives* (Chicago: University of Chicago Press, 1988) pp. 159-172; Jacqueline Jones, *Labor of Love, Labor of Sorrow: Black Women, Work and the Family, From Slavery to Present, 1986* (New York: Vintage); also see Tera Hunter, *To Joy My Freedom: Southern Black Women's Lives and Labors After the Civil War* (Cambridge, Massachusetts: Harvard University Press, 1997)

[103] Willard B. Gatewood, *Aristocrats of Color: The Black Elite, 1880-1920* (Bloomington, Indiana: Indiana University Press, 1993) p. 259

[104] See Gatewood, *Aristocrats of Color*

[105] Lillian G. Dabney, *The History of Schools for Negroes in the District of Columbia: 1807-1947* (Ph.D. dissertation, Catholic University, 1949) p. 113

[106] Ibid., p. 121

[107] Gatewood, *Aristocrats of Color*, pp. 258-259

[108] Ibid.

[109] Fletcher, *A History of Oberlin College*, p. 913; Dabney, *The History of Schools for Negroes*, p. 75

[110] Dabney, *The History of Schools for Negroes*, p. 124

[111] Ibid.

[112] Sadie Daniels, *Women Builders* (Washington, D. C.: Associated Publisher, 1964) p. 112

[113] Opal V. Easter, *Nannie Helen Burroughs and Her Contributions to the Adult Education of African American Women* (New York: Garland Publishing, 1995) p. 34

[114] H. S. Robinson, (1980) "The M Street High School, 1891-1916." Unpublished paper lent to this author courtesy of Dr. Paul Philips Cooke (Private Collection) p. 1

[115] Gatewood, *The Aristocrats of Color*, p. 258

[116] Hutchinson, *Anna J. Cooper, A Voice*, p. 48

[117] Ibid.

[118] Ibid.

[119] Ibid.

[120] S. Fitzpatrick & M. Goodwin, *The Guide to Black Washington: Places and Events of Historical and Cultural Significance in the Nation's Capital* (New York: Hippocrene Books, 1990) p. 89

[121] Robinson, "The M Street High School," p. 3

[122] Mary Church Terrell, (1917) "History of the High School for Negroes in Washington," *Journal of Negro History*, no. 2, p. 261

[123] Ibid.

[124] Hutchinson, *Anna J. Cooper, A Voice*, p. 49

[125] Frederick B. Mohr, (1977) ed., "Francis L. Cardozo Papers," *The Quarterly Journal of the Library of Congress*, p. 354

[126] Terrell, "History of the High School," p. 257

[127] Frederick B. Mohr, ed., "Francis L. Cardozo Papers," p. 354

[128] Terrell, "History of the High School," p. 257

[129] Ibid.

[130] Hutchinson, *Anna J. Cooper, A Voice*, p. 49

[131] Gatewood, *The Aristocrats of Color*, p. 262

[132] Hutchinson, *Anna J. Cooper, A Voice*, p. 49

[133] Ibid.

[134] Terrell, "The History of the High School," p. 258

[135] Renee L. Vasser, *Social History of American Education, 1860 to Present*, vol. 2 (Chicago: Rand McNally & Co, 1965) p. 3

[136] Easter, *Nannie Helen Burroughs*, p. 35

[137] Harrison, *The Dream and the Dreamer*, p. 11

[138] Higginbotham, "Nannie Helen Burroughs," pp. 201-202

[139] Constance M. Green, *The Secret City: A History of Race Relations in the Nation's Capital* (Princeton, New Jersey: Princeton University Press, 1967) p. 137

[140] Ibid.

[141] Ibid.

[142] William Pickens, *Nannie Helen Burroughs and the School of the Three B's* (New York: n. p., 1923) pp. 15-16

[143] Higginbotham, "Nannie Helen Burroughs," p. 202

[144] Green, *The Secret City*, p. 137

[145] Gatewood, *The Aristocrats of Color*, p. 259

[146] Ibid.

[147] Ibid.

[148] Ibid.

[149] Ibid., pp. 259-60

[150] Harrison, *The Dream and the Dreamer*, p. 9

[151] Aurelia Downey, *A Tale of Three Women: God's Call and Their Response* (Brentwood, Maryland: International Graphics, 1993) p. 4

[152] Easter, *Nannie Helen Burroughs*, p. 36

[153] Harrison, *The Dream and the Dreamer*, p. 10

# "A Career to Build, a People to Serve, a Purpose to Accomplish"

> *There is no social activity that more vitally concerns the life of a people than the problem of education. The Colored people of the United States . . . want for themselves and their descendants . . . all the advantages and opportunities of education as the term is interpreted and understood in the most favored groups in our American civilization.*
>
> —ANNA JULIA COOPER[1]

> *Education and justice are democracy's only life insurance. There is no substitute for learning . . . it is the investment of our hopes and dreams for the generations that are to come.*
>
> —NANNIE HELEN BURROUGHS[2]

In this chapter, I will analyze Cooper's and Burroughs' professional lives as educators and their philosophies on education within the context of this question: What were the educational philosophies of Anna Julia Cooper and Nannie Helen Burroughs and what conditions influenced that development?

I explore the themes of teacher as moral and social agents for change and an ethic of caring. This chapter will begin with discussing Cooper's and Burroughs' experience as educators.

## SECTION I: THE PROFESSIONAL CAREERS OF ANNA JULIA COOPER AND NANNIE HELEN BURROUGHS

### ANNA JULIA COOPER

After graduating from Oberlin College, Cooper taught a year of French, German and literature at Wilberforce University in Xenia, Ohio from 1884 to 1885 at a yearly salary of one thousand dollars.[3]

Family problems and obligations prompted Cooper to return to her hometown of Raleigh, North Carolina after a year of teaching at Wilberforce University. Her elderly mother, who continued to work as a domestic laborer, was in her sixties or seventies and her brother Rufus passed away leaving his widowed wife with six children to raise.

While in Raleigh, Cooper taught geometry, Latin, and Greek at her alma mater, Saint Augustine's Normal and Collegiate Institute at a salary rate which was less than Wilberforce's salary.[4]

During the two years Cooper was employed at St. Augustine's, she became actively involved in activities and critical issues related to education. "She began an outreach extension program under the school's aegis, as well as established a Sunday school and a mission guild."[5]

As an active member of the North Carolina Teacher's Association, "she was very vocal in her criticism of North Carolina's State lawmakers failure to appropriate reasonable and just provisions for the training of . . . Colored youth."[6] Cooper also fought to secure equal treatment and salaries in the segregated North Carolina public school. However, her efforts were unsuccessful.

Cooper had not lived in Raleigh since she left in 1881. According to her biographer Louise D. Hutchinson, at the time, it appeared that Cooper had planned on resettling in Raleigh. She had begun building a house and caring for her elderly mother and both of her brothers' families. But for some reason or reasons she remained in her hometown for a brief period of two years. Cooper returned to her southern hometown in 1885—ten years after the Civil Rights Act of 1875 forbade discrimination in public places and eleven years before legalized segregation would be sanctioned by the government. However, she returned to a region of the country which practiced segregation by the way of local laws, customs and practices.[7]

The only type of employment opened to Black women under the segregated system was domestic labor, working in the tobacco fields or sharecropping. If one was fortunate to have a college degree, teaching in

a "Colored" school was the only alternative for him or her. Like Cooper's mother, her sister-in-law worked as a domestic laborer, and Cooper of course was a professor at a "Colored" college.

Segregation would not only restrict the movements, educational experiences, and job opportunities of African Americans, it would also subject them to daily humiliations and even sexual and physical violence. Historian Ulrich B. Philips described the South as "a people with a common resolve indomitably maintained that it shall be and remain a white man's country."[8] There was no escape from the abusive effects of race, class and gender discrimination. In this region of the country, Cooper felt "the shrivelling [sic] caste spirit," as she described it.[9] In her own voice she articulates her experiences and perspective of White male supremacy in the South:

> One of the most singular facts about the unwritten history of this country is the consummate ability with which Southern influence, Southern ideas and Southern ideals, have from the very beginning . . . dictated to and domineered over the brain and sinew of this nation. . . . The Southerner has succeed [ed] . . . in shaping the policy of this government to suit his purposes. Indeed, the Southerner . . . for two hundred and fifty years . . . trained to his hand a people whom he made absolutely his own, in body, mind, and sensibility . . . all became centers of myriad systems of repellent forces, having but one sentiment in common, and that their entire subjection to that master hand.[10]

Was this southern town unbearably too confining, racist, sexist and economically oppressive for Professor Cooper—the avid reader, prolific writer, critical thinker and outspoken activist? In 1887, when the Washington Colored High School offered Cooper a teaching position, "unsought thro [sic] the kindly offices of [her] Alma Mater," she jumped at the opportunity and accepted the job.[11] Washington, D. C. was to become her permanent home. She "immediately began, like the proverbial beaver to build a home, not merely a house to shelter the body, but a home to sustain and refresh the mind, a home where friends foregather for interchange of ideas and agreeable association of sympathetic spirits."[12] Cooper moved to Washington with two orphaned teenagers, John and Lula Love. These siblings' parents were friends of Cooper. She assumed guardianship of the two children after the death of their parents.[13] They attended M Street High School and later became teachers at M Street.

Cooper's arrival at M Street High School found her in familiar company. Her Oberlin alumni included George F. T. Cook, superintendent of

the District's Colored schools; Mary Jane Patterson, former principal of the Washington Preparatory High School 1871-1872 and 1873-1884, and a member of the teaching staff; Mary Church (Terrell) and later Ida A. Gibbs (Hunt), also teachers at the school.[14]

Another teacher at the school, who was not an alumnus of Oberlin but a Harvard graduate, was Robert Terrell. He would later become the husband of Mary Church (Terrell), resign as principal of M Street to accept a presidential appointment as a justice of the peace in the District, and even later be appointed the first Black judge in Municipal Court of the District of Columbia. Francis L. Cardozo, a graduate of Glasgow University, was the school's principal at the time of Cooper's arrival.

The M Street teaching staff was disproportionately female.[15] This was typical of most schools in the United States during this time. The percentage of women teachers in the United States increased from fifty-nine percent in 1870 to seventy percent in 1900.[16] Women teachers were in predominant numbers in major cities such as Washington, D. C.[17] "In the school year 1890-1891, the District of Columbia's public school system employed a total of 265 African American teachers, and of this number 40 were male and 225 were female."[18]

Gender played an important role in determining the employment opportunities of formally educated women.[19] "Teaching, which was perceived as a 'womanly job,' was the primary, if not only, professional occupation for college and normal school Black or White female graduates during the mid to late 1800s."[20] Also women who held medical, law or other professional degrees had some difficulty securing positions in their respective fields. Consequently, they accepted jobs as teachers.[21] "At the same time, educated Black or White men had greater professional job opportunities than educated women of either race."[22]

Economics as well as prevailing ideology supported the emergence of careers for women in education. "The new tax-supported public schools needed large numbers of inexpensive (therefore female) teachers and increasing numbers of women needed a source or income."[23] Mary Lyon, founder of Mount Holyoke Seminary, considered teaching to be respectable employment for women before marriage and "a profession in which she might remain if single" or in the case of Cooper, widowed.[24]

Even though teaching might have been a respectable occupation for women, it offered them a meager pay scale. According to historian Francis Donovan, female teachers were hired "primarily because [they] were cheap." Male teachers were always disproportionately paid more than female teachers because it was assumed that they had families to support.[25]

During the 1890s, the District of Columbia's public schools yearly

average salaries were $588.95 for grammar school teachers and for high school teachers $984.[26] African Americans were paid less than their White colleagues.[27] The year Cooper began teaching at M Street, the starting salary was $750.[28] Cooper, who had three years of teaching experiences by this time and a Master's degree conferred to her by Oberlin, was making $750 her first year. Indeed race and gender discrimination played a part in her starting at the lowest level on the salary scale.

Gender discrimination also played a part in school policies and the marital status of women. The District of Columbia public schools (as well as other public schools across the nation) required by law the barring of married women from obtaining a teaching position. It was thought that wives should be supported by husbands and leave employment opportunities to unmarried women. However, "those wives whose husbands were mentally or physically unable to earn a living or who had been deserted were granted employment as teachers."[29] Widows like Cooper were also allowed to teach. Those who married were required to relinquish their position according to the law. This was the case with Mary Church (Terrell). She was forced to abandon her teaching position when she married Robert Terrell.

The issue of resigning after marriage proved to be problematic for one woman. In a letter she wrote "to a member of the District of Columbia's Board of Education, express[ed] her opposition to the campaign to reenact the ban against married female teachers in the school system."[30] As explained by historian Harley, this teacher questioned

> why [female teachers] should be penalized for marrying after making tremendous sacrifices in order to advance themselves professionally. [She argued] that professional women's "personal obligations—to relatives, do not cease with their marriage and, therefore, [they] have legitimate reasons for continuing to work." Besides, she [argued], "in view of the high cost of living, the proposed motion would lead to secret marriages, fewer families, and fewer vacancies.[31]

Dedicated educators like Anna Julia Cooper, Mary Jane Patterson, and later Nannie Helen Burroughs, remained spinster schoolteachers for the rest of their lives, supporting families on their meager salaries.

Cooper arrived at M Street High School as an experienced teacher. She also had a Master's degree awarded to her by Oberlin in 1887 based on "evidence of three years [of] college teaching of classical subjects."

M Street High School was rapidly growing due to the fact that it was the only high school for African Americans at that time. The year Cooper

arrived, the school consisted of 361 students and nine teachers, exclusive of the art and music instructors. The following school year two more teachers were added to the staff.[32] The overcrowded classrooms were averaging 40 to 47 students per teacher.[33]

Despite the limited resources and the overcrowded classrooms, "Cooper found the administrative and teaching staff at M Street as well as its students highly motivated and intellectually stimulating."[34] Cooper worked under Superintendent George F. T. Cook, who was considered a strong, visionary and innovative leader and devoted educator.[35] Researcher G. S. Wormely notes that "Cook believed that the purpose of education must be to make not more efficient workers but better men and [women], better citizens, and better Christians."[36]

Historian Constance Green explains that "Cook sought to encourage students to reason rather than depend solely upon memory; he added classes in nature study and manual training to the curriculum and arranged field trips for students and teachers to the Library of Congress, the Smithsonian Institution, the zoo, and other places where children could learn by observation."[37] He also stressed the need to "present to the pupils . . . incentives to higher aim in education."[38]

These were innovative techniques for the late 1880s. Notwithstanding the periodic criticisms from the African American community and the Black press about favoritism in teaching appointments, Superintendent George F. T. Cook was "regarded and hailed as an educator who commanded the respect of the Black community."[39] Under his thirty-two year administration, the District's Colored Public Schools were successful in producing overwhelmingly large numbers of highly educated students who went on to pursue higher education.[40] The Colored High School standards and success in educating its students were higher than the two white high schools.[41] In 1912, the Reverend Francis J. Grimke, foremost scholar of the nineteenth century, pastor of the prestigious Fifteenth Street Presbyterian Church (1889-1929), community activist, and good friend of Anna Julia Cooper said the following about Superintendent Cook:

> How I wish we had more men like him today! . . . The schools, all in all, were never in better condition than under his administration. There never had been greater harmony in them; the teachers have never been more strongly drawn towards him; nor have they ever worked with greater freedom and with a greater sense of joy in their work than under his kindly guidance and supervision . . . Men might differ with him . . . but all respected [him]. . . . He was a man . . . of high ideals, of noble aspirations.[42]

As mentioned in Chapter 3, Francis Lewis Cardozo, the principal of M Street, was also a visionary and innovative administrator. Historian Willard B. Gatewood wrote that "few individuals had a more profound influence on the Colored High School and its development than Cardozo. He was described as a courtly gentleman, dignified in his bearing and polished in his manner."[43] During Cardozo's tenure as M Street's principal, the institution acquired a larger and better-equipped facility and emerged as the premier black preparatory school in America.[44] Gatewood notes that African Americans of the "aristocratic class throughout the nation often made great effort and substantial sacrifices for their children to attend Professor Cardozo's school."[45]

M Street High School was an anomaly, especially in reference to the educational level of its teachers and administrators. During the time Cooper was a member of the faculty, the overwhelming majority of the teachers had college degrees from "top-flight northern colleges and universities," a far larger proportion of highly trained educators than the white high schools in the District of Columbia.[46] In addition, it was not common for teachers during the late 1880s to have college degrees. Most had Normal School certificates.

The teachers at M Street were very committed and had fostered their students' intellectual ambitions.[47] According to many who taught and attended the school, the teachers "taught the students to believe in themselves and to believe that they could achieve."[48]

Mary Gibson Hundley, author of *The Dunbar Story: 1870-1955*, former student and teacher of Dunbar High School (M Street changed its name to Paul Laurence Dunbar in 1916), wrote that "the faculty at M Street and Dunbar was dedicated to the noble cause of training and inspiring youth, often contributing money and social uplift as the need arose during its daily contacts with students."[49] According to Hundley, "many teachers were sympathetic with the youth whose problems and aspirations they understood only too well."[50]

The majority of the teachers and administrators including Superintendent Cook lived in the same community as their students and they were "encouraged by a community where many parents of vision and determination kept their children in school . . . despite financial constraints."[51] Researcher Louise D. Hutchinson notes that the "parents fully appreciated the quality of education" that M Street provided and "they enthusiastically supported the school."[52]

Historian David Lewis stated that, "the [M Street and] Dunbar degree was not always a guarantee of brilliant success, but it was very seldom a passport to failure."[53]

M Street incorporated many of the elements that have been identified as contributing to successful schools. Research on successful, effective schools, conducted by the late Ronald Edmonds revealed that those schools shared the following characteristics: (1) a principal who is a strong instructional leader (2) a climate of high expectations in which no children are permitted to fall below minimal levels in an atmosphere that is orderly without being rigid or oppressive (3) an emphasis on the teaching of basic skills in a well-prepared classroom where students spend most of their time on clearly-defined tasks (4) a means of frequent monitoring of pupil progress.[54]

Administrators Cook and Cardozo were strong, innovative and visionary. The highly qualified teachers were committed, caring, supportive and empathetic. Their expectations for the students were high. Parents were very involved in the school and supported the teachers' and administrators' efforts.

M Street was inseparable from the community. Legalized segregation restricted the movements of middle-class African Americans. Thus, the affluent and the less affluent lived in the same residential areas. Administrators, teachers, and students living in the same community no doubt contributed to the success of the school and its students.

In her research on successful teachers, educator and researcher Gloria Ladson-Billings speaks from her own experience the following:

> . . . I went to urban schools that were bursting at the seams. . . . All of the children and most of the teachers were black. But the important thing was that the teachers were not strangers in the community. We students knew them and they knew us. We saw them at church, in the beauty parlor, in the grocery store. . . . Most importantly, the teachers knew our families and had a sense of their dreams and aspirations for us.[55]

Feminist researcher bell hooks also recalled having similar experiences with successful teachers:

> . . . my teachers made sure they knew us. They knew our parents, our economic status, where we worshipped, what our homes were like, and how we were treated in the family. . . . I was being taught by the same teachers who had taught my mother, her sisters, and brothers.[56]

In her book *Other People's Children: Cultural Conflict in the Classroom*, Lisa Delpit contends "if we [teachers / administrators] do not have

some knowledge of children's lives outside of the realms of paper-and pencil work, and even outside of their classrooms, then we cannot know their strengths. Not knowing students' strengths leads to our "teaching down" to children from communities that are culturally different from that of the teachers in the school."[57]

The M Street teachers of course, were from the same cultural background as their students but maybe not the same class background. However, they understood and valued the culture the students brought to the school milieu and no doubt were able to capitalize on their academic strengths. Research conducted by educator James Cummins reveals that "students are less likely to fail in school settings where they feel positive about both their own culture and the majority culture and are not alienated from their own cultural values."[58]

The communal attributes of M Street High School gave rise to academic successes at the school. Research on communal attributes has shown that the communal system can induce levels of productivity and cooperation when people are bound together by affection and commitment to a common cause.[59] Donald Erickson's comparative research on public and private schools, revealed that a communally strong school is characterized by: the mutual commitment of staff and students; consistency of interpersonal influence; the development of affectionate bonds between students and teachers; specialization and parent involvement; and a consensus of values among staff and students. According to Erickson, these aspects of communally strong schools result in reduced dropout rates, positive student self-concepts, and increased collegiate, occupational and social success later in life.[60]

World-renowned psychiatrist and founder of the School Development Program James P. Comer concurs. He argues that "those schools that are attuned to the Black community's history and needs represent one of the best opportunities to prepare more Black youth for successful performances in school and in life."[61]

"The foundation for all human agency as well as teaching is steeped in a commitment to the possibilities for human life and freedom."[62] In the de jure segregated Black high schools of the past, such as M Street, feminist bell hooks observes that there seemed to have been on the part of teachers and their pedagogical practices "a messianic zeal to transform [Black students'] minds and beings."[63] Acquiring knowledge was related to how one lived and behaved and was connected to an anti-racist struggle. "For Black children, education . . . was about the practice of freedom."[64]

Hence, it was in this environment that Cooper spent the majority of

her teaching years. Her professional and personal growth and development as an educator and individual was cultivated at this institution. At M Street, Cooper's educational philosophies and activities would be tested and eventually challenged.

Cooper plunged into teaching with "pluck and energy" her first year as mathematics and science teacher. For two school years (1887-1889), she taught the math and science classes. From 1889 to 1902, Cooper served as Head of the Latin Department.[65] As a teacher and later as a principal, "Mrs. Cooper" was recognized as a dedicated teacher and strict disciplinarian at M Street High School. She instilled in her students high ideals of scholarship, racial pride, and self-improvement.[66] She taught her students to believe in themselves.[67] A former student of Cooper's and later teaching colleague, Caroline Calloway, described "Mrs. Cooper" as "highly respected . . . [and] motherly with her pupils."[68]

Another former student and teaching colleague of Cooper, Ruth Hoffman King, spoke of her with considerable respect and recollected her kindness to and interest in her students.[69]

In later years, when M Street High School changed its name to Paul Laurence Dunbar (after the famous African American poet), a former student, La Verne West, who later also became a colleague of Cooper's, described her as the following:

> I first knew Dr. . . . Cooper in 1920 when as a student at Dunbar High School, I was a member of her . . . Latin . . . class. . . . I remember her eyes flashing as she read in Latin the queries, the patriot Cicero hurled at the maverick young nobleman . . . she would **become** [emphasis from text] Cicero and make us feel his courage. . . . She put her whole heart and complete dedication into the performance of her job of teaching, **demanding** [emphasis from text] attention and participation for her students.[70]

Seven years later as a teaching colleague at Dunbar High School, Mrs. West "found [Cooper] as the same gentle . . . but firm [teacher] in her requirement of excellence from her students. . . . By her own example, she showed the young girls with whom she came in contact that is was possible to be a lady and a scholar."[71]

Cooper was very involved in extra-curricula school activities. When the school changed its name to Paul Laurence Dunbar she wrote the words to the school's Alma Mater and her former student and later teaching colleague, Mary L. Europe, wrote the music.[72]

"She also took a special interest in M Street cadet corps. Each year the winning battalion of the intramural competitive drill was invited to her home for tea."[73] According to biographer Hutchinson, "Cooper believed that the cadet corps instilled pride and a sense of patriotism, and was one of its ardent supporters."[74] Hutchinson explains that the "cadets were a source of community pride as they marched in inaugural parades and performed at special functions on the White House lawn."[75]

"Members of the corps would become the nucleus for the first Colored Battalion of the National Guard, and would later earn great respect during the Spanish-American War."[76]

During her term as assistant principal, "Cooper instituted a course of weekly lectures to the girls on topics relating to personal and social improvement, which proved very beneficial."[77]

After fifteen years of teaching at M Street High School, the forty-year old Cooper was appointed principal on January 2, 1902. During these years, "she had won the distinction as a teacher of Latin and as a writer and lecturer concerned with the advancement of her gender and race."[78] Her appointment followed the resignation of Robert H. Terrell who accepted a presidential appointment as a justice of the peace in the nation's capital.[79] According to a published report in *The Women's Tribune*, prior to her appointment as principal, "Mrs. Cooper has been assistant principal . . . and her promotion was made in strict accord with the merit system . . ."[80]

Cooper was the last of the high school principals to serve under the administration of Superintendent Cook. When Cook retired, the dual positions of superintendent for Colored and white schools was abolished.[81] The Board of Education was authorized to appoint one superintendent for both the Colored and white public schools.[82] The new appointed superintendent was Alexander T. Stuart, a White male. Black and White males were appointed assistant superintendents for the Colored and white schools respectively.[83] Many new supervisory positions were also created by the Board of Education. One included a director of public high schools.[84] The new director for the high schools was Percy M. Hughes, a White male. He would later play a key role in Cooper's dismissal as principal of M Street High School.

As principal of M Street, Cooper continued many of the academic traditions that her predecessor implemented.[85] During her first year as principal, the student population was 530 pupils—of whom 130 were boys and 400 were girls.[86] The teaching staff was predominantly women, all unmarried or widowed no doubt. M Street during this time continued

to offer four-year classical studies curriculum, and a two-year curriculum.[87] According to Mary Church Terrell, the M Street curriculum was considerably changed and greatly enlarged under Cooper's administration.[88] The first-year students were required to take the traditional classical courses. Hutchinson notes that "English and Latin were the only required subjects for third and fourth year students." Some of the electives included French, German, Spanish, Greek, history courses, trigonometry, advanced geometry, chemistry, physics, and political economy.[89]

Hundley described "Mrs. Cooper [as] a woman of rare courage and vision, [who] reaffirmed the college preparatory goals and standardized the curriculum."[90] H. S. Robinson, researcher of M Street High School, argues that Cooper "strove unceasingly to prepare her pupils for successful admittance to non-segregated northern and mid-western universities, viz., Amherst, Brown, Harvard, Radcliffe, Oberlin, Yale, University of Pennsylvania, Cornel, Rutgers, Smith, Wesleyan and Western Reserve."[91]

During her tenure as principal, "M Street won recognition for the first time by Ivy League institutions, which gave scholarships to the graduating students."[92] "The graduating students were admitted directly into these institutions on passing rigid entrance examinations. Many of them successfully passed the required exams."[93]

Also for the first time "in the history of the Colored High School, it was listed as accredited by Harvard."[94]

Gabel explains that under Cooper's administration, "superior instruction was fostered by insistence on high standards of scholarship."[95] She made provisions for "special tutorials to prepare promising students for college entrance examinations."[96] "Some members of Cooper's staff applied to their own colleges for scholarships for their students."[97] Teachers appealing to their former college or university for scholarship aid "became a school tradition which continued until the mid 1950s."[98]

One year after Cooper became principal of M Street High School, Father Felix Klein, a professor from the Institut Catholique de Paris visited M Street.[99] He recorded the following research observations about M Street:

> I arrived . . . one morning, about ten o'clock, at the colored high school. . . . I espied [sic] near a staircase, this notice:
>
> Principal's room on the second floor" . . . seated in an office . . . was a negress [sic] pretty, young, and intelligent looking. I addressed her, explained the object of my visit. . . . She gave me an outline of the courses of study, answered my questions, and offered most graciously

> to show or to explain anything that might be of interest to me. . . . We entered the different classes without interrupting the work. . . . These young people seemed attentive, wide awake and intelligent. . . . I stopped in an English class where George Eliot's novels was being explained and where I heard some very satisfactory answers.[100]

Father Klein writes the following about a Latin class he observed:

> The Latin class contained sixteen pupils, of whom three were young girls . . . [Cooper] began to explain the first part of the Aeneid. Those called upon to recite acquitted themselves so creditably that I suspected a recent previous acquaintance with the passage . . . the explanation must have been followed with the closet attention and well remembered.[101]

Klein commented that "Professor Cooper gave excellent explanations of the poem Aeneid, Virgil's aim, of the historical and mythological allusions, the metre, the grammatical rules and the matter of the text."[102]

Upon leaving the Latin class, Klein observed the dismissal of other classes and was surprised at seeing the students "file by in ranks, two by two, in absolute silence."[103] Cooper explained "with such a large number of pupils, this is necessary for good order and for rapidity."[104]

The discipline record during Cooper's administration (particularly 1905-1906) illustrates the types of offenses for which the students were punished, i. e., bean shooting, cutting drill, fighting, smoking, trifling in study hour, banging the piano in the armory, disorder at a lecture, betting about books.[105] Forfeiture of recess was a form of punishment. A student was suspended for disrespect to a teacher. [106] Leaving drill without permission was also cause for suspension. Juvenile delinquency was not a problem.[107]

As Cooper and Klein ended the tour of the school she proudly informed him that,

> . . . the previous year she had been able to obtain for one her students a scholarship at Harvard University; and . . . she thought [this] . . . would be a splendid encouragement for a means of increasing the number of leaders who seek to elevate her race.[108]

In fact, during the course of her tenure as principal, Cooper had obtained seventeen scholarships and assisted twenty-eight young men and women gain admissions in the universities mentioned above.[109]

Klein was extremely impressed at what he observed at this segregated public school for Colored youth, that he made the final comments:

> To see these 530 young negroes, and negresses, well dressed and well-bred, under teachers of their own race, pursuing the same studies as our average college students, who would dream of the existence of a terrible race question in the United States?[110]

The glowing reviews Cooper received in Abbe Felix Klein's aforementioned book brought national and international attention to her work as a principal at M Street High School. This attention, Cooper writes, "caused a general raising of eyebrows in the United States and a few red faces in Washington, D. C."[111] One scholar notes that "many Whites were offended that Klein esteemed the Colored high school as the best high school in Washington . . . especially one [administered] by a Black woman."[112]

Cooper and Klein "maintained an amicable friendship over the years." Twenty years later, Klein would play a vital role in assisting Cooper in her pursuit of the doctorate degree from the University of Paris at the Sorbonne.

One scholar notes that "at the time Cooper became principal, Booker T. Washington's program of vocational and industrial training was emerging as the model for black education and consequently was playing into the prejudices of Whites who believed in black intellectual inferiority."[113] As noted by educational historian Linda Perkins "in a speech before the National Education Association in Madison, Wisconsin in 1884, Washington ridiculed Blacks who received a classical education. He referred to them as 'loafers'—with 'beaver hat, kid gloves and walking cane,' contributing nothing to their race."[114]

"Washington's educational program at Tuskegee Institute modeled that of Samuel Armstrong, founder of Hampton Institute, whose educational ideology stressed moral philosophy and the dignity of labor."[115] According to Perkins, "both the Hampton and Tuskegee Institutes had drawn considerable [funding] from Northern philanthropists primarily because of the schools' advocacy of African Americans remaining in the South, being apolitical and aspiring to those occupations that were considered honorable and most often menial."[116]

Perkins explains that as "Washington grew in prominence, he sought to reshape the thinking of Black educators concerning the needs of Black youth."[117] "Washington," she argues, "often stated that the best way to

solve the race problems was through the educational institutions such as Hampton and Tuskegee."[118]

Superintendent Stuart found it imperative to visit Tuskegee. Upon returning he recommended that Washington's "Colored" schools, in particularly M Street High School, be reorganized similarly to Tuskegee Institute.[119] The new high school director, Percy M Hughes, was apparently in agreement with this new plan because he asserted that the pupils of the M Street High School were "incapable of taking the same [classical] studies" as the students in the District's white high schools.[120] Hughes submitted a proposal to the Board of Education that would "give the pupils of this school [M Street] a course of study equal to their abilities."[121]

Cooper adamantly opposed any lowering of academic standards at M Street and fought to keep the curriculum classical and college preparatory.[122] Cooper initially won "the fight to keep the existing curriculum at M Street High School, and the District opened up Armstrong High School as a vocational institution in 1902."[123] However, Cooper's position on keeping M Street an institution for classical educational training not only placed her on a collision course with Stuart, Hughes and the Board of Education members, but it also located her in the camp of supporters of the traditional classical curriculum led by W. E. B. Du Bois.[124]

Du Bois, Booker T. Washington's harshest critic, maintained it was unrealistic to conclude that "industrial education would give rise to the elevation of the black race to its full humanity," eliminate class oppression, and bring about racial synergy as long as institutional structures preclude such possibilities.[125] He took the position that Blacks needed a "training designed . . . to make them men of power and thought."[126] Du Bois believed that a curriculum based in the classical arts would allow for the development of one's fullest God-given "power" and potential.[127] "Washington found it necessary to accommodate the demands of the White power structure in the South as it related to Black progress."[128] As educational historian Gerald Gutek points out, "Du Bois on the other hand, took a larger and more universal world view as it related to the social, political and educational progress of Black America by arguing" the following:

> Whatever their region of residence, Blacks throughout the United States were entitled to the same political, legal, and educational opportunities and rights enjoyed by other Americans; Blacks in the United States did not live in cultural isolation from Black people in other parts

of the world; and sharing a common racial ancestry and cultural heritage, American Blacks and Africans should embrace a pan-African world-view.[129]

Gutek explains that,

unlike Washington, who advised Blacks to avoid political activism and membership in labor unions, Du Bois, who had Marxist inclinations, believed that they shared a common agenda with the American working class to end economic exploitation. Also, unlike Washington, who sought to raise the economic position of Blacks by a slow but egalitarian climb up the economic ladder, Du Bois believed it necessary to educate an elite leadership group—the "Talented Tenth," to be the vanguard of African Americans.[130]

Returning to the M Street situation, Gabel aptly observes that "Cooper's victory did not silence opposition; her opponents still had ways of dealing, if not with the school, then with a principal committed to a rival educational philosophy."[131] Percy M. Hughes brought charges of insubordination against Cooper due to her educational views. Her position and educational beliefs eventually led to her dismissal as principal of M Street High School.

## THE CONTROVERSY

On October 30, 1905, "Mrs. Cooper" was brought before the District's Board of Education to face the following charges: failing to adopt the District's authorized history textbooks; failing to demote "unqualified" students; employing "sympathetic" teaching methods to help "unqualified" and "weak" students to pass the high school curriculum, in other words, she did not "maintain a proper standard" of evaluating and grading students who had difficulty with the high school curriculum; not being able to enforce and maintain discipline, especially in light of the fact that two students had been caught drinking; not maintaining loyalty to the director of high schools (Percy M. Hughes); and lack of "proper" spirit of unity and loyalty among the faculty.[132]

It had also been rumored that the forty-six year old widowed Cooper was having an affair with a young thirty-six year old bachelor (John Love) who was a M Street teacher and a resident of her home. These rumors were also used to tarnish the image of Cooper as an effective, ac-

ceptable teacher and administrator. It needs to be stressed that there were other single female teachers also residing in her spacious home as board-ers. John Love, who was also Cooper's foster son, continued to live with his foster mother.[133] Students at M Street were very much aware of Cooper and Love's closeness. As researcher Mary Helen Washington points out, that one former student stated that "some parents went so far as to refuse to let their children study Latin under Cooper because of the [alleged] affair."[134]

Feminist scholar Beverly Guy-Sheftall and researcher Mary Helen Washington explain, that the Victorian "social doctrine" of the day dic-tated a standard of conduct for women that not only confined them to the private sphere but also attempted to control and repress women's sexual and social behaviors—no matter how innocent; as in the case of Cooper, sexuality had to be contained and repressed.[135]

Indeed, unmarried women educators were quickly dismissed if they broke strict Victorian rules imposed on them by a given Board of Educa-tion. During this time, female teachers were not allowed to marry during their contract; keep company with men; ride in an automobile with any man unless he was their father or brother; smoke cigarettes; dress in bright colors; or dye their hair. They had to wear at least two petticoats and their dresses had to be no shorter than two inches above the ankle.[136]

John Love was in fact in love with Cooper and wrote numerous love letters to her after he moved to Kansas City. In the letters, he confessed his love for her and asked for her hand in marriage. He too was eventu-ally dismissed from his teaching position along with Cooper. The reasons are not clear. Cooper's great-niece, Mrs. Regina Bronson, threw the love letters away years after Cooper's death and stated that Cooper confided in her that she "was fond of him but not as a sweet heart [only as her foster son] . . . she always love her husband and . . . would never marry again."[137] Mrs. Bronson also stated that "Sis Annie" did not have time for love in her life. "She was so concerned about the education of people."[138]

The Board praised Cooper for being "a woman of good intellectual attainment, . . . high moral character, and of excellent reputation among her people;" however, the main charges levied against her was she had "too sympathetic feeling[s] for the weak pupils under her care."[139] They noted that "while this sentiment may be commended in itself . . . we are clearly of the opinion that it should not prevail to the prejudice of proper standards of work in a high school."[140]

Cooper and the "M Street School Controversy" drew city-wide attention and received extensive coverage in the *Washington Post*, *The Washington Star* and the *Washington Bee* from 1905 to 1906. The African American newspaper editorials came out in consistent support of Cooper while at the same time criticizing the Board.[141] She also received an outpouring of support from students of M Street; parents of M Street students; and leaders of distinguished citizenship, including the president of George Washington University and leaders of numerous organizations and churches.[142]

After a year of disputes and investigations, the Board failed to produce any proof of the allegations brought against Cooper. However, they proceeded to vote to dismiss Cooper effective September 14, 1906.[143]

Educator and author Horace Mann Bond argued that Cooper's problems arose when "she aligned herself with the Du Bois group and succeeded in keeping M Street's curriculum that of the standard college preparatory school of the time."[144] In a series of articles written by the *Washington Post*, the paper seemed to assert that Cooper's problems could be traced to her inviting W. E. B. Du Bois to give a lecture before a group of students at M Street in the winter of 1902-03.[145] According to the *Washington Post's* article, in his lecture, Du Bois "called attention to the tendency throughout the country to restrict the curriculum of colored schools."[146] Du Bois strongly held the belief that institutions of Black higher education should be vehicles in which they would revolutionize the existing economic and cultural order.[147]

In his extensive research and analysis into the factors behind Cooper's dismissal, educator, scholar and former Dunbar High School student, Dr. Paul Philips Cooke concluded, "with all the evidence—both facts and judgments—the reasons for Cooper's dismissal cannot be unequivocally established."[148] However, he concluded the following about Cooper's dismissal:

> Cooper . . . fell to the wave of industrial education. Those who opposed the academic program could not destroy M Street High but could be rid of Anna J. Cooper. Similarly, the general belief that Negroes were inherently inferior and that in general should be subordinate to whites [was] also served by her dismissal. The charges—about the texbooks, the two inebriated students, the occasional unqualified child, the aid to weaker students, did not warrant dismissal. The argument for the male principal is not strong. The support for her character vitiates the linking of Cooper with John Love. . . . I conclude that

Anna J. Cooper lost out because she represented a substantial force against the view of what Negroes should be.[149]

Cooper seemed to believe that sexism, racism and her educational views were factors behind her dismissal.[150] She confided in her niece that she believed that the Board wanted a man as principal for the school.[151] However, Dr. Cooke's investigation into the factor revealed no strong evidence. Cooper also believed, to use her words, that the 'industrializing wave' (a.k.a. "The Tuskegee Machine"), that was sweeping the South and threatening the curriculum at M Street High School influenced her dismissal."[152] Cooper contended that her dismissal was "unfortunate and unfair" especially due to the fact that she espoused different educational views about educating Black youth. She argued that

> . . . no people can progress, without vivifying touch of ideas and ideals. The very policy of segregation renders all the more the necessary leadership that has been on the Mount. If any group or class cannot be allowed living contact through seeing, hearing, feeling the best of life in their day and generation, there is no compensation morally or socially except to let them find their thrills through the inspiration of the broadest education and generously equipped schools.[153]

To comprehend fully the dynamics of the M Street situation, one needs to link and deconstruct the relationship between education and the capitalist economy. "The political space that education occupies," argues critical educational theorist Peter McLaren, "de-emphasizes the struggle for teacher and student empowerment. Furthermore, "it serves to reproduce the technocratic and corporate ideologies [or during that time industrial capitalist ideologies] that characterize dominant societies."[154] Educational programs are "designed to create individuals who operate in the interests of the state—whose social function is primarily to sustain and legitimate the status quo."[155] Educational programs correspond to the demands of industry thereby reproducing in schools the existing class, race, and gender relations in our society.[156]

Underlying Percy M. Hughes, proposal to reorganize and restructure M Street with the implementation of an industrial education program, was a design to prepare Black students' lives that would fulfill the expectations of the segregated order—lives based on racial and gender oppression and economic subordination. Cooper was not opposed "to industrial training

as such but to the proposed supplanting of the classical curriculum at her school and elsewhere by an industrial program supposedly more realistic and appropriate for Blacks."[157] Also Cooper got fired because she chose to employ her own methods, which she called "sympathetic" to assist "weak" students in their achievement. In addition, she and her staff collectively decided against using the Board adopted text-books instead used the one she felt was more appropriate for her students' level.

McLaren points out that too often in the public school setting, teachers are stripped of their decision-making potentials because, from the perspective of school boards, the state etc, teaching is viewed as "nearly synonymous with executing pre-fashioned methodologies and delivering prepackaged curricula."[158] When Cooper challenged the status quo by refusing to be what critical educator Henry Giroux calls a "clerk of the empire," she was in effect attempting to empower her students and teachers' "dreams," "desires," "voices," and rights to have access to an equitable educational experience. This kind of teaching not only reflects a revolutionary pedagogy of resistance but also a form of Black feminist activism essential to the struggle for group survival and institutional transformation.[159]

Cooper left M Street "suffer[ing] . . . the punishment of the damned from both the White masters and the Colored understrappers." She left, however, "stand[ing] on the double foundation stone of [her] Alma Mater—'Labor and Learning'—unrestricted and harmonious, without clash and without cliques, simply, for [her] people and for all people a man's chance to earn a living not dissociated from man's first right and highest prerogative—to live."[160]

Cooper headed to the Mid-west to teach foreign languages at Lincoln Institute in Jefferson City, Missouri.[161] She remained in "exile" for four years. In 1910, the new Superintendent asked Professor Cooper to return to teach Latin at M Street. She accepted the offer and remained until her retirement in June 1930.

Cooper's "innate and indomitable" spirit "to want to know more" found her in the classrooms of Oberlin College during the summers she was in "exile." "It was pleasant to spend the summers of those four years in Oberlin, she said, "the college of so many happy memories. I contented myself with stimulating courses in belles lettres."[162] Her enjoyment of learning also included study and travel abroad in Paris, France at the La Guilde Internationale. Cooper had a strong desire to pursue doctoral studies but Oberlin did not offer such a degree. Consequently, her pursuit took her to Columbia University in New York. On July 3, 1914,

she became matriculated.[163] She studied during the summer sessions, "completing two full courses each session, four points each, [thereby meeting] the required number of . . . credits."[164] With her course work behind her, Columbia certified her proficiency in French, Latin, and Greek. She had also completed all course work in the French language, including Old French and French literature. There was a required research project that she had to complete. Cooper successfully completed this project which was the preparation of a college edition of the "*Pelerinage de Charlemagne*," an epic of the 11th Century.[165]

Unexpected family problems interfered with Cooper completing the one-year residency requirement at the University. Cooper began caring for the grandchildren of her brother because he was seriously ill.[166] Regia, John, Andrew, Marion, and the baby Annie Cooper Haywood ranged in age from twelve years to six months.[167] Baker-Fletcher points out that the "middle-aged Cooper was determined to fulfill two callings she viewed as 'most noble': motherhood and teaching."[168] Her "other mother" role did not deter her from pursuing her dream of obtaining a Ph.D.

Through the help of her friend Father Felix Klein, Cooper was able to transfer her units to the Sorbonne. Consequently, five years prior to her retirement, she was awarded a Ph.D. from the Universite de Paris at the Sorbonne on March 23, 1925 at the age of 66. The Alpha Kappa sorority sponsored an event that recognized Cooper's accomplishment of obtaining a doctorate. This event was held on December 29, 1925, at Howard University.[169] At that ceremony, Cooper stated the following:

> . . . surely no deeper joy can come to any one than the pure pleasure of this moment in the expression of appreciation on the part of the community where the best service of my life has been given. In the language of my favorite [writer] Cicero, "nothing dumb can delight me." I ask no memorial in bronze. There is nothing in life worth striving for but the esteem of just men founded on the sincere effort to serve the best of one's powers in the advancement of one's day & [sic] generation.
>
> . . . I take at your hands . . . this diploma not as a symbol of cold intellectual success in my achievement at the Sorbonne, but with the warm pulsing heart throbs of a people's satisfaction in my humble efforts to serve them.[170]

Her dissertation, *L'Attiude de la France a l'egard de l'esclavage Pendant la Revolution*, is a study in "French relations between the eigh-

teenth century revolutionists of Paris and representatives and inhabitants of the riches of French colonies, Santo Domingo, now Haiti."[171] As explained by Baker-Fletcher, Cooper argued that the abolition of slavery "became a major issue during the French Revolution and revolutionary France could have avoided the loss of Haiti as a province if it had been consistent in its principles on human rights."[172] Cooper argued that

> legal slavery and the trade in slaves became a major issue that epito-
> mized other issues in the struggle over the rights of all citizens during
> the French Revolution. When the revolutionists of Paris deflected the
> question of slavery in Santo Domingo, the people of France lost the op-
> portunity to escalate their liberty and their equality. . . . It was tragic,
> she contended, that France abolished slavery not by appeal to moral
> law and legislation but in response to violent revolution.[173]

Her dissertation reflected her broad knowledge, sound scholarship, and interest in Pan-Africanism.[174]

## ANNA JULIA COOPER'S PRESIDENCY AT FRELINGHUYSEN UNIVERSITY

> *The ideals & [sic] purpose of a life-struggle
> take concrete form & [sic] substance in the
> foundation of the Hannah Stanley Opportunity
> School of Frelinghuysen University for Em-
> ployed Colored persons.*
> —ANNA JULIA COOPER, 1932[175]

On June 15, 1930, Cooper was inaugurated the second president of Frel-
inghuysen University in Washington, D.C. She served as President until
her retirement in 1941. However, she continued to work at the school as
Registrar until 1949. Cooper allowed six rooms of her spacious home to
be used as classrooms and the library.[176] Frelinghuysen University was
founded in 1906 after a conference held to discuss the needs of the Negro
race. Jesse Lawson created the school for Employed Adults who sought
educational opportunities denied them during their youth.[177] Originally a
network of schools in buildings and homes throughout Washington, D.
C., Frelinghuysen offered a complete high school education and college
work on the undergraduate and graduate level. The college courses in-

cluded liberal arts, sociology, applied science, fine arts, applied Christianity, theology, law, and pharmacy.[178]

Due to financial problems, the school stopped conferring degrees after 1929. The school also had problems securing a permanent location. Cooper finally decided to house the school in her home in the fall of 1931.[179] That following Spring of 1932, Cooper decided to bequeath her property to the School in order to keep it financially afloat. In a letter to her best friend Francis Grimke, she wrote the following:

> I . . . seek to interest you in the work I am now doing & [sic] what I expect to be the final disposition of the property I have built up thro [sic] my labor & [sic] self-sacrifice . . .
>
> I have chosen seven trustees . . . to carry out the terms of my last will & [sic] testament regarding the property to serve for life, vacancies to be filled by unanimous vote of the six survivors.[180]

Cooper, along with the seven trustees, established an annex to Frelinghuysen named after her mother, the Hannah Stanley Opportunity School (HSOS). Work that was offered at the School was confined to HSOS for unclassified adults, and to the Frelinghuysen School of Religion and Law.[181] As noted by researcher Melinda Chateauvert, the School had a broad appeal because it "emphasized both Booker T. Washington's trade and semi-professional training approach and W. E. B. Du Bois' push for professional education."[182]

Research conducted by Melinda Chateauvert revealed that Frelinghuysen was different from other post-secondary institutions in that it was "designed for the non-elite population;" it scheduled night classes so that "working people could participate"; it implemented a "home college whereby classes were held at various convenient locations to eliminate long distance travel to and from classes"; and the tuition fee was very low and affordable.[183] Under Cooper's administration, the school was "supported by tuition paid by its students, half of which [went toward] teaching & [sic] other half for running expenses."[184]

If the Dunbar experience thwarted Cooper's efforts in implementing her philosophies about education, her presidency at Frelinghuysen University allowed her the freedom and autonomy to set her philosophies in motion.

Cooper brought to this institution many years of successful teaching, organizational and administrational skills and a strong sense of commitment to her students. Cooper wanted Frelinghuysen to be an

institution that would enable its students to "stand on their own feet [and] pluck the fruit of the Tree of Knowledge ... not for self-centered exploitation or childish glorification, but as a high responsibility for thoughtful investments in service for the common good."[185]

In a letter to Dr. Larned of the Board of Education, Cooper wrote her thoughts and feelings about why she considered the position:

> While there are for white adults in Washington several universities and colleges for men and women of means, some five or six night schools ... to meet the needs of ... those who are otherwise workers by day, there is absolutely no door open to the struggling colored man or woman, aspiring for the privileges of advanced education and not able to make the hours scheduled at Howard. ... We are poor, our constituency is poor, and it is hard ... to realize what this means.[186]

Cooper believed in the School's goals and felt that it would "provide the educational opportunities to those who had been shut out of other schools because of their race, [class,] work schedules [and] lack of financial" means.[187] She was committed to making the school a beacon of hope—a school that would uplift the masses from illiteracy and despair. She wanted "Frelinghuysen to represent the ideals [she] ... stood for & [sic] worked for & [she] plann[ed] to devote it to the education of colored people ..."[188]

For Cooper, the goal and purpose of Frelinghuysen would be to reach the "lowest down, the intentionally forgotten man, untaught and unprovided [sic] for either in the public schools for all classes or in the colleges and universities for the talented tenth ... "[189]

The students who attended Frelinghuysen were native Washingtonians. As noted by Chateauvert, unlike Howard University students, whose parents had professional occupations, the parents of Frelinghuysen's students "were illiterate and employed in a variety of low-paying service jobs. Many of their fathers were janitors and porters. Their mothers were domestic laborers and charwomen."[190]

As mentioned previously, many of Frelinghuysen students worked. Their jobs included vocational positions or other semi-skilled jobs. Chateauvert notes that an alumnus of the school was described by friends as a "self-made man who began life as a bricklayer."[191] Former legal studies students found employment in the Treasury Department of General Printing Office.[192] Chateauvert points out that men were the majority of Frelinghuysen's students. She postulates that perhaps the

"school's curriculum, which trained students primarily for low-level professional jobs opened to Black men during the 1930s," is the reason why male students were in predominant numbers. In addition, she notes that the "evening course schedule probably prevented employed married women's participation because of family and work obligations."[193]

The School was having problems becoming accredited. Numerous supporters of the School employed various methods to help keep the School open. Chateauvert explains that

> ministers from local churches regularly lectured the theology students and taught the less orthodox Christian courses. Professor Sterling Brown of Howard University willed his entire library to the School and Dr. Carter G. Woodson, founder of the Association for the Study of Afro-American History, supervised the completion of one student's master's degree in history.[194]

To keep the financial expenditure at a minimum, Cooper accepted a salary of $50 dollars a month and her teachers worked for little to no pay.[195] In spite of the efforts to keep the school afloat, Frelinghuysen permanently closed it doors in 1964.

Anna Julia Cooper dedicated her life to many years of teaching Black youth and adults. By the time she was 100 years old, her experience in the field of education encompassed the reconstruction to the *Brown v. Board of Education* 1954 decision. When asked her opinion of the Brown decision, during a newspaper interview, she replied, "I'm against it." She argued that "under the segregated systems, Black children were taught to take pride in themselves and the achievements" of their heritage. "Desegregation meant that loss of race-conscious education."[196]

As explained by feminist bell hooks' personal experience in segregated schools, Cooper was aware of the fact that "when Black children entered racist, desegregated, white schools, they left a world where teachers believed that to educate Black children rightly would require a political commitment."[197] Gloria Ladson-Billings explains her experience in the segregated schools she attended:

> It never occurred to me in those days that African Americans were not a special people. My education both at home and at school reinforced that idea. We were a people who overcame incredible odds. I knew that

we were discriminated against but I witnessed too much competence—
and excellence to believe that African Americans didn't have distinctly
valuable attributes.[198]

hooks argues that Black children in integrated schools were "taught by
White teachers whose lessons reinforced racist stereotypes. For Black
children, education was no longer about the practice of freedom."[199]
"The politics and pedagogy was not counter-hegemonic. School in inte-
grated environments became a political place where Black children
countered racist assumptions about their genetic inferiority."[200]

Later, in the same interview, Cooper reflects on her life's experience
by stating, "It isn't what we say about ourselves, it's what our lives stand
for."[201] Unwavering, pertinacious commitment and dedication to educa-
tion and social justice characterize what her life stood for. For Cooper,
education was a liberating force in the Black community, a force needed
to resist the interlocking structures of oppression that characterized the
lives of African Americans.

Cooper died in her home on February 26, 1964 at the age of 105.[202]
"After a simple service held in Saint Augustine's College Chapel, she
was buried at her request beside her husband in the Colored section of
the Raleigh City Cemetery."[203] Twenty-four years prior to her death, Dr.
Cooper wrote the following sentimental poem:

### No Flowers Please

*Oh just a rose perhaps, a few violets*
*or even a handful of wild honeysuckle*
*or star of Bethlehem & sweet alyssum*
*which says you remember kindly.*
*For this I shall thank you, wherever I am. . . .*
*But please, please, don't pass the hat for big florists offerings. . . .*

*No flowers please, just the smile of sweet understanding,*
*the knowing look that sees beyond and says*
*gently & kindly Somebody's teacher on vacation*
*now—resting for the Fall opening.*[204]

During the 1980s, the District of Columbia named a street, *Anna J.
Cooper Memorial Circle* (3rd and T Streets, NW), in honor of this for-
mer neighborhood resident. The street is located in a landmark commu-
nity called *LeDroit Park*.[205]

## NANNIE HELEN BURROUGHS

Two years before Cooper became principal of M Street High School, Burroughs attended the National Baptist Convention in Richmond, Virginia in 1900. At the convention, she gave a speech which "expressed the discontent of the women and spoke of their desire to work with the men in the Christian evangelization of the world."[206] As a result of her speech, The Women's Auxiliary to the National Baptist Convention (WC) was established and Burroughs was elected Corresponding Secretary.[207] One year later, in January 1901, Burroughs appealed to the WC to build a Training School for Women and Girls. She argued that "the age in which we live demands that we have well-trained men and women in all walks of life."[208] She also argued that "that preparation of our women for domestic and professional service, in the home and communities, ranks next in importance to preparing their souls for the world to come."[209] Thus, "the object of the school shall be to (1) train women for mission work in this and other lands (2) prepare women as teachers of the Word of God in our Sunday schools (3) train them to give better domestic service."[210]

After many years of arguing her position for a school, the WC and the National Baptist Convention agreed to establish a school. The National Training School Committee was formed in 1906. Eighty members, predominately women, were on the Committee.[211] The "school must be on a hill," stated Burroughs, "it will be God's hill."[212] Biographer Earl L. Harrison wrote that "she . . . came upon an eight-room house on a hill [that included a barn, a stable, a well and fruit trees] . . . a for sale sign was attached to six acres of land, overlooking the capital of the nation [in Washington, D. C.]."[213] The Spirit of the Lord informed her that "that was the site."[214] The sale price of the property was "$6000 and $500 that was to be paid in ten days and a second $500 in twenty days."[215]

Burroughs received no money from the WC or the National Baptist Convention, thus she raised the money herself from her "own people."[216] Maggie Lena Walker, an African American and the first woman bank president in the United States, donated $500 to be put toward the down payment. According to Burroughs, many poor women contributed money toward the purchase of the property also.[217] Within 30 days, Burroughs was able to raise $1000.[218] In 1907, the WC secured a charter, independently of the National Baptist Convention, and underwrote the purchase of six acres of land on a hill as the site of the future school.[219] The by-laws of the charter of the School placed control of the School in the hands of a Board of Trustees made up of members in good standing

in regular Baptist churches.[220] The Charter also stated that "the Board of Trustees shall have the power to sell, the property, provided the sale has been ratified by two-thirds vote of the Woman's Auxiliary and the National Baptist Convention in a joint session at annual meetings of the convention" [given three month's notice].[221]

The National Training School for Women and Girls (NTS) opened, debt free, with seven students, five assistants, a matron and teachers "in the areas of mission work, academics, sewing, and music."[222]

Classes were held in an eight-room farmhouse.[223] The total enrollment for the first year was 31. Many of the students came from various parts of the United States as well as from various countries in Africa, Central America and the Caribbean.[224]

The first year the School was in operation, Burroughs faced many obstacles but she managed to persevere and sought creative ways to solve her problems.[225] Biographer Aurelia Downey describes the creative ways Burroughs attempted to solve her problems in the following:

> When the weeds were about to take over the place, she cut them down. When the hill was about to wash away down the gulleys and into the valleys, she filled them in with top soil; when the food was short, she planted a garden and canned the fruits and vegetables; when there were meatless days, she raised pigs; when the butter was short, she milked the cows and churned the butter; when the pump became impaired and there was no money to hire a plumber, she brought water from the spring at the foot of the hill for a whole winter in buckets and tubs to fill the tank at the top of a three story building; when classroom and dormitory space became limited, she converted the barn and stable in the back of the house into classrooms and dormitory use.[226]

At the end of the first year of the school's operation, Burroughs had raised $3,627.32 of which the WC gave $405.51 at their annual meeting.[227]

The School started on the sixth grade level. As the institution grew, Burroughs revised the curriculum to meet the changing needs of the times and of her international student body. Consequently, the academic program expanded gradually to the junior high level, high school level and by 1929, the junior college level.[228] Also by this time, the enrollment had increased to 140. The School offered a teacher's preparatory program and trade and professional courses.[229] NTS was advertised as a single-gender (females only) Christian school.[230]

The courses offered those early years of the School's operation included missionary training, sewing, typing, shorthand, English, drama, bookkeeping, music, public speaking, and gardening. Gradually, the expanded courses correlated with trades and professional courses, which also included Christian social service.[231]

"Printing was added to the curriculum with the opening of the Trades Hall."[232] The Trade School offered courses in business, practical nursing, beauty culture, domestic science and home economics, waitressing, household management, millinery, dressmaking, tailoring and laundering just to name a few. Burroughs decided to build a laundry facility in order to save money that was spent sending laundry out. The "laundry served the School and others outside of the school environment. The laundry also provided not only classroom training opportunity" for those students working in it, but also "it enabled less fortunate girls to work their way through the School and earn spending money."[233]

Burroughs was a strong advocate of teaching Black history in her School as well as the need to teach it in all schools that educate predominately African American children.

Courses in Negro History were core requirements at her School. Every student was not only required to complete courses in Black history, they had to pass a written and oral examination at the end of the courses.[234]

The textbooks that were used for the Black history courses were authored by Dr. Carter G. Woodson. Woodson was a scholar, educator, "Father of Negro History Week," and founder of The Association of the Study of Negro Life. The School had a special library for studying and disseminating information pertaining to Black history.[235] Burroughs strongly believed that African Americans had a duty to learn their own history in order to have a sense of racial pride. She also believed that Whites had a duty "to learn the spiritual strivings and achievements of a despised but not inferior people."[236]

In addition to learning the three R's, the students had to live by the three B's and later the three C's. The Bible, bath and broom were the school's motto. "The bath and broom symbolized training in cleanliness and housekeeping skills as part of racial advancement."[237] It was also illustrative of Burroughs' religious beliefs. For she believed that "cleanliness is next to Godliness" therefore she could not "conceive of any industrious woman being dirty, even at her work."[238] The three C's symbolized Culture, Character, and Christian Education.

Burroughs awarded prizes for "academic achievement and desirable personality traits, such as industry, common sense, cooperation, dependability, honesty and initiative."[239]

A 1925-26 school brochure described the "special aims and objectives" of the school:

> The school's special aim is the full development of true womanhood. The training is therefore designed to make its pupils keen of vision, alert in action, modest in deportment, deft of hand, and industrious in life.
>
> Our objectives are:
>
> To give personal attention to the whole life of the girl—health, manners and character as well as to the mind.
>
> To prepare girls to preside over and maintain well ordered homes.
>
> To build the fibre [sic] of a sturdy moral, industrious and intellectual woman.
>
> To prepare leaders by emphasizing honor, orderliness, precision, promptness, courage.
>
> To train woman in the art of homemaking and housekeeping.
>
> We keep in close touch with the masses, study their condition and shape our curriculum to meet the actual needs of the race.[240]

The aims and objectives of the School changed very little over time. Burroughs always insisted upon high standards for her students. She wanted her students to be successful in school and in life especially if they mastered the following three key concepts: (1) every task is a test, (2) we specialize in the wholly impossible—doing the things no one else can do, (3) no matter how trivial the job, the way you do it works for or against you.[241]

Students from ages fifteen to eighteen were accepted into the school. All of the students at the school were boarders. "There were three dormitories [and] two were used as classrooms."[242]

In 1934, Burroughs changed the school name to the National Trade and Professional School for Women and Girls (NTPS) because there was another school in the District of Columbia that had the same name. The other school's "program was specifically designed for girls with problems."[243] NTPS was inactive during the Depression of the 1930s. After a period of closure, Burroughs reopened the School and continued to direct it until her death in 1961.

The type of students Burroughs admitted into the School were young ladies who exhibited "promise and ambition . . . good character,

good health, and good scholarship." Students who were "delinquents" or "problems" were not accepted "under any circumstances."[244]

Black women college graduates from various parts of the United States applied to come teach at the School.[245] The prospective teachers were "selected on the basis of Christian character [and] professional fitness."[246] Teachers had to exhibit "definite interest in the growth and development of the students, fitness of spirit and excellence in social behavior."[247] Prospective teachers had to be committed and dedicated to "A Cause Like This," to use her words, which meant teamwork, cooperation and vision. The "Cause" also required teachers to "(1) know young people's character ideals [and] (2) influence them."[248]

Her teachers were expected to "bring . . . high standards of conduct" to the teaching profession as well as "uphold and promote the honor, dignity and effectiveness of teaching."[249] "Teachers who did not set good examples" according to the Code of Ethics established by NTPS, "or who did not abstain from smoking, drinking, and similar adult Victorian vices were dismissed at the end of the school year."[250] The teachers employed at the school were predominantly African American women. The pay was low and the majority if not all of the teachers lived on campus. The one White teacher resided off campus. Burroughs lived on campus as well.[251]

According to Easter, a former student of NTPS described the campus as beautiful. Students were given the freedom, even in this somewhat Victorian Christian environment, to study outside under the trees.[252] As explained by Easter, "Burroughs mingled with the students and knew them all by name." She would inquire about family members, and other matters on a personal level. "She would counsel them about their grades, join them for breakfast and lunch" and give them "gifts for Christmas."[253] Burroughs "knew how to make her students feel needed, wanted and appreciated. She expected the very best from them and got it."[254] As noted by biographer Aurelia Downey, Burroughs' students were very loyal and supportive of her. Burroughs, who was "tall and erect," wore "beautiful blouses with puffy sleeves and high collars, and long dark skirts."[255] She smiled a lot and was very motherly with her students.[256] "Miss Burroughs" was also a strict disciplinarian. "Student violators were summarily expelled from NTPS with her terse farewell: The arch [referring to the gate at the main entrance] is open, the trains are running, and God bless you."[257]

## IDEAS ABOUT WOMEN'S EDUCATION: THE NATIONAL TRAINING SCHOOL

Burroughs dreamed of a school that would educate all women regardless of class background and denomination, hence she "deliberately excluded the word 'Baptist' from the school's name" to emphasize the school's open door policy.[258] Also, her sincere "concern for the working poor" and the "lack of employment options for African American women led her to establish an industrial school rather than a classical liberal arts institution."[259] By 1900, "nine out of ten African Americans still lived in the South, primarily in the Cotton Belt, 80 percent of whom resided in rural areas."[260] Burroughs was aware of the fact that work options for Black women were limited to domestic labor, laundry work, cooking, and agriculture labor in the late nineteenth and early twentieth century.

Indeed a "woman's race, class, and geographical location determined the nature of her daily experiences, such as her participation in the labor force, her access to education, and her life expectancy."[261] In the largest southern cities, from 50 to 70 percent of all adult Black females were gainfully employed at least part of the year around the turn of the century.[262] "Many more Black women were employed than White women—54 percent as compared with 17 percent by 1910."[263] As noted by historian Jacqueline Jones, "the marital status of Black women did not affect their labor force participation rate, as was the case with White women. African American married women entered the work force five times more often relative to White wives due to the fact that the lack of job opportunities for Black men caused their wives to leave their families to search for work."[264]

During the period under consideration, Black women constituted the vast majority of domestic servants in southern cities.[265] "Seventy-six percent worked in agriculture, 66 percent were laborers who performed unspecified jobs, and 65 percent were laundresses."[266] Jones' research reveals that between 1900 and 1930, "large numbers of African Americans left the South—to escape the oppressive sharecropping system, disenfranchisement and Jim Crow laws, and migrated to the industrial Northeast and Midwest."[267] A significant number of Black women migrated to the nation's capital "in search of better paying employment."[268] According to historian Sharon Harley's research, "by 1900, slightly over one-half (54.4 percent) of all Black women in the District were single or widowed compared to 47.1 percent of the Black male population."[269]

In Washington, D. C. during this time period, work for unskilled

African American women were limited to domestic labor, washer-women, cooks, and cleaning government office buildings.[270] In fact, as explained by historian Higginbotham, the discussion to locate NTPS in the nation's capital was determined by the focus on domestic training and especially the perceptions of greater job opportunities for domestic servants in the Washington area.[271]

Burroughs argued that Southern Black women came to Washington in order to work "in the homes of government officials and other wealthy residents."[272] Hence, Burroughs wanted to establish an educational institution that would "prepare Black women for the social and economic realities facing them."[273] She argued that

> . . . the majority of our women make their living at service, and the demand is for trained servants. Unless we prepare our selves, we will find within the next few years that our women will be pushed out of their places, filled by white foreigners who are . . . taking advantages of the instruction . . . in schools of domestic science. . . . Since we must serve, let us serve well, and retain the places we have long held in the best homes in the land.[274]

As noted by historian Evelyn Higginbotham, "the industrial focus of the National Training School affirmed the position of WC over black education [industrial vs. classical], but also affirmed [Burroughs'] consciousness of trends in women's education."[275] The early 1900s witnessed "the professionalization of home economics as a female led scientific field."[276] According to educational historian Elizabeth Hansot, "the country became increasingly urban and industrialized, home economics programs were seen as providing the training that earlier had been the purview of the family."[277] Hansot explains that "the proponents of home economics wanted it to go well beyond training in the cooking and sewing that had been the staples of some schools in the nineteenth century."[278] "Home economics was to be the study of the laws, conditions, principles, and ideals."[279] Proponents wanted it "to become the science of household management and child raising."[280]

Advocates of home economics saw it "as holding the key to pressing social problems"—it would provide the learning needed for "right living."[281] Knowledge of nutrition and hygiene would reduce the high rates of infant mortality and improve child health.[282]

However, "a discipline that was defined by women began to look different from one that was defined by men." The domestic science courses that began to proliferate in the curriculum of public schools,

and the post-secondary schools throughout the country—reflected the growing concern with preparing women for marriage and the home.[283] It was argued at the time that if homemaking was made into a "profession based on the sciences, home economics would dignify the occupation, [reduce the divorce rate] and stem the drop in the birthrate of native born women . . . [It] would also give women the knowledge they needed for municipal housecleaning for making the larger environment safe for families."[284]

The home economics / domestic science curricular differed significantly depending on one's race, ethnicity and class status.[285] Higginbotham notes that,

> Domestic science in White schools was designed to train White middle-class women to become good homemakers or good managers of household servants. At the collegiate level White women also prepared for jobs as dieticians or teachers of domestic science.[285] White schools did not prepare their graduates for domestic service.[286]

In schools that were predominately women of color and or White immigrant populations, home economic courses were required courses, especially in the South.[287] As noted by educational historians David Tyack and Elisabeth Hansot, "instruction in proper homemaking would help to 'Americanize' immigrant women and their families and thus hasten their adoption of 'correct standards.' Vocational courses would train Latinas and African American females for domestic service and thereby help alleviate the 'servant problem' (members of the General Federation of Women's Clubs complained about the ignorance and lack of skills of domestic laborers)."[288]

In the National Trade and Professional School (NTPS) there was an emphasis placed on domestic training because Burroughs believed that "98 percent of [Negro girls] must keep their own homes without any outside help and according to present statistics, 58 percent of the women who work are cooks, nurse-maids, etc."[289] Much of the domestic training work was implemented in the NTPS model cottage on the school grounds, which also served as a practical training center where various conventions were held there.[290]

Higginbotham contends that the National Trade and Professional School attempted to address the reality of unskilled Black women's work by "professionalizing" it.[291] She further argues that Burroughs' attempt to professionalize domestic servants constituted "an effort to re-defined

and re-present Black women's work identities as skilled workers rather than incompetent menials."[292]

Burroughs also passionately and sincerely adhered to the principal of "Whoever builds a fine Christian Womanhood, builds an enduring civilization."[293] With that motto in mind, she set out on her mission to "build fine Christian women" who would embark on a mission to "build an enduring civilization."

## FINANCIAL SUPPORT

Throughout the years, Burroughs had to solicit support and raise money to keep the School solvent.[294] She "scorned the advice of the [many] who told her that unless she could get donations from wealthy White philanthropists, her efforts were doomed."[295] Hence, it was "only after the actual opening of the school" that Burroughs solicited financial support from White philanthropists. However, as noted by Higginbotham, the school did not depend on White support for its existence.[296] Harrison notes that "more than 90 percent of the money" collected was "in response to Burroughs' personal appeals" rather than the WC obligation.[297] As Corresponding Secretary to WC, Burroughs traveled around the country recruiting students and appealing for funds for her School. Ella Whitefield, field secretary for WC, also spent many years faithfully travelling from state to state soliciting funds for the School.[298]

Burroughs was an astute business woman who was able to solicit financial support from numerous prominent people. Some of these individuals included Hubert Delany, Tax Commissioner for the Borough of Manhattan, Adam Clayton Powell Sr. of the Abyssinian Baptist Church in New York City, John Hope, the President of Morehouse College in Atlanta, Georgia, and Illinois Congressman Oscar de Priest.[299]

Burroughs once wrote to John D. Rockefeller requesting financial assistance for her School. According to an account told by biographer Aurelia Downey, Rockefeller responded to Burroughs' letter by sending a one-dollar bill

> with a request that she inform him how she plans to invest it. She then shelled peanuts, roasted them, put them in a box and mailed them back to Rockefeller and asked that he respectfully autograph each one and return them to her. She would then sell them for one-dollar each. [Rockefeller was apparently] impressed and convinced that she was indeed a very clear and astute businesswoman.[300]

She received assistance from him.

Burroughs also made efforts to get support from philanthropist Julius Rosenwald. She asked Booker T. Washington to speak on her behalf.[301] Washington, who had disagreed with the establishment of NTPS in Washington, D. C. because he believed that "Washington's Colored folks could never be made to favor anything but styles and politics," "controlled the flow of northern philanthropic monies into black educational institutions of the South."[302] In other words, he had a lot of power and backing when it came to granting or denying financial support to struggling black educational institutions.[303] Higginbotham notes that Burroughs

> wanted Rosenwald to match half of the amount necessary for the erection of an industrial hall. Washington did not respond enthusiastically to her request. He believed Black Washingtonians to be the highest per capita recipients of philanthropy. As a result, Burroughs did not receive the funds from Rosenwald.[304]

Burroughs sought other creative ways to get funding for her school. During the 1916-17 school year, the students and teachers conducted fund raising activities for the building of a $25,000 Trades Hall. As a result of their efforts, the Hall was built in 1928.[305] During the 1930s, the Colgate Company offered $4000 for collecting one million coupons from their products. Burroughs asked all she knew to "send their coupons to the School."[306] Hence, soap-wrapper coupons were collected by the WC, which provided much needed operating capital. She also organized a club which included "four classes of givers." These clubs included: (1) the million quarters' club (2) the million dimes' club (3) the 22, 000 feet of pennies club and (4) the National Birthday club. Members would give one-dollar or more on their birthdays.[307]

Funding of the School was drawn primarily from individual contributions within the Black community. "Without the assistance of large philanthropic donations, the School survived because of the cumulative power of countless small gifts."[308] "Nearly one-half came in nickels, dimes, quarters and sometimes dollars."[309]

Black Baptist churches and individual church members consistently lent financial support.[310] The WC always contributed funding to the School; however, their support never reached a thousand dollars or more.[311]

As explained by Easter, White supporters of NTPS provided technical help and sent teachers to the school.[312] The school also received a

myriad of gifts from the White Baptists, including classroom and office furniture.[313] Other financial support came from the Phelps-Stokes and Slater foundations.[314]

The second largest source of funding for the School was students' tuition and the School's laundry (which was opened to the public).[315] Other events generated revenue through selling student made products and operating "a summer school program for adult women offering courses in social service and community organizing."[316] The students and teachers of NTPS put on plays and concerts as an additional way of raising funds for the school.[317]

As Corresponding Secretary to the Women's Convention of the National Baptist Convention (WC), Burroughs realized that large numbers of Christian women did not have access to publish Christian literature.[318] Consequently, in 1934, she began publication of *The Worker*, a missionary quarterly, which is still being distributed today through the Nannie Helen Burroughs Publications.[319] Burroughs used the funds from this magazine to help finance the School.

Even though Burroughs was able to manage the school's financial affairs in an efficient manner, the School became delinquent in its payment of mortgage notes and other bills during the 1930s. "We are simply broke. . . . We are fighting with our backs to the wall, but . . . fighting right on. . . ."[320] Pressing financial problems forced Burroughs to mortgage her personal property to pay an important bill. She also cashed in her life insurance policy in order to build additional classroom buildings. In 1956, Burroughs was able to complete a "$200,000 dormitory [and] a large memorial chapel in 1960, both debt free."[321] By this time, a total of nine buildings were constructed on the campus."

## THE CONTROVERSY

As noted by biographer Opal Easter, Burroughs administered the School almost single-handedly and managed to keep it independent of the National Baptist Convention. However, there was an ongoing issue of "regulation of management," "making the School a point of contention and competition" between the Woman's Convention and the male ministers of the National Baptist Convention (NBC) throughout the years.[322] Easter argues that the "story of the struggle [over the School illustrates] the role sexism played in the relationship between the women of WC, and between the men of the NBC and Burroughs."[323]

Over the years on several occasions, the NBC put forth efforts to

seize the School. Burroughs, however, was able to successfully maintain control of her school. Easter explains that Burroughs "had documented the number of schools operated by the Black Baptist men, which were failing or in deep financial trouble and did not want to see her School become one of them."[324] Burroughs deemed it important to "hold the School in trust for the women of the WC" because it was the women who founded and patronized the School.[325] NBC eventually withdrew support, thereby forcing NTPS to become an autonomous institution.

Burroughs was able to keep the School up and running, and as a result she was successfully able to educate thousands of women across the nation and around the world. Indeed NTPS became a center for numerous social and political activities, especially pertaining to issues dealing with women and children.

Burroughs established NTPS in response to the external constraints of racism, sexism and the economic and social structures of oppression that Black women faced in the early twentieth century. During these times of hardship and despair, she believed that Black women needed faith, strength and resiliency to resist the interlocking structures of oppression. Thus, her mission as a Christian and member of a "despised race" and an "inferior sex" would be to "uplift" the women and the race. Her School was to be used as a vehicle to "make [Black] women dynamic and socially distinctive so that their lives will have power to revitalize the spirit of a distressed race" and to lead them out of the despairing conditions of the times.

Nannie Helen Burroughs died on May 20, 1961 at the age of 82. It was reported that 5,500 people came to the Nineteenth Street Baptist Church in Washington, to pay their last respects.[326] After her death in 1961, the Board of Trustees decided to revamp the school curriculum. The new school, which continues to operate today, included a preschool to the elementary level program. It was renamed the Nannie Helen Burroughs School. In the Fall of 1997, the School expanded the curriculum to include seventh grade courses.

In 1975, on May 10th was proclaimed Nannie Helen Burroughs Day by the District.[327] In 1976, the District renamed the street that runs in front of the School *Nannie Helen Burroughs Avenue*.[328]

The Nannie Helen Burroughs School was declared a historical landmark in 1991.[329]

## SECTION II:
## ANNA JULIA COOPER'S AND NANNIE HELEN
## BURROUGHS' EDUCATIONAL PHILOSOPHIES

> *The teacher's task must take the form of a criti-*
> *cal pedagogy . . . He or she must make class-*
> *rooms into critical spaces that truly endanger*
> *the obviousness of culture, i. e., the way reality*
> *is usually constructed—as a collection of unal-*
> *terable truths and unchangeable social rela-*
> *tions. Within such critical spaces, he or she*
> *must excavate the "subjugated knowledges" of*
> *those who have rarely been made public.*
> —PETER MCLAREN, 1994[330]

> *For Black folks teaching—educating—was*
> *fundamentally political because it was rooted in*
> *an anti-racist struggle.*
> —BELL HOOKS, 1994[331]

> *. . . Successful teachers . . . travel a different*
> *route to ensure the growth and development of*
> *their students.*
> —GLORIA LADSON-BILLINGS, 1994[332]

Anna Julia Cooper and Nannie Helen Burroughs and other educated Black women were "traditionally brought up to see their education as something gained not just for their own development but for the purpose of race uplift."[333]

Hence, when Cooper and Burroughs embarked on their journey as educators and activists they came prepared for a life of dedication and commitment through service to women, the race and the poor. Each brought to the school milieu her brand of educational ideas that were rooted in their own schooling experiences, their religious beliefs, and in the predominant views relating to the role of black education and women's education. Tenets of Victorian femininity—the "ideal" woman—redefined as the "ideal" Black woman (for the purpose of

informing the role of the educated Black woman), intersected with the two prevailing philosophies of black intellectual thought—those of Booker T. Washington and W. E. B. Du Bois, and formed the bases for Cooper's and Burroughs' educational theories.

According to Carol Perkins' research,

> the concept of the "ideal" Black woman differed from the majority culture's ideal woman whose responsibilities seem to end at her own front door. Black women felt that they could not afford the luxury of being concerned only about their own households when the race as well as society in general suffered from a vast array of problems.[334]

As cultural workers for social and moral change, Cooper and Burroughs utilized a teaching praxis focused on transforming practices that circumscribed the lives of African American students. Their pedagogy was political and revolutionary. It was rooted in an anti-racist, anti-sexist, and anti-classist struggle. Fighting for equitable educational opportunities for Black youth became intertwined with the fight for women's rights and the rights of the poor.

Both women's educational ideals were similar in many respects and dissimilar in other ways. Both argued passionately and eloquently for the education of African American women as "vital agents" in "uplifting" the race. Cooper argued

> I ask the men and women who are teachers and coworkers for the highest interests of the race, that they give the girls a chance!. . . . Let us insist . . . special encouragement for the education of our women and special care in their training. . . . Teach them that there is a race with special needs which they and only they can help. . . . The earnest well trained Christian young woman, as a teacher, as a home-maker, as a wife, mother, or silent influence even, is as potent a missionary agency among our people as is the theologian. . . . Let us then, here and now, recognize this force and resolve to make the most of it—not the boys less, but the girls more.[335]

Speaking from a similar perspective, Burroughs declared

> Teachers, preachers and leaders cannot solve the problems of the race alone. The race needs an army of skilled workers and the properly educated Negro woman is the most essential factor.[336]

Black feminist research reveals that the uplifting of the race through the participation of women in education of children was a common theme educated Black women shared collectively. The struggle for group survival and institutional transformation was part of Black women educators commitment to race uplift. Collins notes that "this feeling was so strong that the women founding the National Association of Colored Women's Clubs chose as their motto 'Lifting As We Climb.' "[337] Cooper was one of the founding members of this organization and Burroughs became a member in later years.

This commitment as a teacher / activist in the arena of the struggle for group survival is described in the following by Burroughs: "[As a student at M Street High School] I wanted to teach girls how to do things. I wanted to tell them some of the things I felt."[338] At a later time she also explained:

> I've put my whole life in this hill [her school on the hill] but I have done it for God. He has chosen to use my life to build something for humanity, a place where women and girls of my race can come and learn some sense, about how to live to the glory of God . . . I am going home [to heaven] one of these days but while my spirit serves in the divine realm I still will be helping some working woman or some growing girl here on this hill.[339]

Similar sentiments are found in Cooper's statements: "Teaching has always seemed to me the noblest of callings. I believe that if I were white I should still want to teach those whose need presents a stronger appeal than money. . . . It is human to be stimulated by appreciation where it is genuine."[340] Teaching the "underprivileged," a term she used, has always been her desire, A desire which was sparked "not far from kindergarten age."[341]

Typical of early Black women educators, Cooper and Burroughs believed that they had a special responsibility to their students and to their respective community, which they alone could fulfill. They often saw themselves as social and moral change agents. Teacher as social and moral agent thus became a theme in each educator's writings, lectures and pedagogy. From their standpoint, education was the tool for liberation. Its purpose was to assist in the economic, political, and social improvement of African Americans.

Like feminist bell hooks' experience as a student who had socially and morally committed teachers, Cooper's and Burroughs' students "learned early that their devotion to learning, to life of the mind, was a

counter-hegemonic act, a fundamental way to resist every strategy of White racist colonization."[342] Hence, Cooper's and Burroughs' teaching practices were linked to the "creation of social practice and moral referents necessary for the construction of a democratic public sphere."[343]

The theme of an ethic of caring is found throughout their pedagogical practices. White feminist scholars such as Nel Noddings, and Carol Gilligan "have brought the voice of caring to our understanding of the social construction of gender."[344] Caring, they claim, is part of women's experience. Collins reiterates its centrality to Black women's lives and scholarship. "The ethic of caring suggests that personal expressiveness, emotions, and empathy are central to the knowledge validation process."[345] Collins explains that

> caring from a Black feminist perspective involves the convergence of Afro-centric and feminist values. Collins argues that White women may have access to a woman's tradition valuing emotion and expressiveness, but few Eurocentric institutions except the family validate this way of knowledge. In contrast, Black women have long had the support of the Black church, an institution with deep roots in the African past and a philosophy that accepts expressiveness and an ethic of caring.[346]

Cooper and Burroughs exhibited an ethic of caring. As dedicated educators, they were strict disciplinarians but in a caring way. Cooper and Burroughs were described by their students and colleagues as being "motherly," concerned teachers who took personal interests in their students' cognitive and social and emotional well-being. Like many Black women educators, Cooper and Burroughs worked with their students to ensure that they would fulfill their intellectual destiny and by so doing uplift the race. Many of the students who came under the tutelage and influence of both educators did achieve success, led useful lives, and made significant contributions to the society in which they found themselves.

Hutchinson lists in her book, a significant number of Cooper's students who were successful. Nannie Helen Burroughs was one of them. In 1916, when a new school was built to replace M Street High School, it was renamed Paul Laurence Dunbar High School. Burroughs was selected to speak at the dedication ceremony. Among all of the alumni she was identified as the one who made "the greatest individual achievement."[347] Other students of Cooper's were:

Sadie Tanner Mossell, class of 1915. She became a civil rights activist, successful attorney and the first Black woman to earn a Ph.D. in economics from the University of Pennsylvania in 1912; Eva Dykes earned a master's and Ph.D degrees from Radcliffe College in 1918 and 1921 respectively. She later returned to Dunbar High School to teach; Albertus Brown graduated from Howard University Law School, became an attorney, founded the Frederick Douglas Community Center and organized the Toledo, Ohio branch of the National Association for the Advancement of Colored People (NAACP).[348]

The list is too numerous to continue.

Burroughs' students were successful as well. However, as noted by Higginbotham, [unlike Cooper,]

> who challenged the "Talent Tenth" to aspire to high-status professions in spite of racism and economic hardship, Burroughs entreated women in low-status jobs to perform with skill and efficiency. Her school taught the students to do "ordinary things in an extraordinary way.[349]

A large number of her students worked as domestic servants, taught domestic science or vocational training courses, worked as secretaries, opened their own businesses such as beauty salons, printing shops, and restaurants. A number of them worked as missionaries in West Africa and the Caribbean. One student became the first Black bail bondsperson and certified notary public in Dade County, Florida. She was also a public stenographer. Another woman was a cottage mother at a New York City Colored Orphanage. Still another was a tailor in a New York dressshop. And yet another became a teacher in religious education.[350] Burroughs noted that her students had won such fine reputations for their work that the School received requests for more workers than it could supply.

Cooper and Burroughs produced successful students because they developed links with their parents and the community from which they hailed. Feminist research on an ethic of caring as well as Lisa Delpit's research of teacher education training suggests, that if teachers "do not foster inquiry into who [their] students really are or . . . develop links to the often rich home lives of students, [they will not be able to] begin to understand who sits before them."[351]

Caring teachers are successful because they "travel a different route

to ensure the growth and development of their students."[352] Cooper traveled a different route when she was principal at M Street. The "sympathetic methods," a term she used, involved individual attention and constant reexaminations of students having difficulty with high school work. Many of the students were able to pass while others were not. Also, Cooper and her teaching staff decided collectively not to use the School Board-adopted textbooks on English history. They chose to secure another textbook, which they felt was more appropriate for their students' abilities. The different route she traveled gave rise to successful school achievement for many of her students and demonstrated a need for teachers to have an ethic of caring for their students if success is to be the end goal. It also illustrated the need for teachers to be empowered to have a voice in the education of their students.

An ethic of caring or "traveling a different route" meant to Burroughs creating a school that was centered on the needs of her students. In a faculty meeting she pointed out to her teachers that

> Every teacher should be conscious of what is taking place in the lives
> of students, especially girls. . . . The student is nine-tenths right most
> of the time, especially when it comes to an analysis of what a teacher
> actually knows about the thing she is teaching. Students see our lives.
> Sometimes they don't understand what we say but they do understand
> what we do.[353]

At this meeting, she encouraged her teachers to dedicate themselves whole-heartedly to helping their students. Burroughs concluded the meeting by saying, "I have put much into this Cause [the cause requiring teachers to know young people and influence them],. . . . I want you to catch the spirit of this thing. Put your heart in it . . ."[354]

Burroughs' efforts to create a caring environment, which was student-centered, is also evident in the teaching strategies she suggested her teachers to implement. These strategies included: (a) individual conferences with pupils (b) accepting and utilizing the students' "voice," opinions or experiences (c) student evaluation of their own and other student's work (d) students creating their own exams (e) better students helping others; just to name a few.[355]

Cooper and Burroughs were often described as devoting themselves to helping their students build better lives and realize their full potential. Cooper maintained, "the elemental principal and foundation of all education everywhere—namely [is] the fullest development of the individ-

ual in and by and for the best possible environing society."[356] "Education," explains Cooper, should be aim[ed] at the making of men rather than constructing machines."[357]

Burroughs believed that "all education is continued growth . . . in everything—in our thinking, our methods of teaching, in our choice of books . . . and also in our professional attitudes, personality, choices . . ."[358] She also postulated that "the greatest service that a school can render is to help young people discover their talent and glorify it through training and devoted service."[359]

Alice Smith, a former student and surrogate daughter of Burroughs, described her as one who

> . . . helped you to overcome and to become. The sky was the limit. She would help you do whatever you wanted to do. She was teacher, mother, and friend to me. All that I owe that's any good, I owe first to God and then to Nannie Burroughs.[360]

In Lyle Slovick's research and analysis of Burroughs' relationship with her students, it was revealed that

> . . . A certain allegiance to Burroughs and the school was developed among the girls, who felt a responsibility to live up to the Burroughs creed, said a senior class president. . . . Our one great ambition is to carry out your desires. . . . The student body as a whole is specializing in the wholly impossible, doing the things that no one else can do.[361]

Judging from the descriptions Cooper and Burroughs received from their students and colleagues, they were committed to nurturing the intellect of their students so that their students would become scholars, thinkers and cultural workers.

Cooper forged a link with Burroughs in reference to Christian industrial education for girls. From a pragmatic perspective, Cooper maintained that it was "the domestic worker who could mold favorable sentiment without ever opening her lips on the Negro problem, therefore a thorough course of general education would do an effective job in training women for domestic industry."[362] In reference to Christian education, she criticized the church for not supporting the education of women as they did for men. She believed it was the church's mission to "prepare our girls in head, heart and hand for the duties and responsibility that await the intelligent wife, the Christian mother, the earnest,

virtuous helpful woman, at once both the lever and the fulcrum for up-lifting race."[363]

Burroughs also wanted female students to have the same opportunities as male students receiving a Christian education, but was pragmatic in her approach. Not only would her female students be trained as productive workers, training of spiritual character was also emphasized.[364] Burroughs found that

> . . . The greatest thing any Christian School can render our women is to give them thorough training in the fundamentals of education through High School and Junior College and then give them courses in Bible Missionary Training, Business, homemaking and social welfare. If we do that, we will be doing for Negro homes, Church and community life, the thing that we need above everything else.[365]

Haboring pragmatic educational perspectives with a touch of idealism, Cooper and Burroughs maintained that the best educational program included classical liberal arts and industrial vocational education curricular. They, like many other Black female educators of their time espoused the belief that a combination of classical and industrial education provided "a trained hand in [the trades], and a cultured brain in liberal education." In an article titled "On Education," Cooper argued that

> The only sane education . . . is that which conserves the very lowest stratum, the best and most economical . . . [because it] . . . gives to each individual according to his capacity that training of head, hand and heart, or more literally, of mind, body and spirit which converts him into a beneficent force in the service of the world.[366]

Making the following address before the WC in reference to the educational training of her students Burroughs declared

> I believe that an industrial and classical education can be simultaneously, attained, and it is our duty [WC] to get both. . . . We [WC] are anxious for our girls to learn to think but it is indispensable that they learn how to work.[367]

There were points of departure in Cooper's and Burroughs' educational philosophies. What differentiated in the two women's perspectives stemmed from the twenty-year differences in age, educational back-

grounds, their work experiences, and religious beliefs. Cooper, the older of the two and a former slave from the deep South, came of age during the Reconstruction era—a period of hope and possibilities. Her social, feminist and educational perspectives began to develop within this context.

Burroughs was also born in the South, but grew to adulthood in Washington, D. C. during the post-Reconstruction and the Jim Crow era—an era described as the "nadir" in the African American experience. In contrast to Burroughs' somewhat limited educational opportunities, Cooper enjoyed a more extensive education in the integrated northern environments of Oberlin and Columbia University. Her studies abroad fostered a cosmopolitanism that influenced her philosophies. Dr. Cooper received classical liberal arts training throughout her academic schooling. Consequently, her professional experience as an educator found her teaching classical liberal arts courses on the college level and on the public high school level. These experiences led Cooper to perceive the world through many lenses, (as a former slave, a Southerner, a feminist, educator, activist, Pan-Africanist and intellectual).

Burroughs, conversely, never obtained any college degrees, with the exception of an honorary degree, received a combination of vocational and liberal arts training in a segregated high school. Her strong Christian faith and activism in the church shaped significantly the way she perceived the world. Her teaching experiences were limited to the small industrial school she began in Kentucky and of course NTPS.

While Cooper and Burroughs shared similar goals for the education of Black youth, especially women, there were noticeable differences in those objectives. Although Burroughs' School combined elements of liberal arts and vocational educational training, she was much more pragmatic in her educational views and she was a strong supporter of certain elements of Booker T. Washington's philosophies. Burroughs was often called the "female Booker T. Washington." Her educational views were very similar to Washington's and the courses offered at NTPS were similar to those offered at Tuskegee.[368] Burroughs once "argued that there was a need for an institution like Tuskegee in the nation's capital for Black females. She even criticized individuals who downplayed the effectiveness of Washington and Tuskegee Institute."[369]

Like Washington, Burroughs, stressed cleanliness, morality, racial pride, solidarity and habits of industry. The National Trade and Professional School, like Tuskegee, was designed to train females or future domestic laborers, to be efficient, hard working and moral. The students at both schools were responsible for housekeeping chores, gardening,

canning the fruits and vegetables, and working in the school laundry.[370] The National Trade and Professional School was distinctive from Tuskegee in that it did not depend upon funding from White philanthropists, thus Burroughs had the freedom to offer classical liberal arts courses along with the industrial vocational courses.

Unlike Washington, Burroughs never believed that an industrial curriculum would end race, class and gender exploitation. She, however, believed that the "measure of Black progress rested not upon the Talented Tenth, but upon the economic and moral status of the great mass of laboring people, especially the women."[371]

Cooper was much more an academic theoretician and intellectual but she was also pragmatic in her thinking and her work experience is reflective of this. Her pragmatic thinking is reflected in the civic activism work she did in the community and the teaching / administrative work at Frelinghuysen University. Cooper was called a "female W. E. B. Du Bois." She was a strong supporter of Du Bois and a hesitant supporter of Booker T. Washington, although she never joined the anti-Booker T. Washington movement. Her position on classical versus industrial education predates Booker T. Washington's rise to national prominence and prior to the philosophical debates "between Washington and Du Bois had escalated to the level of the now historical controversy."[372] There are many similarities between Cooper's and Du Bois' life experiences and perspectives. Cooper and Du Bois, both received their classical liberal arts training at historically Black Colleges in the South (St. Augustine's and Fisk respectively); collegiate training in northern universities and both studied abroad in Europe. Both found studying and travelling abroad to be intellectually stimulating. Like, Cooper, Du Bois pursued doctoral studies, eventually getting his Ph.D. from Harvard University in 1896. Du Bois, like Cooper, focused his dissertation on slavery. As explained by one scholar, "the Suppression of the African Slave Trade in America" was his topic. As explained by one scholar, "both Cooper and Du Bois thought the anxieties of the so-called mulattos and the miseries of slaves became pivotal issues in the struggle for liberty in France. Both believed slavery was a matter of international moment. Du Bois' dissertation heralded this view."[373]

Cooper and Du Bois were friends. They lectured at a lot of conferences together. Cooper apparently thought very highly of Du Bois' intellect and scholarship. On December 31, 1929 she wrote a letter to Du Bois encouraging him to respond to the racist book *The Tragic Era: The Revolution after Lincoln* by Claude G. Bowers.

> My Dear Doctor Du Bois:
>
> It seems to me that the *Tragic Era* should be answered ade-
> quately. . . . Finally & [sic] again it seems to me **Thou** art the Man!
> [emphasize in the text]. Take it up seriously thro [sic] the *Crisis* & let
> us buy up 10,000 copies to be distributed [and] broadcast [it] thro the
> land. Will you do it?[374]

Six years later, Du Bois responded by writing *Black Reconstruction in America, 1860-1880.*

Notwithstanding the fact that Cooper and Burroughs were dubbed the female "Du Bois" and the female "Washington" respectively, their lives were much more complex and symbolic of a bigger struggle. The intersection of their gender with race during a time when Blacks and women were considered second-class citizens and in particular when Black women were considered "immoral scourges" of the earth gave rise to an incumbent mission that only they as Black women could embark upon. This mission influenced their philosophical thinking and activism.

Cooper's view on industrial vocational training was articulated at the Second Hampton Negro Conference on May 25, 1893. At the Confer-ence, Cooper declared

> I believe in industrial education with all my heart. We can't all be pro-
> fessional people. We must have a backbone to the race. . . . There is a
> crisis ahead in the labor question. The foreign elements is [sic] unsta-
> ble and restive, ready for strikes, and as a rule impatient of control. The
> people of this country will inevitably look around for a stable working
> class. When the time comes for the need to be appreciated and satis-
> fied, the Negro must be ready to satisfy it; there will be no prejudice
> against the colored man as a worker . . . If our young men are to have
> trades they must get them in industrial schools.[375]

Both educators were relatively naïve in thinking that African Ameri-can laborers would not experience racism or other forms of discrimina-tion due to the fact the his/her industrial education provided him/her with a skill. "Burroughs was extremely influenced by the puritan work ethic. To her, the interests of the capitalist could be reconciled with those of the worker if both were honest with each other."[376] Absent from their view was a comprehensive understanding that industrial capitalism desired a trained, skilled labor force for economic interests.

Critical educational theorists Bowles and Gintis maintain that the

motivating force in the capitalist economy is the employer's quest of profit. They explain that "profits are made through hiring skilled workers and organizing production in such a way that the price paid for the worker's time—the wage—is less than the value of the goods produced by labor."[377] "Racism and sexism played a significant role in the type of work a laborer had access to as well as the level of exploitation a laborer experienced."[378] "The labor force in the North and the South remained segregated and capitalists used the Black labor force to offset the growing assertiveness of White labor unions."[379]

Whereas both women actively argued for equal educational opportunities for female students on every level, Cooper undertook a stronger stand for higher education. Her ideal for the women of her race was a liberal education that would prepare the Talented Tenth not only for race leadership, but also for a role in establishing new values that would redefine the very basis of Western culture. In contrast, Burroughs positioned herself on the side of vocational training as the appropriate form of education for the masses of Black women whom she hoped would be very much a part of the world in action and thought as skilled workers, capable leaders in their chosen fields and "biblical Dorcas," and activists in the community.

## SUMMARY AND CONCLUSION

The common themes that emerged between Anna Julia Cooper and Nannie Helen Burroughs was that each woman viewed herself as social and moral change agents for group survival and institutional transformation. Working for race uplift and education became intertwined. Tenet of the doctrine of femininity—"ideal" woman was redefined as the "ideal Black" woman, which suggested that Black women have a moral obligation to "uplift" the race out of the despairing conditions of the times, is found in their educational philosophies.

Even though both women believed that the ideal educational program combined classical liberal arts and industrial vocational training, Cooper was a stronger supporter of liberal arts education stemming from her own educational experiences. She was also a strong supporter of W. E. B. Du Bois and a hesitant supporter of Booker T. Washington. In contrast, Burroughs' educational experience influenced her beliefs and she positioned her philosophical ideas closer to Washington's views. Her School's educational programs seemed to have been modeled from Washington's Tuskegee Institute. She too was a supporter of both men but greatly admired Washington. Both women's philosophies informed

their pedagogical practices. Their teaching practices were revolutionary in that they sought to teach in a way that was counter-hegemonic and anti-racist and anti-sexist.

They "traveled different routes" to ensure the successes of their students. An ethic caring resonated throughout their teaching practices. These educators were committed, dedicated, nurturing and caring. They worked compassionately to produce successful students who would in turn be committed to race uplift. The influence Cooper had on Burroughs resulted in her being identified as having one who made "the greatest individual achievement" of the M Street alumni.

When Burroughs opened the National Trade and Professional School on October 19, 1909, she joined the list of Black women pioneers who felt compelled to start their own schools. As president of this institution, Burroughs' career as a distinguished educator activist began. Burroughs in turn committed herself to helping young Black women build better lives and realize their full potential.

Cooper's career as an educator spanned for a period of sixty-two years, which encompassed the Reconstruction to the Civil Rights era. Cooper was a consummate educator, scholar, and feminist who was outspoken on issues pertaining to race, gender, class and educational issues. Education meant empowerment and freedom. Cooper passionately enjoyed learning and teaching.

Anna Julia Cooper and Nannie Helen Burroughs did not retire from their work as educators and activists until the ages of eighty-four and eighty-two respectively. The legacy of the lives, works and philosophies of these life-long educators has greatly influenced the opportunities and experiences of African American women to follow.

Cooper and Burroughs lived during a time when the interlocking structures of oppression attempted to break the spirit, silence the voices and disempower the African American community. Discontented, they found the strength and resiliency to actively seek solutions to the problems experienced by Blacks. Their global concern for the African American community both here and abroad took them outside of the classrooms and into their communities. Their work as social change agents and activists will be discussed in the next chapter.

## NOTES

[1] Undated document by Anna J. Cooper, AJC papers, courtesy of MSRC

[2] Nannie Helen Burroughs, *Think on These Things*, (Washington, D. C.: Nannie H. Burroughs Publications, 1982) p. 55; Undated document by Nannie

H. Burroughs, Nannie Helen Burroughs papers, courtesy of the Manuscript Division, Library of Congress (hereafter cited as NHB papers, courtesy of LC)

³ "Data desired relative to Group B examination," question b1, December 17, 1921, AJC papers, courtesy of MSRC

⁴ Undated autobiographical document, Anna J. Cooper, AJC papers, courtesy of MSRC

⁵ Louise D. Hutchinson, "Anna Julia Cooper," in *Black Women in America: An Historical Encyclopedia in* Darlene Clark Hine, eds., vol. I (Bloomington, Indiana: Indiana University Press, 1993) p. 277

⁶ Ibid.

⁷ See C. Vann Woodard, *The Strange Career of Jim Crow*, (New York: Oxford University Press, 1974)

⁸ Ulrich B. Philips quoted in C. Vann Woodard, *The Strange Career of Jim Crow*, (New York: Oxford University Press, 1974) p. 8

⁹ Frances R. Keller, *Slavery and the French Revolutionists, 1788-1805*, (Lewiston, New York: The Edwin Mellen Press, 1988) p. 12

¹⁰ Anna J. Cooper, *A Voice from the South*, in the Schomburg Library of Nineteenth Century Black Women Writers, eds., (New York: Oxford University Press, 1988) pp. 101-102

¹¹ Anna J. Cooper, *Personal Recollections of the Grimke Family & The Life and Writings of Charlotte Forten Grimke*, (Privately Printed, 1951) p. 8

¹² Ibid.

¹³ Paul Philips Cooke, (1981) "Anna J. Cooper." Unpublished paper lent to this author, courtesy of Dr. Paul Philips Cooke, p. 6

¹⁴ Leona C. Gabel, *From Slavery to the Sorbonne & Beyond: The Life & Writings of Anna J. Cooper*, (Northampton, Massachusetts: Smith College Studies in History, 1982) p. 25

¹⁵ Louise D. Hutchinson, *Anna J. Cooper, A Voice from the South* (Washington, D. C.: Smithsonian Institute Press, 1981) p. 49

¹⁶ David Tyack, *The One Best System: A History of American Urban Education* (Cambridge, Massachusetts: Harvard University Press, 1973) p. 61

¹⁷ Ibid.

¹⁸ Hutchinson, *Anna J. Cooper, A Voice*, p. 49

¹⁹ See Sharon Harley, "Black Women in a Southern City: Washington, D. C. 1890-1920," in Darlene Clark Hine, eds., *Black Women in American History*, vol. 2, (Brooklyn, New York: Carlson Publishing) pp. 487-506

²⁰ Ibid.

²¹ Ibid.

²² Ibid.

²³ M. S. Seller, Introduction to *Women Educators in the United States, 1820-1993: A Bio-Bibliographical Sourcebook* (London: Greenwood Press, 1994) p. xviii

[24] S. N. Kersey, *Classic in the Education of Girls and Women* (Metuchen, New Jersey: The Scarecrow Press, 1981) p. 307; also see Sharon Harley (1982) "Beyond the Classroom: The Organizational Lives of Black Female Educators in the District of Columbia, 1890-1930," *Journal of Negro Education*, vol. 51, no. 3, p. 256—the footnote section of the article.

[25] See Tyack, *The One Best System*; also see Harley, "Black Women in a Southern City"

[26] For a short listing of figures for teachers' salaries, see Sharon Harley, (1982) "Beyond the Classroom: The Organizational Lives of Black Female Educators in the District of Columbia, 1890-1930," *Journal of Negro Education*, vol. 51, no. 3, p. 256. The figures she quotes are taken from the Report of the Superintendent of the Washington, D. C. Public Schools 1890.

[27] Constance M. Green, *The Secret City: A History of Race Relations in the Nation's Capital* (Princeton, New Jersey: Princeton University Press, 1967) p. 137

[28] Ibid.

[29] See Thomas Woody, *A History of Women's Education in the United States*, vols. I & II (New York: The Science Press, 1929)

[30] Sharon Harley, "For the Good of the Family and Race: Gender, Work, and Domestic Roles in the Black Community, 1880-1930," in M. Malson, eds., *Black Women in America: Social Science Perspectives* (Chicago: University of Chicago Press, 1988) p. 167

[31] Ibid.

[32] Mary Church Terrell (July, 1917) "History of the High School for Negroes in Washington," *Journal of Negro History*, vol. 2, pp. 255-257

[33] Green, *The Secret City*, p.137

[34] Hutchinson, *Anna J. Cooper, A Voice*, p. 51

[35] See Green, *A Secret City*

[36] G. S. Wormely, (April, 1932) "Educators of the Public Schools of the District of Columbia," *Journal of Negro History*, vol. 17, no. 2, p. 126

[37] Green, *The Secret City*, p. 137

[38] Hutchinson, *Anna J. Cooper, A Voice*, p. 57

[39] Green, *The Secret City*, p. 137; Wormley, "Educators of the Public Schools," p. 126

[40] Lillian Dabney, *The History of Schools for Negroes in the District of Columbia: 1807-1947* (Ph.D dissertation, Catholic University, 1949) p. 203

[41] Green, *The Secret City*, p. 137

[42] Francis Grimke is quoted in G. S. Wormley, (April, 132) "Educators of the Public Schools of the District of Columbia," *Journal of Negro History*, vol. 17, no. 2, p. 126

[43] Willard B. Gatewood, *The Aristocrats of Color: The Black Elite: 1880-1920* (Bloomington, Indiana: Indiana University Press, 1993) p. 261

[44] Ibid.

[45] Ibid.

[46] Green, *The Secret City*, p. 137

[47] Terrell, "History of the High School," p. 261; Green, *The Secret City*, p. 137

[48] Hutchinson, *Anna J. Cooper, A Voice*, p. 58

[49] Mary Gibson Hundley, *The Dunbar Story: 1870-1955* (New York: Vintage Press, 1965) p. 13

[50] Ibid.

[51] Ibid.

[52] Hutchinson, *Anna J. Cooper, A Voice*, p. 58

[53] David Lewis is quoted in S. Fitzpatrick & M. Goodwin, *The Guide to Black Washington: Places and Events of Historical and Cultural Significance in the Nation's Capital* (New York: Hippocrene Books, 1990) p. 92

[54] Ronald Edmonds is cited in C. D. Moody & C. Moody, "Elements of Effective Black Schools," in W. de M. Smith et al eds., *Black Education: A Quest for Equity and Excellence* (London: Transaction Publisher, 1976) pp. 176-186

[55] Gloria Ladson-Billings, *The Dreamkeepers: Successful Teachers of African American Children* (San Francisco: Jossey-Bass Publishers, 1994) p. 7

[56] bell hooks, *Teaching to Transgress: Education as the Practice of Freedom* (New York: Routledge, 1994) p. 3

[57] Lisa Delpit, *Other People's Children: Cultural Conflict in the Classroom* (New York: The New Press, 1995) p. 173

[58] James Cummins quoted in Gloria Ladson-Billings, *The Dreamkeepers: Successful Teachers of African American Children* (San Francisco: Jossey-Bass Publishers, 1994) p. 11

[59] Donald Erickson, "The Communal Ethos, Privatization and the Dilemma of being Public," in C. Solomon & L. Solomon, eds., *From the Campus Perspectives on the School Reform Movement* (New York: Vantage Press, 1989) pp. 136-153

[60] Ibid.

[61] James P. Comer, "Empowering Black Children's Educational Environments," in H. McAdoo, eds., *Black Children and Social Educational and Parental Environments* (New York: Sage, 1985) p. 138

[62] Peter McLaren, *Life in Schools: An Introduction to Critical Pedagogy in the Foundation of Education* (New York: Longman, 1994) p. 240

[63] bell hooks, *Teaching to Transgress*, p. 3

[64] Ibid.

[65] "Data desired relative to Group B examination," December 17, 1921, AJC papers, courtesy of MSRC

[66] H. S. Robinson, (1980) "The M Street High School, 1891-1916." Unpublished paper lent to this author by courtesy of Dr. Paul Philips Cooke's (Private Collection)

[67] A. B. Chitty, (1980). "The Life and Works of Anna Haywood Cooper, 1858-1964." Unpublished paper presented at Saint Augustine's College Library, Raleigh, North Carolina, lent to this author courtesy of Dr. Paul Philips Cooke (Private Collection)

[68] Letter correspondence to Dr. Paul Philips Cooke, August, 1980. Lent to this author courtesy of Dr. Paul Philips Cook (Private Collection)

[69] Paul Philips Cooke, (1981) "Anna J. Cooper." Unpublished paper lent to this author courtesy of Dr. Paul Philips Cooke (Private Collection) pp. 20-21

[70] La Vern West is quoted in Leona Gabel's *From Slavery to the Sorbonne and Beyond: The Life and Writings of Anna Julia Cooper* (Northampton, Massachusetts: Smith College Studies in History, 1982) p. 66

[71] Leona Gabel, *From Slavery to the Sorbonne and Beyond: The Life and Writings of Anna Julia Cooper* (Northampton, Massachusetts: Smith College Studies in History, 1982) pp. 66-67

[72] See Hundley, *The Dunbar Story*

[73] Hutchinson, *Anna J. Cooper, A Voice*, p. 51

[74] Ibid.

[75] Ibid.

[76] Ibid.

[77] Ibid., p. 56

[78] Gabel, *From Slavery to the Sorbonne*, p. 46

[79] Ibid., p. 29

[80] Hutchinson, *Anna J. Cooper, A Voice*, pp. 56-57

[81] Dabney, *The History of Schools*, p. 203

[82] Ibid.

[83] Ibid.

[84] Ibid.

[85] Wormley, "Educators of the Public Schools," p. 130; Hutchinson, *Anna J. Cooper, A Voice,* p. 57

[86] Father Felix Klein, *In the Land of the Strenuous Life* (Chicago: A. C. Mc-Clurg & Co.,1905) p. 293. This book was lent to this author courtesy of Sterling Smith, Anna Julia Cooper's great-great-great nephew (Private Collection)

[87] Hutchinson, *Anna J. Cooper, A Voice*, p. 57

[88] Terrell, "The History of the High School," p. 259

[89] Hutchinson, p. 58

[90] Hundley, *The Dunbar Story*, p. 15

[91] H. S. Robinson, "The M Street High School," p. 6

[92] Hundley, *The Dunbar Story*, p. 19

[93] Robinson, "The M Street High School," p. 6

[94] Ibid.

[95] Gabel, *From Slavery to the Sorbonne*, p. 49

[96] Ibid.

[97] Ibid.

[98] Hundley, *The Dunbar Story*, p. 131

[99] Hutchinson, *Anna J. Cooper, A Voice*, p. 58

[100] Father Felix Klein, *In the Land of the Strenuous Life*, pp. 293-294

[101] Ibid., p. 294

[102] Ibid.

[103] Ibid., p. 295

[104] Ibid.

[105] Hundley, *The Dunbar Story*, pp. 61-62

[106] Ibid.

[107] Ibid.

[108] Klein, *In the Land of Strenuous Life*, p. 295

[109] Paul Philips Cooke, "Anna Julia Cooper," pp. 17-18

[110] Klein, *In the Land of Strenuous Life*, p. 296

[111] Cooper, *The Third Step*, p. 3

[112] Karen Baker-Fletcher, *A Singing Something: Womanist Reflections on Anna Julia Cooper*, (New York: Crossroad, 1994) pp. 53-54

[113] Mary Helen Washington, Introduction to Anna Julia Cooper's *A Voice from the South*, in Schomburg Nineteenth Century Black Women Writers, eds., (New York: Oxford University Press, 1988) pp. xxxiii-xxxiv

[114] Linda M. Perkins, *Fanny Jackson Coppin and the Institute for Colored Youth, 1865-1902* (New York: Garland Publishing, 1987) p. 249

[115] Ibid.

[116] Ibid.

[117] Ibid., p. 252

[118] Ibid.

[119] Hutchinson, *Anna J. Cooper, A Voice*, p. 68

[120] Robinson, "The M Street High School," p. 8

[121] Hutchinson, *Ann J. Cooper, A Voice*, p. 67

[122] Robinson, "The M Street High School," p. 8; Hundley, *The Dunbar Story*, p. 15

[123] Gabel, *From Slavery to the Sorbonne*, p. 49

[124] Ibid.

[125] W. E. B. Du Bois, "Of Mr. Booker T. Washington and Others," in Julius Lester, eds, *The Seventh Son*, (New York: Vantage Books, 1971) pp. 364-365

[126] W. E. B. Du Bois, *The Education of Black People* (Amherst, Massachusetts: University of Massachusetts Press, 1963) p. 14

[127] Ibid., pp. 5-16

[128] Gerald Gutek, ed, "The Civil War, Reconstruction, and the Education of Black Americans," in *Education in the United States: An Historical Perspective* (Englewood Cliffs: Prentice Hall, 1986) p. 169

[129] Ibid.

[130] Ibid.

[131] Gabel, *From Slavery to the Sorbonne*, p. 49

[132] "Report of the Board of Education 1905." A copy of this document was lent to this author, courtesy of Dr. Paul Philips Cooke (Private Collection)

[133] Interview with Dr. Paul Philips Cooke, Washington, D. C., 23 October 1996

[134] Mary Helen Washington, Introduction to *A Voice from the South*, p. xxxvii

[135] See Beverly Guy Sheftall, "Anna Julia Cooper" in M. S. Seller, eds., *Women Educators in the United States, 1820-1993: A Bio-Bibliographical Sourcebook* (London: Green Wood Press, 1994); Washington, Introduction to *A Voice from the South*, p. xxxvi

[136] "Rules for Teachers 1915." These rules were lent to this author courtesy of Sterling Smith, (Private Collection)

[137] Interview with Dr. Paul Philips Cooke, Washington, D. C. 23 & 26 October 1996; See Cooke, "Anna J. Cooper," pp. 1-39

[138] Ibid.

[139] "Report of the Board of Education," 1905

[140] Ibid.

[141] Cooke, "Anna J. Cooper," p. 22

[142] Ibid., pp. 17-18

[143] Ibid., p. 26

[144] Hutchinson, *Anna J. Cooper, A Voice*, p. 67

[145] "Colored High School," *Washington Post*, 1905, pp. 1-4

[146] Ibid., p. 1

[147] Du Bois, "Of Mr. Booker T. Washington," p. 385

[148] Cooke, "Anna J. Cooper," p. 26

[149] Ibid., p. 29; also interview with Dr. Paul Philips Cooke, Washington, D. C. 26 October 1996

[150] Cooke, "Anna J. Cooper," p. 27

[151] Interview with Dr. Paul Philips Cooke, Washington, D. C. 26 October 1996; Cooke, "Anna J. Cooper," p. 15

[152] Gabel, *From Slavery to the Sorbonne*, pp. 50-51

[153] Hutchinson, *Anna J. Cooper, A Voice*, p. 83

[154] Peter McLaren, *Life in Schools: An Introduction to Critical Pedagogy in the Foundations of Education* (New York: Longman Publishing, 1994) p. 1

[155] Ibid.

[156] Ibid., p. 2

[157] Gabel, *From Slavery to the Sorbonne*, p. 51

[158] McLaren, *Life in Schools*, p. 1

[159] hooks, *Teaching to Transgress*, p. 2; Patricia Hill Collins, *Black Feminist Thought* (New York: Routledge, 1991) p. 151

[160] Hutchinson, *Anna J. Cooper, A Voice*, p. 83

[161] "Negro College Graduates' Questionnaire," question # 11, AJC papers, courtesy of MSRC

[162] Cooper, *The Third Step*, p. 3

[163] Ibid.

[164] Ibid.

[165] Ibid.

[166] Ibid., p. 4

[167] Cooper, *The Third Step*, p. 4

[168] Baker-Fletcher, *A Singing Something*, p. 54

[169] Cooper, *The Third Step*, p. 15

[170] Undated document by Anna Cooper, AJC papers, courtesy of MSRC

[171] Francis R. Keller, *Slavery and the French Revolutionist*, pp. 5-6

[172] Baker-Fletcher, *A Singing Something*, p. 55

[173] Ibid., Keller, *Slavery and the French Revolutionist*, p. 6

[174] Gabel, *From Slavery to the Sorbonne*, p. 64

[175] Letter from Anna Cooper to Francis Grimke, 19 March 1932, Francis Grimke papers, courtesy of Moorland-Spingard Research Center, Howard University

[176] Melinda Chateauvert, "The Third Step: Anna Julia Cooper and Black Education in the District of Columbia, 1910-1960," in Darlene Clark Hine, ed., *Black Women in United States History*, vol. 5 (Brooklyn, New York: Carlson Publishing, 1990) p. 266

[177] Dabney, *The History of Schools for Negroes*, pp. 183-184

[178] Ibid., p. 184

[179] Ibid., p. 184; Baker-Fletcher, *A Singing Something*, p. 56

[180] Letter from Anna Cooper to Francis Grimke, 19 March 1932, Francis Grimke papers, courtesy of MSRC

[181] Dabney, *The History of Schools for Negroes*, pp. 184-185

[182] Chateauvert, "The Third Step: Anna Julia Cooper," p. 265

[183] Ibid.

[184] Letter from Anna J. Cooper to Francis Grimke, 19 March 1932, Francis Grimke papers, courtesy of MSRC

[185] Decennial Catalogue of Frelinghuysen University, n.d., p. 5

[186] Letter from Anna Cooper to Dr. Larned quoted in Chateauvert's "The Third Step: Anna Julia Cooper," p. 266

[187] Chateauvert, "The Third Step: Anna Julia Cooper," p. 266

[188] Letter from Anna Cooper to Francis Grimke, 19 March 1932, courtesy of MSRC

[189] Ibid.

[190] Chateauvert, "The Third Step: Anna Julia Cooper," p. 269

[191] Ibid.

[192] Ibid.

[193] Ibid., p. 270

[194] Ibid., p. 269

[195] "Negro College Graduates' Questionnaire," question #8 and #9, AJC papers, courtesy of MSRC

[196] Chateauvert, "The Third Step: Anna Julia Cooper," p. 272

[197] hooks, *Teaching to Trangress*, p. 3

[198] Ladson-Billings, *The Dreamkeepers*, p. 10

[199] hooks, *Teaching to Transgress*, p. 3

[200] Ibid., pp. 3-4

[201] Hutchinson, *Anna J. Cooper, A Voice*, p. 175

[202] Interview with Sterling Smith, the great-great-great nephew of Anna Julia Cooper, 19 October 1996

[203] Chitty, "The Life and Works of Anna Haywood Cooper," n. p.

[204] Cooper is quoted in Louise D. Hutchinson, *Anna J. Cooper, A Voice*, p. 188

[205] S. Fitzpatrick & M. Goodwin, *The Guide to Black Washington: Places and Events of Historical and Cultural Significance in the Nation's Capital* (New York: Hippocrene Books, 1990) p. 108

[206] Opal Easter, *Nannie Helen Burroughs and Her Contributions to the Adult Education of African American Women* (Ed.D. dissertation, Northern Illinois University, 1992) p. 38

[207] Evelyn Higginbotham, "Nannie Helen Burroughs,"in Darlene Clark Hine, eds., *Black Women in American History: An Historical Encyclopedia* (Blooming, Indiana: Indiana University, 1993) p. 201

[208] Earl L.Harrison, *The Dream and the Dreamer: An Abbreviated Story of the Life of Dr. Nannie Helen Burroughs and Nannie Helen Burroughs School* (Washington, D. C.: Nannie H. Burroughs Literature Foundation Publisher, 1956) p. 17

[209] "National Baptist Convention, Eighth Annual Assembly of the Women's Convention," 1908, NHB papers, courtesy of LC

[210] Harrison, *The Dream and The Dreamer*, p. 17

[211] William B. Pickens, *Nannie Burroughs and the School of the Three B's* (New York: n. p.) p. 20

[212] Harrison, *The Dream and The Dreamer*, p. 36, 37

213 Ibid., p. 36

214 Ibid.

215 Ibid.

216 Ibid.

217 "Circular of Information for the Seventh Annual Session of the National Training School for Women and Girls," Incorporated, 1925-26," p. 9, NHB papers, courtesy of LC

218 Harrison, *The Dream and the Dreamer*, pp. 36-37

219 Pickens, *Nannie Helen Burroughs*, p. 8

220 Easter, *Nannie Helen Burroughs*, p. 77

221 "Circular of Information for the Seventh Annual Session of the National Training School for Women and Girls," 1925-26," p. 9, NHB papers, courtesy of LC

222 Easter, *Nannie Helen Burroughs*, p. 82

223 "School Brochure," 1925-26," p. 1, NHB papers, courtesy of LC

224 Harrison, *The Dream and the Dreamer*, pp. 46-47

225 Ibid.

226 Aurelia Downey, *A Tale of Three Women: God's Call and Their Response* (Brentwood, Maryland: International Grapics, 1993) pp. 10-11

227 Pickens, *Nannie Burroughs*, p. 9

228 Frederick Mohr, ed., (1977) "Nannie Helen Burroughs," *The Quarterly Journal of the Library of Congress*, p. 356

229 Ibid.

230 "School Brochure," 1951, NHB papers, courtesy of LC, n. p.

231 Ibid.

232 Easter, *Nannie Helen Burroughs*, p. 86

233 Ibid.

234 V. Wolcott, "National Training School for Women and Girls," in Darlene Clark Hine, eds., *Black Women in American History: An Historical Encyclopedia* (Bloomington, Indiana: Indiana University Press, 1993) p. 869

235 "Negro History," School activities folder, n. d., NHB papers, courtesy of LC

236 Easter, *Nannie Helen Burroughs*, p. 142

237 Wolcott, "National Training School," p. 868

238 Lyle Slovick, *Nannie Helen Burroughs: The Role of Religion and Education in the Improvement of her Race* (M.A. Thesis, George Washington University, 1992) p. 104

239 Mohr, "Nannie Helen Burroughs," p. 356

240 "School Brochure," 1925-26, NHB papers, courtesy of LC, p. 13

241 Slovick, "Nannie Helen Burroughs," p. 104

[242] Easter, *Nannie Helen Burroughs*, p. 89

[243] Downey, *A Tale of Three Women*, p. 15

[244] "School Brochure," 1951, NHB papers, courtesy of LC, n.p.

[245] "Teacher applications," 1942, NHB papers, courtesy LC

[246] "School Brochure," 1951, NHB papers, courtesy of LC, n.p.

[247] Ibid.

[248] "Talk at Faculty Meeting," 1942, NHB papers, courtesy of LC

[249] "Code of Ethics," NHB papers, courtesy of LC

[250] Mohr, "Nannie Helen Burroughs," pp. 356-357

[251] Easter, *Nannie Helen Burroughs*, p. 89

[252] Ibid.

[253] Ibid., pp. 89-90

[254] Downey, *A Tale of Three Women*, p. 15

[255] Easter, *Nannie Helen Burroughs*, p. 90

[256] Ibid.

[257] Mohr, "Nannie Helen Burroughs," p. 356

[258] Wolcott, "National Training School," p. 868

[259] Evelyn Higginbotham, *Righteous Discontent: The Women's Movement in the Black Baptist Church, 1880-1920* (Cambridge, Massachusetts: Harvard University Press, 1993) p. 211

[260] Beverly Guy-Sheftall, *Daughters of Sorrow: Attitudes Toward Black Women, 1880-1929* (Ph.D. dissertation, Emory University, 1984) p.32

[261] Ibid., pp. 32-33

[262] Jacqueline Jones, *Labor of Love, Labor of Sorrow: Black Women, Work and the Family, from Slavery to the Present* (New York: Vintage Books, 1986) p. 113

[263] P. B. Worthman & J. R. Green, "Black Workers in the New South, 1865-1915," in N. I, eds., *Key Issues in the Afro-American Experience* (New York: Harcourt Brace Jovanovich, 1971) p. 53

[264] Jones, *Labor of Love*, p. 113

[265] Ibid., p. 128

[266] Cynthia Neverdon-Morton, *Afro-American Women of the South and the Advancement of the Race, 1895-1925* (Knoxville, Tennessee: University of Tennessee Press, 1989) p. 68

[267] Jones, *Labor of Love*, p. 153

[268] Sharon Harley, "For the Good of the Family and Race: Gender, Work, and Domestic Roles in the Black Community, 1880-1930," in M. Malson, eds., *Black Women in America: Social Science Perspectives* (Chicago: University of Chicago Press, 1988) p. 165

[269] Ibid.

[270] Ibid., pp. 161-162

[271] Higginbotham, *Righteous Discontent*, p. 212

[272] Ibid.

[273] Slovick, *Nannie Helen Burroughs*, p. 102

[274] Burroughs is quoted in L.H. Hammond, *In the Vanguard of the Race* (New York: Council of Women of Home Missions, 1923) pp. 22-23

[275] Higginbotham, *Righteous Discontent*, p. 214

[276] Ibid.

[277] Elisabeth Hansot, "Historical and Contemporary Views of Gender and Education," in S. K. Bilken & Diane Pollard, eds., *Gender and Education* (Chicago: University of Chicago Press, 1993) p. 16

[278] Ibid.

[279] P. J. Thompson, "Beyond Gender: Equity Issues for Home Economics in Education," in L. Stone, eds., *The Education Feminism Reader* (New York: Routledge, 1994) p. 188

[280] Hansot, "Historical and Contemporary Views," p. 16

[281] Thompson, "Beyond Gender," p. 189; Hansot, "Historical and Contemporary Views," p. 16

[282] Hansot, "Historical and Contemporary Views," p. 17

[283] Thompson, "Beyond Gender," p. 189; Higginbotham, *Righteous Discontent*, p. 215

[284] David Tyack & Elisabeth Hansot, *Learning Together: A History of Coeducation in American Public Schools* (New York: Russell Sage Foundation, 1992) p. 217

[285] Ibid.

[286] Higginbotham, *Righteous Discontent*, p. 215

[287] Ibid., Hansot, "Historical and Contemporary Views," p. 17

[288] Tyack & Hansot, *Learning Together*, p. 217

[289] Evelyn Brooks-Barnet, "Nannie Burroughs and the Education of Black Women," in S. Harley and R. Terborg-Penn, eds., *The Afro-American Woman, Struggles and Images* (Port Washington, New York: Kennikat Press, 1978) p. 101

[290] Ibid.

[291] Higginbotham, *Righteous Discontent*, p. 212

[292] Ibid.

[293] "School Brochure," 1925-26, NHB papers, courtesy of LC

[294] Mohr, "Nannie Helen Burroughs," p. 359

[295] Slovick, *Nannie Helen Burroughs*, p. 110

[296] Higginbotham, *Righteous Discontent*, p. 220

[297] Harrison, *The Dream and the Dreamer*, p. 68

[298] Hammond, *In the Vanguard of the Race*, p. 34

[299] Harrison, *The Dream and the Dreamer*, p. 74

[300] Downey, *The Tale of Three Women*, p. 19

[301] Higginbotham, *Righteous Discontent*, p. 293

[302] Pickens, *Nannie Helen Burroughs*, p. 7; Carol Perkins, *Pragmatic Idealism*, p. 89

[303] Carol Perkins, *Pragmatic Idealism: Industrial Training, Liberal Education and Women's Special Needs. Conflict and Continuity in the Experience of Mary McLeod Bethune and other Black Women Educators, 1900-1930* (Ph.D. dissertation, Claremont Graduate School and San Diego State University, 1986) p. 89

[304] Higginbotham, *Righteous Discontent*, p. 293

[305] Mohr, "Nannie Helen Burroughs," p. 359

[306] For the fund raising activities Burroughs engaged in see Opal Easter's "How the School was Funded," in *Nannie Helen Burroughs*, pp. 91-99

[307] Letter from Burroughs to Bradley, 1934, box 34, NHB papers, courtesy of LC

[308] Higginbotham, *Righteous Discontent*, p. 220

[309] Hammond, *In the Vanguard of the Race*, p. 33

[310] Ibid., p. 34

[311] Ibid.

[312] Easter, *Nannie Helen Burroughs*, p. 99

[313] Ibid.

[314] Ibid.

[315] Hammond, *In the Vanguard of the Race*, p. 33

[316] Wolcott, "National Training School," p. 868

[317] Ibid.

[318] Downey, *A Tale of Three Women*, pp. 19-20

[319] Interview with Mrs. Shirley Haynes, Prinicipal of the Nannie Helen Burroughs Elementary, Washinton, D. C. 28 October 1996

[320] Mohr, "Nannie Helen Burroughs," p. 359

[321] Ibid.

[322] Easter, *Nannie Helen Burroughs*, pp. 102-103

[323] Ibid., p. 103

[324] Ibid., p. 123

[325] Ibid.

[326] Higginbotham, "Nannie Helen Burroughs," p. 205

[327] *Orange County Review*, 1976, p. 6

[328] "Resolution of the Council," NHB papers, Vertical Files, courtesy of Martin Luther King Library, Washingtonian Division, Washington, D. C.

[329] Easter, *Nannie Helen Burroughs*, p. 119

[330] McLaren, *Life in Schools*, p. 204

[331] hooks, *Teaching to Transgress*, p. 2

[332] Ladson-Billings, *The Dreamkeepers*, p. 15

[333] Collins, *Black Feminist Thought*, p. 149

[334] Perkins, *Pragmatic Idealism*, p. 17

[335] Cooper, *A Voice from the South*, pp. 78-79

[336] Burroughs is quoted in Higginbotham, *Righteous Discontent*, p. 213

[337] Collins, *Black Feminist Thought*, p. 149

[338] Slovick, *Nannie Helen Burroughs*, p. 81

[339] Burroughs is quoted in Harrison, *The Dream and the Dreamer*, pp. 37-38

[340] "Negro College Graduate Questionnaire," question #45, AJC papers, courtesy of MSRC

[341] Ibid., question # 39

[342] hooks, *Teaching to Transgress*, p. 2

[343] McLaren, *Life in Schools*, p. 240

[344] See Ladson-Billings, *The Dreamkeepers*,

[345] Collins, *Black Feminist Thought*, p. 215

[346] Ibid., p. 217

[347] Pickens, *Nannie Helen Burroughs*, p. 29

[348] For a comprehensive list of Cooper's students see Hutchinson, *Anna J. Cooper, A Voice*, pp. 62-63

[349] Higginbotham, *Righteous Discontent*, p. 213

[350] For a list of former NTPS students and their successes, see the "Former Student Questionnaire," NHB papers, courtesy of LC

[351] Lisa Delpit, *Other People's Children*, p. 179

[352] Ladson-Billings, *The Dreamkeepers*, p. 15

[353] "Talk to the Faculty," 1942, NHB papers, courtesy of LC

[354] Ibid.

[355] "Good Teaching Procedures," NHB papers, courtesy of LC

[356] "Educational Aims," AJC papers, courtesy of MSRC

[357] "On Education," AJC papers, courtesy of MSRC

[358] "Teachers' Conference," 1941, NHB papers, courtesy of LC

[359] Ibid.

[360] Alice Smith is quoted in Lyle Slovick, *Nannie Helen Burroughs*, p. 135

[361] Senior student quoted in Slovick, *Nannie Helen Burroughs*, pp. 133-134

[362] Cooper is quoted in Chateauvert, "Anna Julia Cooper," p. 11

[363] Cooper, *A Voice from the South*, p. 45

[364] Barnett, "Nannie Helen Burroughs," p. 99

[365] Burroughs is quoted in Slovick, *Nannie Helen Burroughs*, p. 135

[366] "On Education," AJC papers, courtesy of MSRC

[367] Harrison, *The Dream and the Dreamer*, p. 26

[368] Higginbotham, *Righteous Discontent*, p. 213

[369] Slovick, *Nannie Helen Burroughs*, p. 106

[370] Harrison, *The Dream and the Dreamer*, p. 97

[371] Higginbotham, *Righteous Discontent*, p. 213

[372] Hutchinson, *Anna J. Cooper, A Voice*, p. 60

[373] Keller, *Slavery and the French Revolutionists*, p. 23

[374] H. B. Aptheker, *The Correspondences of W. E. B. Du Bois: Selections 1877-1934* (Boston, Massachusetts: University of Massachusetts Press, 1973) p. 411

[375] Cooper is quoted in Hutchinson, *Ann J. Cooper, A Voice*, p. 61

[376] Barnett, "Nannie Helen Burroughs," p. 102

[377] Samuel Bowles, & Herbert Gintis, *Schooling in Capitalist America: Educational Reform and the Contradictions of Economic Life* (New York: Basic Books, A Division of Harper Collins Publishers, 1976) p. 10

[378] See *Jones, Labor of Love,*

[379] Gabel, *From Slavery to the Sorbonne*, p. 51

# "Lifting as They Climb"

*The race that fails to do all within its power to*
*help itself will never rise. . . . God does not do*
*for us what we can do for ourselves.*
—NANNIE HELEN BURROUGHS[1]

*There is nothing in life really worth striving for*
*but the esteem of just men [and women] that*
*follows a sincere effort to serve the best of one's*
*power's in the advancement of ones' generation.*
—ANNA JULIA COOPER[2]

Anna Julia Cooper and Nannie Helen Burroughs were dedicated and committed to the education of their students. Education and schooling was viewed as a vehicle to liberation. As mentioned in Chapter 4, Cooper and Burroughs perceived themselves as social and moral agents of change. The era in which they came of age in, the Christian tenets to which they adhered to, their experiences with oppression and the educational institutions they attended, awaken in them a sense of responsibility to utilize their knowledge, skills and education for the enhancement of future possibilities of Black people.[3] Their roles were not only to educate the youth it also included becoming involved in resistance struggles in order to counter-act the repressive interlocking forces of oppression. This struggle took them beyond the boundaries of their classrooms and into the arena of civic and political activism. Thus, education became intertwined with civic and political activism.

Cooper and Burroughs come from a long historical tradition of Black women struggling against oppressive structures of American society. As politically and socially conscious educators, activists and feminists they continued that tradition. They dedicated their lives to improving the living conditions of the African American community. Hence, the two women embarked on a lifelong journey of "uplift" activities—self-help, social reform, institution building and community orga-

nizing. The goal was to ensure the survival of the group as well as the transformation of oppressive institutional structures.

Traditional histories and social science research have tended to ignore the importance of African American women's activist tradition. Sociologist Patricia Hill Collins notes that this "neglect stems from the exclusion of Black women's experiences as a subject of serious study from both traditional study and its Afrocentric and feminist critiques, as well as the problems existing in scholarly conceptualizations of power, resistance and activism."[4]

The life experiences of Cooper and Burroughs as social and moral agents for change will be examined in this chapter. An investigation of their activism and resistance to the interlocking structures of race, gender and class oppression enables us to conceptualize their struggle for group survival and institutional transformation within the context of the Black woman's activist tradition.

## SECTION I:
## DEFINING BLACK WOMEN'S ACTIVISM

African American women's activism and legacy of struggle for group survival and institutional transformation constitutes one of the several core themes of Black women's standpoint.[5] In her essay "The Emergence of Black Feminist Consciousness," womanist theologian Katie G. Canon illustrates this point clearly. She writes: "throughout the history of the United States, the interrelationship of White supremacy and male superiority has characterized the Black woman's reality as a situation of struggle—a struggle to survive in two contradictory worlds simultaneously, one White, privileged, and oppressive, the other Black, exploited, and oppressed."[6] Collins states that "in spite of the differences created by historical era, age, social class, sexual orientation, or ethnicity, the legacy of struggle against racism and sexism is a common thread binding African American women."[7]

According to Collins, African American women's activist tradition consists of two interdependent primary dimensions. The first is the struggle for group survival and the second dimension is for institutional transformation.[8] The first dimension consists of "actions taken to create Black female spheres of influence within existing structures of oppression." Collin explains that this "dimension does not directly challenge oppressive structures because direct confrontation is neither preferred nor possible." Instead, Black women resist oppressive structures indirectly by

undermining them. For example, Black women's "strategies of everyday resistance have largely consisted of trying to create spheres of influence, authority, and power within institutions, that traditionally have allowed [Black] women little formal authority or real power."[9] The organized group behavior of club and churchwomen has used a variety of strategies to undermine oppressive institutions. According to Collins, these "strategies occur in three settings: political and economic institutions, extended families, and the community."[10]

The second dimension consists of the struggle to change institutional structures of oppression.[11] Actions taken to eliminate legal discrimination and customary rules of discrimination "represent activism aimed at changing the rules that circumscribe African American women's lives."[12]

What follows is a brief historical overview of the African American women's legacy of struggle and activism and a discussion of Cooper's and Burroughs' social and political activities.

## BLACK WOMEN'S ACTIVIST TRADITION: AN HISTORICAL OVERVIEW

The inception of African American women's organizational experiences dates back to the antebellum era in which Black women organized "literary societies and benevolent organizations."[13] Black women founded mutual aid organizations and benevolent societies as early as 1793.[14]

Daughters of Africa, formed in 1821, was a "mutual aid organization of approximately 200 Black working-class women. Members bought groceries and supplies for the needy, paid sick benefits, and lent money to society members in emergency situations."[15] Researcher Dorothy Salem notes that "Philadelphia, the city with the largest nineteenth century Black population in the North, was a leading city for mutual aid societies by 1890."[16] In 1838, there were 119 black mutual aid societies with 7,372 members in Philadelphia.[17] In many northern cities, the African Dorcas Association "provided clothing, hats, and shoes for Black children."[18]

"The majority of these organizations' main efforts were associated with anti-slavery causes."[19] When slavery ended, African American women had considerable experience in operating mutual aid organizations and benevolent societies. "These self-help organizations continued into the Reconstruction era and Black women's activities were prominent."[20] The charity work provided by the mutual aid societies and

benevolent associations and the anti-slavery campaigns typified the com-
bined actions these women engaged in to struggle for group survival as
well as to transform laws and customs that contributed to the exploitation
and oppression of African Americans. W. E. B. Du Bois wrote "after the
[Civil] war the sacrifice of Negro women for freedom and uplift is one of
the finest chapters in their history."[21]

## IN RESPONSE TO RACE AND GENDER OPPRESSION AND ECONOMIC SUBORDINATION

The period from the 1880s to the 1920s was one of upheaval, dramatic
transformation and rapid expansion in American society. The economy
was shifting from an agrarian to an industrial and urbanized one. There
was a large influx of a poor immigrant European population and a more
rigidly defined class structure. One eighth of the population controlled
seven eighths of the country's wealth.[22] Also during this time, there was a
massive migration of African Americans from the southern states to the
urban Northeast and Midwest; heightened materialism of consumer cul-
ture; and a world war.[23]

Women's organizations came of age during this time. "The organi-
zation of the General Federation of Women's Clubs in 1890 signaled the
beginning of significant transformation in the lives of middle-class
White women."[24] There was an increase in women's participation in the
workforce. Women became actively involved in public activities such as
the suffragist movement. Social reform movements were prevalent dur-
ing this period. The movement, also known as "uplift" activities, gave
rise to a proliferation of self-help and social service programs through-
out the country. Historian Neverdon-Morton notes that the Progressive
Movement, and particularly Theodore Roosevelt and the Muckrakers,
helped to bring about needed reform and restructuring of White soci-
ety.[25] Hence, as argued by historian Kevin Gaines, "many middle-class
Americans embraced voluntaristic efforts, filling the void created by
government inaction."[26]

However, as discussed in Chapter 3, the late nineteenth and early
twentieth century was also a period of disillusionment and difficulty for
African Americans. In response to lynching, mob violence, literary at-
tacks on Black women's morality, legalized segregation and, in particu-
lar, the abysmal living conditions of African Americans, Black leaders
and intelligentsia articulated a universal call for "racial uplift." As a re-
sult, literary, intellectual and social reform activities and institution

building sprang from the "racial uplift" ideology.[27] There were a proliferation of Black women's clubs, forming first on local levels, then later on state and national and international levels. The civic and political activism that Black women participated in was part of a larger social welfare reform movement of both "White and Black women who were responding to the need to improve access to health care, adequate schools, housing, childcare, care for the elderly" and other societal ills that were plaguing the nation.[28] The organizations Black women created undertook educational, philanthropic and welfare activities to address the problems experienced by the African American community. Researcher Susan Smith notes that club work was "midway between the work of personal charity and professional institutions, and as such influenced the direction of social welfare work during the so-called Progressive era."[29]

The club women's areas of concern were multiple. Club women established day nurseries and kindergartens in response to the needs of mothers in the labor force. Other educational institutions were also established such as Nannie Helen Burroughs' National Training School for Women and Girls (later National Trade and Professional School for Women and Girls) as well as a number of colleges. There were 151 church-connected and 161 nonsectarian private Black schools founded with Black women contributing disproportionately to the founding and maintaining of these institutions.[30] Black reformers or activists also opened boarding homes to assist young Black female migrant workers from the South with housing, employment information, and job training. They also provided "moral instruction in order to protect them from the sexual dangers of urban areas."[31] In addition, orphanages, clinics, settlement homes, and homes for the elderly were institutions Black club women or church women founded during this era.

Issues relating to health were the second area of concern and thus addressed by these women. Black hospitals, while primarily initiated by Black and White men, depended on crucial support from Black women. According to historian Linda Gordon's research, "between 1890 and 1930 African Americans created approximately 200 hospitals and nurse-training schools, and women often took charge of the community organizing and fund-raising labor."[32] There were beneficial and insurance societies that paid sickness as well as burial benefits. "There were other organizations or societies that also paid for medicines. Some actually created their own health maintenance organizations."[33]

Cooper was actively involved in the Colored Woman's League, an

organization located in Washington, D. C. This organization was incorporated on January 11, 1894.[34] According to activist Mary Church Terrell, also a member, the Colored Woman's League (CWL) was the first club organized for the purpose of becoming a national organization. For many years, Cooper chaired the CWL Alley Sanitation Committee and was the corresponding secretary.[35] Under her active participation, the League founded day nurseries and kindergarten classes.

The model "kindergarten classes of the League predated the adoption of similar classes in the District's school system."[36] The League also conducted night classes in literature and foreign languages, an area of expertise of Cooper's. In addition, the League's Industrial Committee provided sewing classes and kitchen gardening.[37] The League also offered "rescue work among the city's poor and indigent population," and provided classes "designed to improve women's industrial and homemaking skills."[38] CWL worked in conjunction with churches and other benevolent societies, and as a result of this joint effort, African American women were given the opportunity to gain "marketable skills, viable alternatives and new hope."[39]

The overwhelming majority of the women involved in club work and reform activities were educators such as Cooper and Burroughs. Historian Sharon Harley argues that these middle-class educated women involved themselves in the social reform activities because they believed "they had a special responsibility to their respective communities which they alone could fulfill."[40] Harley notes that educators, who were involved in club activities, "often perpetuated a single image of themselves as magnanimous public servants rather than as individuals working solely to earn a living."[41] Mary Church Terrell, first president of the National Association of Colored Women, seemed to have echoed the sentiments of many of the educated middle-class women of that time when she wrote in 1940 the following:

> Colored women of education and culture . . . see that policy and self-preservation demand that they go down among the lowly, the illiterate and even the vicious, to whom they are bound by the ties of race and sex, and put forth every possible effort to reclaim them. . . . By discharging our obligations to the children, by coming into the closest possible labor question as it affects the race, by establishing schools of domestic science, by setting a high moral standard and living up to it, by purifying the home, colored women will render their race as service whose value it is not in my power to estimate or express.[42]

Many of the middle-class educated club women were steeped in the prevailing Christian Protestant doctrine of that time period. Indeed the evangelical Protestant movement of the late nineteenth and early twentieth century espoused religious morality and bourgeois middle-class values, and as historian Paula Giddings points out, "these women never questioned the suppose superiority of middle-class values or way of life, or had any romantic notions of the inherent nobility of the poor, uneducated masses."[43]

Sharon Harley explains that comments like the above indicate that it was "generally thought that a woman's level of educational attainment and professional success was supposedly indicative of her cultural, moral, and social standing while those who were uneducated did not possess culture and morality."[44] Even though the notion of "uplifting" the "lowly, illiterate" masses contained elements of race pride, solidarity, protest and a sense of evangelical progress, researcher Kevin K. Gaines observes that it also contained "vestiges of paternalistic, conservative neo-Calvinist morality grounded in cultural assumptions of human depravity."[45]

Cooper and Burroughs often evoked a feminist and racial analysis to the problems that plagued Black women. But when it came to analyzing the problems of the poor, they were often very conservative. Their analysis spoke to their social location as middle-class women. In many of their speeches and writings, they failed to intersect class oppression with race and gender oppression and link it to the institutional structures of industrial capitalism. Too often the masses were blamed for their own victimization.

Despite the bourgeois tendencies, the conservative analysis of the secular club women and the inherent contradictions in the "uplift" ideology, Black women involved in the social reform movement were motivated more by the problems and demands confronting the African American community than by benevolent intentions. Their fate as middle-class women was bound with that of the poor. Their experiences with racism and other forms of oppression linked them more intimately to their "lowly, illiterate" brothers and sisters. Oppression and exploitation in their lives were real. Racial terror and violence in the form of lynching and indiscriminate sexual assaults of Black women was rampant. The Ku Klux Klan had increased its membership to six million in the 1920s. Government sanctioned dejure, segregation denied Blacks basic rights, and access to class privileges, restricted their movements, and limited their career opportunities. Refusing to be victims, these

activists pulled their resources together and organized themselves in a resistance struggle against the oppressive institutional structures in nineteenth century America by creating opportunities and institutions that were beneficial for all in the African American community. Historian Darlene Clark Hine writes the following about the Black leaders of the women's clubs and organizations:

> . . . their giving of their time and effort and commitment to racial uplift work—including the protection for young black womanhood—and their endless struggle to create living space for segregated, often illiterate, unskilled, and impoverished blacks were [invaluable]. Black women's philanthropy . . . attempted to help blacks survive and to improve their lot by developing themselves. The goal was social change and individual improvement . . .[46]

As a result of their efforts, these women laid the foundation for the social reform movement of the twentieth century.

Many of the secular clubs excluded the uneducated, unskilled women because it was believed that these "women were in need of social and moral uplift and therefore lacked the refinement to join in the uplift process."[47]

Burroughs was critical of some of the clubs for not working directly with the uneducated, unskilled women involved in uplift activities. She argued that "secular club existing under the good name of charity are only agencies to bring together certain classes, at the exclusion of the poor, ignorant women who need to be led by the educated class."[48] Harley observes that the reluctance of the middle-class educated reformers to seek out non middle-class members in their clubs or organizations must have dissuaded those women from joining in the clubs or organizations. Instead, many of these less educated women became members in "churchwomen's groups and other benevolent societies, which often required less affluent lifestyles and had more practical benefits for their members."[49]

The biblical teachings of the Black church served as a "bulwark against segregation laws, and oppressive institutional structures that rendered African Americans nonentities."[50] Womanist theologian Katie Canon notes that it was "the biblical faith grounded in the prophetic tradition that helped Black church women devise strategies and tactics to make Black people less susceptible to the indignities and proscriptions" of an oppressive industrialized capitalist patriarchal social order.[51]

Church women were extremely active in "practicing their religious lives, yet at the same time were able to expand their concern for their moral development to their families, and ultimately take their concerns to the larger society through moral reform activities."[52] Historian Evelyn Higginbotham's research reveals that "feminist theologians of the Black Baptist church considered the combined efforts of Black and White women critical to the progress of African American people and to harmonious race relations."[53] Higginbotham notes that these women believed that by "Christianizing the home and educating the masses, women provided the key to solving the race problem in America."[54]

Black churchwomen envisioned themselves as "intermediaries between White America and their own people."[55] In response to a hostile environment that denied so many opportunities and services to the Black community, churchwomen became crusaders in the development of various social service improvement leagues and aid societies. Through the Black church, schools were established, health clinics, publishing houses, libraries, recreation centers, vocational training, relief to the needy, job placement and the list goes on.[56] Black religion and the Black church served as a sustaining force in the lives of the African Americans. And in the vanguard of this force were the women who, serving as what Canon calls "prophets," beckoning other women forth to engage in a resistance struggle against the interlocking structures of oppression.[57]

Historian Paula Giddings aptly observes that society failed to see Black women like Cooper and Burroughs as a "distinct political and social force."[58] At a time when White women were riding the wave of moral superiority that sanctioned their activism, "Black women were seen as immoral scourges."[59] As discussed in Chapter 3, nineteenth century American social thought and popular culture denigrated and "maligned the image of the Black woman, [and of Black men and children] on the grounds of racial make-up and questionable moral character."[60] Social scientists and others publically debated the "barbaric," "animalistic" nature of the African American. Black men were portrayed as sexually aggressive individuals who harbored desires of raping white women. The myth of the Black rapist emerged from this image and it justified the rampant lynching of Black men.[61] Black men were also portrayed as sambo—docile, loyal servant; and coon—sly, lazy, incapable of adapting to freedom right after slavery.

The socially constructed images of Black womanhood and Black manhood served to set African Americans aside from humanity—as the objectified "Other." All the images were and still are central to the inter-

locking systems of race, class and gender oppression. Cultural critic Angela Davis explains that the situation of "lynching, in turn complemented by the continued rape of Black women, became an essential ingredient of the postwar strategy of racist terror." This terror justified the brutal exploitation of African American labor.

In 1895, the First National Conference of Colored Women convened in Boston. The purpose of the conference was to discuss important issues pertaining to African Americans and in particular to women. The impetus for the gathering was due to a letter written by John Jacks, a pro-lynching president of the Missouri Press Association.[62] In his letter, "Jacks attacked Ida B. Wells for her anti-lynching activities and he defended the White South by maligning Black women for their 'immorality.' "[63] Consequently, the delegates had come together to decide upon a "strategy of resistance to the current propagandistic assaults on Black women and the continued reign of the lynch law."[64] As explained by Giddings, Black women were "frustrated by the negative images, sexual assaults and racial epithets hurled at them by the White patriarchal social structure, and by the failure of Black leaders to defend them or the race as a whole."[65] They were also concerned and outraged over the ongoing systematic and unchecked lynching of Black men. Cooper and Burroughs and other Black secular club and church women embarked on a lifelong mission to challenge the controlling images and re-define Black womanhood and manhood and to collectively eradicate economic exploitation, gender subordination and racial oppression. The objective of this mission was to ensure the survival of the group as well to transform American societal institutions. The delegates also came together to

> . . . talk over not only those things that are of vital importance to us as women, but also the things that are of especial interest to us as colored women. The training of our children . . . how they can be prepared for occupations . . . of the race . . . [as well as] . . . to prepare them to meet the peculiar conditions in which they shall find themselves [and] how to make the most of our own, to some extent, limited opportunities. These are some of our peculiar questions to be discussed.[66]

Cooper was one of the delegates to address the first evening's convention goers. She delivered a paper that outlined the need for organizing Black women nationally.[67] Elected president Mary Church Terrell stood before the delegates and urged the women to "decide if it be not time for us to stand before the world and declare ourselves and our principles ...

The time is short but everything is ripe; and remember, earnest women can do anything."[68] Researcher Louise Hutchinson writes that the meeting was well attended by representatives from fourteen states and fifty-three clubs.[69]

During this era of difficulty and despair, these women felt that they had their work cut out for them, and the best way to resist the forces of oppression was to engage in a collective struggle on a national level. The result of this convention lead to the formation of one of the leading women's association club that sought to combat race, class and gender oppression and to express a sense of identity and solidarity among Black women on a national level. The National Association of Colored Women (NACW) was established in 1896 when the National Federation of Afro-American Women, located in Boston and the National League of Colored Women located in Washington, D. C. combined.

NACW was established on the national level in order to share experiences, pool resources, and wield greater influence to achieve common ends.[70] Also, racism in the White women's organizations, such as the General Federation of Women's Clubs (GFWC) and the National American Woman Suffrage Association excluded the membership of African American women. Mary Church Terrell was elected NACW first president. Cooper and later Burroughs were also members in this organization.

There were a number of things in common with the NACW and GFWC. Each adhered to the prevailing notion of the "so-called superiority of middle-class values or lifestyles; believed in the importance of the home and women's moral influence within it"; provided social services to the community; struggled for women's equality and progress.[71] However, there were significant variations between White and Black women's clubs stemming from the perspectives and experiences that characterized Black and White women's lives. "White women had no need to vindicate their dignity nor did they have the severe problems of racial discrimination that compounded the plight of African American women in all aspects of their lives."[72]

These clubs reflected the feminist concerns of Black women as well as concerns for the Black community. African American Club organizer and social reform activist Josephine St. Pierre Ruffin points that the clubs were organized not "for race work alone, but for work along the lines that make for Black women's progress."[73] Like Ruffin, Cooper and Burroughs also clearly understood that issues of race and gender were inextricably linked. Cooper wrote that the Black woman "is confronted by both a woman question and a race problem."[74]

Cooper and Burroughs were Black, female, products of humble, poor backgrounds, daughters of former slaves/domestic workers, who came of age in the South during the Reconstruction and post-Reconstruction era. Their experiences and understanding of oppression intersected with their race and gender simultaneously. Their perspectives and theoretical frameworks reflected an "unique angle of vision of self, community, and society"—a Black feminist standpoint—which emerged from their multiple identities and experiences with oppression. Thus their struggle for group survival and institutional transformation was one that involved the battle against racism and sexism and classism. Burroughs and Cooper revealed in their writings, speeches and the activities they each undertook, an awareness that being Black, female and poor summoned them to engage in multiple sets of responsibilities. "Responsibilities," as Cooper stated, "which ramify through the profoundest and most varied interests of [the Black woman's] country and race."[75]

Both Black club women and church women activists operated in the belief that they stood firmly on the "threshold of the woman's era."[76] Abolitionist, lecturer, essayist, poet and novelist Francis E. W. Harper stated: "If the fifteenth century discovered America to the Old World, the nineteenth is discovering woman to herself."[77] Echoing similar sentiments Cooper writes:

> To be alive . . . at such an epoch is a privilege, to be a woman . . . sublime. . . . To be a woman in such an age carries with it a privilege and an opportunity never implied before. But to be a woman of the Negro race in America, and to be able to grasp the deep significance of the possibilities of the crisis, is to have a heritage, it seems to me, unique in the ages. . . . I can honor my name and vindicate my race!. . . . What a responsibility . . . to have the sole management of the primal lights and shadows! Such is the colored woman's office. She must stamp weal or woe on the coming history of this people. May she see her opportunity and vindicate her high prerogative.[78]

Cooper, the activist and one of the leading African American spokeswoman of her time, argued her strongly held belief that it was the Black woman who is the vital agent for racial and gender progress in America. In her 1893 speech at the World's Congress of Representative Women, Cooper made the following statement:

> Let woman's claim be as broad in the concrete as in the abstract. We take our stand on the solidarity of humanity, the oneness of life, and the

unnaturalness and injustice of all special favoritisms, whether of sex, race, country or condition. . . . A bridge is no stronger than its weakest part, and a cause is not worthier than its weakest element. Least of all can woman's cause afford to decry the weak. We want them, as toilers for the universal triumph of justice and human rights, to go to our homes from this Congress, demanding an entrance not through a gateway for ourselves, our race, our sex, or our sect, but a grand highway for humanity. The Colored woman feels that woman's cause is one and universal; and that . . . universal title of humanity to life, liberty, and the pursuit of happiness is conceded to be inalienable to all; not till then is woman's lesson taught and woman's cause won—not the white woman's, nor the black woman's, nor the red woman's but the cause of every man and of every woman who has writhed silently under a mighty wrong. Woman's wrongs are thus indissolubly linked with all undefended woe, and the acquirement of her "rights" will mean the final triumph of all right over might, the supremacy of the moral forces of reason, and justice, and love in the government of the nations of earth.[79]

In less than twenty years after its founding, NACW represented 50,000 women in twenty-eight federations and over 1,000 clubs.[80] By 1913, NACW had affiliated organizations in thirty states, Canada, Liberia and Madagascar.[81] The organization adopted the motto "Lifting as We Climb" because as stated by Mary Church Terrell "policy and self-preservation . . . demand that we go down among the lowly, the illiterate . . . whom we are bound by race and sex, and . . . uplift and reclaim them."[82] NACW implemented mother's clubs, day nurseries, kindergartens, and schools of domestic science and innumerable other institutions and programs.[83]

As a member of NACW, Cooper was appointed to head the Committee to Study the Georgia Convict System. NACW actively supported the "major women's reform movements seeking moral purity, temperance, self-improvement, and suffrage."[84] Anti-lynching campaigns were a major priority in their resistance struggle.

Cooper and Burroughs as well as other NACW members were also active participants in the women's suffrage movement. Their struggle for the women's vote was not separate from the struggle for the Black vote. As women who experienced the interlocking structures of oppression, the vote represented the key to their empowerment. Margaret Murray Washington, a NACW leader and wife of Booker T. Washington, following views reflected the consensus:

Colored women, quite as much as colored men, realized that if there is
ever to be equal justice and fair play in the protection in the courts
everywhere for all races, then there must be an equal chance for
women as well as men to express their preference through their votes.[85]

Burroughs often spoke of the vote as giving the Black woman

. . . the respect and protection that she needs. . . . Under present condi-
tions, when she appears in court in defence [sic] of her virtue, she is
looked upon with amused contempt. She needs the ballot to reckon
with men who place no value upon her virtue, and to mould healthy
public sentiment in favor of her own protection.[86]

African American men, from Frederick Douglas to W. E. B. Du
Bois, as a group supported and worked for the enfranchisement of
women.[87] In fact, Du Bois emerged as the leading male advocate in the
twentieth century. Du Bois believed that the "enfranchisement of [Black
women] will not be a mere doubling of our vote and voice in the nation,
but will lead to a "stronger and more normal political life."[88]

NACW established a Suffrage Department to impart to its members
knowledge about legal and government affairs, ". . . so that women may
be prepared to handle the vote intelligently and wisely . . ."[89]

Mary Church Terrell's biographer Beverly Jones argues that NACW
was radically new because for the "first time Black women controlled an
organization established on a national level."[90] NACW also created the
first cohesive network of communication among Black women through-
out the United States. Jones notes that NACW became a "laboratory that
fostered leadership skills among its members." However, it was a conser-
vative organization that "did not aim to alter the domestic nature of the
social position of its members, but to make them better wives and moth-
ers."[91] As explained by Giddings these women believed in the impor-
tance of the home and woman's moral influence within it.[92] The home as
well as society had to be purified and it was their job to do it. However,
there were women such as Cooper and Burroughs who felt that Black
women must also become involved in the public sphere but not just as
wage earner.[93] ". . . no woman," argued Cooper, "can possibly put herself
or her sex outside any of the interests that affect humanity. All depart-
ments in the new era are to be hers . . ."[94]

NACW was the leading national race organization that predated the
establishment of the NAACP by fifteen years. After the NAACP was cre-

ated, "NACW remained the leading black national organization working for the individual and collective advance of the Black community."[95] This organization was a new national voice through which Cooper and Burroughs and other Black clubwomen could struggle to improve the personal lives and general standard of life within the African American community.

NACW was also a mechanism through which Cooper and Burroughs could organize the community for political action. Within this female sphere of influence, NACW achieved its legacy shaping leadership and building institutions through the vanguard of Black women.

## SECTION II:
## ANNA JULIA COOPER'S AND NANNIE HELEN BURROUGHS' STRUGGLE FOR GROUP SURVIVAL AND INSTITUTIONAL TRANSFORMATION

"I am my sister's keeper!" Cooper proclaimed, "should be the hearty response of every man and woman of the race." As a "vital agent" for race, class and gender progress and institutional transformation, Cooper and Burroughs practiced what they preached. They spent their lives advocating equal opportunities and human rights for all Americans. Their form of activism has consisted of both the struggle for group survival as well as the struggle for institutional transformation.

Cooper, like Burroughs and many other women activists, held multiple memberships in various clubs and organizations in the Washington, D. C. vicinity. Cooper's membership included the National Advancement of the Association of Colored People, World Fellowship of Religions, National Education Association, Guardian of Camp Fire Girls and the La Societe Des Amis De La Langue Et De La Culture Francaises.[96]

Cooper was one of the founding and staffing members of the Colored Social Settlement House, (which later became the Southwest Settlement House in the District of Columbia) in 1901. Harley points out that the settlement houses, founded and operated by Black women educators, reflected the dedication of these women to their respective communities.[97] The Settlement House that Cooper founded, staffed and supervised was "associations of men and women of the educated classes who take up residence in the poorer quarters . . . for the purpose of bringing culture, knowledge, . . . recreations and . . . personal influence to bear upon the poor in order to better and brighten their lives."[98] The Settlement House also provided classes in music, cooking, sewing, and "the

principles of domestic economy in the homes of those families" in need of such services.[99] A visiting cook would go out to the homes of individual families in need. In addition the Settlement provided a daily milk dispensary to babies in low-income neighborhoods, along with the free services of a doctor and nurse. As a result of those services, the rate of infant mortality had greatly diminished.[100] It also provided special entertainment activities for the community during the era of Segregation. On Tuesdays and Thursdays, the Settlement House opened a reading room for the neighborhood public school children's use and access. Friday nights were opened for social entertainment. Music classes were held on Saturdays and Sunday afternoons provided singing by the Southwest Washington Choral Society.[101] It is interesting to note that the activities provided for boys and girls defined them to the prevailing philosophies of male and females "proper" functions in society. The activities provided for the boys were ones that would "develop [them] into strong and wholesome men and sober citizens." They included "fun and games and play" and physical training classes. The activities for the girls were story telling, music and sewing. The goal was to ensure that "these girls [will acquire] a better spirit and higher standards of living into their homes [and] . . . become . . . more useful, happier, better women."[102]

Concerns for "better lodging places for [Black] girls and women seeking work in Washington" gave rise to a small group of educated Black women known as the Book Lovers, to establish the Colored Young Women's Association (CYWCA) now the Phyllis Wheatley YWCA, in the Spring of 1905. The "Y" became the first YWCA to be founded in the District of Columbia.[103] As a life member and Board of Directors of the CYWCA, Cooper was among the early developers of recreational and social development programs for young African American women in the District of Columbia.

According to Hutchinson, the "Y" grew to 193 members by the end of the first year.[104] After five years of growth and expansion, it moved to new quarters and implemented "sewing, cooking, Bible study, missionary work, music, and Negro history classes."[105] The CYWCA was an important institution in the community. The activities Cooper had at the "Y" "attempted to address the educational and vocational needs of the African American community in addition to the religious, social and welfare needs."[106]

Cooper was considered an intellectual and scholar by her peers. Her opinions were valued and respected. She was often sought after to give lectures pertaining to a variety of topics. In between her teaching and

civic activities, Cooper traveled the country and abroad lecturing on multiple issues concerning race uplift, women's equality, national issues, and issues pertaining to education. Her speeches, writings and lectures consistently reflected a Black feminist analysis. From her lived experiences she clearly understood that African American women confronted both a "woman question and a race problem." Many of her lectures reflected the issues discussed in her 1892, book, *A Voice from the South: By a Black Woman of the South.* This book consists of a collection of essays that reflect a Black feminist and global analysis of racism, sexism, imperialism and colonialism. One of her essays strongly argues for higher education of Black women. This work "marked her only book-length survey of the full landscape of Black politics and culture, the women's movement, and American society."[107]

As an intellectual and activist, Cooper was invited to speak at the first Pan-African Conference in London's Westminster Hall in 1900. She was one of two women to present at the "international gathering of African, Afro-Caribbean, and African American descendants."[108]

The close of the nineteenth century found Cooper and the women of the NACW and the CWL assiduously involved in a variety of community activities that would not only extend into the twentieth century but would also involve the next generation of club women.

Nannie Helen Burroughs enters the picture at this juncture. She indeed represented the next "generation of club women, who would continue and expand the work" that Terrell, Cooper and others initiated "within a religious context" and as a NACW member.[109] Burroughs was a high school student at M Street when her favorite teachers and role models, Cooper and Terrell, were activists in NACW and a host of other organizations. After leaving Washington, D.C. in 1896 and them returning eleven years later, Burroughs would join her former teachers/sisters/comrades in the struggle for social justice. Like Terrell and Cooper, Burroughs was an active participant in NACW as well. I will return to her participation in NACW later.

Burroughs became actively involved in club and church work years prior to joining NACW. While living in Louisville, Kentucky she organized a local club call the Women's Industrial Club for the purpose of attending to the needs of women workers.[110] Burroughs rented a house and began evening classes teaching a variety of things, such as bookkeeping, typing, cooking, laundry, hygiene and childcare.[111] To help cover the expense of the classes, the women sold lunches to local workers and paid ten cents a week for membership dues.[112] The rapid expansion of the

club led Burroughs to hire additional staff to assist her with the teaching.[113] Extremely impressed with the work she was doing in Louisville, a local White owned newspaper printed the following commentary:

> Probably, no Women's Club in Louisville . . . is doing as much practical, far reaching good as the association of colored women. . . . This organization is in its fifth year and was instituted by a remarkable young colored woman, Miss Nannie Burroughs, who had added to her natural abilities a very liberal education, and who is fired with enthusiasm for the advancement of her race . . . along the most practical lines. . . . She has found time . . . to devote a large interest to local needs. Kentucky delights to honor her and call her "Our own Nannie Burroughs."[114]

Burroughs was a devoted Baptist and active participant in the church from childhood until her death. Did religion play a significant role in Burroughs life because her father was a minister; her mother a devoted Christian; and or the fact that the Black church was considered the single most important institution in the African American community? Burroughs firmly believed that "religion has made the Negro know that he can do something to help himself despite his condition."[115] Religion obviously gave her the faith, strength and resiliency she needed to "Climb Up on the Rough Side of the Mountain," as the title of the hymn suggests. As a young child and later as an adult, Burroughs was a member of the Nineteenth Street Baptist Church in Washington, D.C. Her pastor, Walter H. Brooks, seemed to have been a role model, confidant and source of inspiration for Burroughs. Later in life she thanked him "for his noble example, constant advice, and unstinted help in the work of the Lord, to which I have dedicated my life."[116] Pastor Brooks compassionately believed in the education of women on the post-secondary level. Hence, his church held the National Association of Colored Women founding meeting in 1896.[117]

At the National Baptist Convention (NBC) in Richmond, Virginia, Nannie Helen Borroughs gained national recognition in 1900.[118] She delivered a speech which "expressed the discontent of Black women and proclaimed their burning zeal to be co-workers with Baptist men in the Christian evangelization of the world."[119] In the speech she claimed:

> For a number of years there has been a righteous discontent a burning zeal to go forward in His [Christ's] name among the Baptist women of

our churches and it will be the dynamic force in the religious campaign at the opening of the 20th century.[120]

Her feminist analysis of sexism within the Black church gave rise to her becoming a national leader in the NBC. Historian Evelyn Higginbotham notes that her speech resulted in the establishment of the Women's Convention (WC), an Auxiliary to the NBC. The objectives of WC were to organize women and children for the purpose of collecting and raising money for education and missions in the United States and overseas, disseminate information, and to assist in the progress of the activities of existing women's clubs and organizations. Burroughs was elected corresponding secretary to WC. She was twenty-two years old at the time of her election.[121]

Burroughs, often described as an "eloquent speaker and organizational genius, was the dynamic force behind WC."[122] "What began in 1900 as an organization with 38 members, grew to nearly a million women by the year 1903," due to Burroughs' active recruitment.[123] According to Brooks, "Burroughs' charisma and leadership abilities epitomized the essence of the Black Baptist women's movement, which she led until her death in 1961."[124] Under her leadership and guidance, WC embarked on a number of projects that attacked institutionalized race, class and gender oppression. WC protested against legalized segregation and the negative stereotyping of African Americans in literature, film, newspapers and on the stage. WC also called for the removal of classroom textbooks that denigrated and maligned African Americans. NAACP and NACW, WC demanded anti-lynching legislation. Burroughs wrote a report calling for the "passage of anti-lynching legislation and for the repeal of the segregated rail coach law."[125] In 1919, the NAACP, NACW and WC recommended that "churches and Sunday schools throughout the nation dedicate the Sunday before Thanksgiving to fast and pray in order to protest the ongoing unchecked lynching, sexual violence and other discriminating and barbarous treatment of its colored people."[126] Burroughs severely criticized Woodrow Wilson and his World War I slogan, "Make the world safe for democracy," for not passing an anti-lynching bill and putting an end to segregation.

Burroughs' work with NACW began in 1912. She served as "Regional President in 1922."[127]

Working class women were not members in large numbers in the mostly middle-class NACW club, hence their personal concerns and issues were not being articulated from their voices at NACW meetings.

This led Burroughs to suggest to Mary B. Talbert, president of NACW, that a conference was needed to discuss issues relating to working women. With Burroughs' insistence, at the 1920 biennial meeting of the NACW, "the leadership called for working women to affiliate with the club women."[128] Through NACW, Burroughs established the National Association of Wage Earners. This affiliated club was created for the purpose of: the development of efficient workers; to assist women in finding . . . work; to elevate the migrant . . . workers and incorporate them permanently in service; standardize living conditions; secure wages that will enable women to live decently; to assemble . . . grievances of employers and employees into a set of common demands and strive, mutually, to adjust them; to enlighten women to the value of organization; to make and supply . . . uniforms for working women . . . through . . . profit sharing enterprise operated by the Association; to influence just legislation affecting women wage earners.[129] Burroughs was president of this association and Mary McLeod Bethune was vice-president. The association provided a forum for working-class women to voice the problems and issues of concern from their perspectives and experiences.

Another project of Burroughs, McLeod-Bethune and other members of NACW was the preservation of the Frederick Douglass home in Washington, D. C. The result of their efforts led to his home becoming a national memorial.

Following the ratification of the nineteenth amendment in 1920 giving women the right to vote, a significant number of Black women activists became involved in political organizations.[130] The National League of Republican Colored Women was established in Washington, D. C. with Burroughs as the president and Mary Church Terrell as treasurer in 1924. During that time, an overwhelming majority of African Americans were Republicans (President Lincoln's Party). Burroughs biographer Opal Easter notes that the women in this organization were "active in educating the electorate, the selection of Black leadership and discussing pending legislation and all political matters affecting Republican Colored women and African Americans."[131] This organization often conducted "membership drives in black churches as well as among female secret orders."[132] As a political and social outspoken activist who viewed the vote as a tool of empowerment Burroughs felt that

> . . . since the Negro women have the ballot, they must not under value
> it. They must study municipal problems—men and measures, parties
> and principles. The race is doomed unless Negro women take an active

part in local, state and national politics. They must study and measure the men and women who aspire to public office. They must oppose parties and candidates opposed to equal citizenship. They must organize to fight discrimination and class legislation. They must not sell their votes. They must use them to elect the right brand of Americans to office.[133]

Burroughs was actively involved in the NAACP and also served as a member of the Executive Board of the National Urban League. She served as head of the Young Women's Work Department in 1912 and as a Regional President in 1922.[134]
The problems of working class women, especially domestic workers were often a concern of Burroughs. In a column of the black newspaper, the Pittsburgh Courier, she wrote the following:

The Negro woman "totes" more water; grows more corn; picks more cotton; washes more clothes; cooks more meals nurses more babies; mammies more Nordics; supports more churches . . . takes more punishment; gets less protection and appreciation than do the women in any other civilized group in the world. She has been the economic and social slave of mankind.[135]

Burroughs, like Cooper and others, can be perceived as Pan-African global feminists because of their concerns for people of color abroad particularly Africans in the Diaspora and on the African continent. The struggle for self-determination, political autonomy, and economic independence were issues concerning African and Caribbean nations. Interests in the experiences, lives, oppression and struggles of Third World people of color and the efforts to establish linkages with oppressed people abroad was a significant aspect of Black women's activism. In 1924, The "International Council of Women of the Darker Races came into existence by the racial uplift impulses and the international educational projects of the Black women's club and church women's activities."[136] The Council was organized by several women including Burroughs, McLeod-Bethune, Terrell and Margaret Murray Washington. The objective of this organization was to study the history of peoples of color throughout the world and disseminate knowledge about them for the purpose of engendering racial pride and respect.[137] The group met regularly at Burroughs' school. The council studied the situation of women and children of color internationally and it also supported

fund-raising efforts to help Adelaide Casely-Hayford, an African educator and feminist, build a school in the West African country of Sierra Leone.

## SUMMARY AND CONCLUSION

To understand Anna Julia Cooper's and Nannie Helen Burroughs' activism and resistance to the interlocking structures of oppression, their stories and experiences needed to be told within the historical context in which they lived. Hence, this chapter attempted to explore and conceptualized their activism during the late nineteenth and early twentieth century and within the Black woman's activist tradition.

The contours of Cooper's and Burroughs' civic and political activism were shaped by the social upheavals and transformation of the late nineteenth century, social reform movements, suffrage movement, racial oppression, gender subordination, and economic exploitation. To combat the repressive institutional forces of oppression and exploitation, Cooper and Burroughs and other Black secular club and church women collectively organized on a local, national and international level.

The actions and resistant strategies they engaged in within these organizations typified the struggle for group survival and institutional transformations. These strategies included providing services for the community, building health and educational institutions, petitions, verbal protests, calls to actions, anti-lynching campaigns, and forging alliances on a national and international level. Their efforts not only provided social welfare services to the Black community, but also they turned to the state to ensure the permanency of such programs, thereby laying the foundation for the modern welfare state.

The national organizations Anna Julia Cooper and Nannie Helen Burroughs founded (NACW, WC) represented the visions and abilities of their efforts to improve and maintain the lives of African Americans. NACW and WC provided a space where a culture of resistance was fostered and cultivated. From this milieu emerged Cooper and Burroughs as cultural workers armed with leadership tools and a political conscienceness to engage in liberatory acts of resistance.

NACW and WC created spheres of influence, authority and power that afforded Cooper and Burroughs the opportunity to speak more profoundly about the problems specific to them as Black women and problems that affected them as a race. Self-help, racial uplift activities,

community development, transforming societal institutions, and women's equality were all important objectives of Anna Julia Cooper's and Nannie Helen Burroughs' civic and political activism. In analyzing Cooper's and Burroughs' work as activists, we see their strength and resiliency came from their ability to build sustaining institutions for group survival and challenging the legal and customary rules governing women's and Blacks' subordination. It is the example of courage and determination displayed by Cooper and Burroughs in their struggle to resist victimization, exploitation, dehumanization, and subordination that best epitomize their overall activism.

## NOTES

[1] "Student Records and Miscellany," NHB papers, courtesy of Manuscript Division, LC

[2] Undated document by Anna Cooper, AJC papers, courtesy of MSRC

[3] Cynthia Neverdon-Morton, *Afro-American Women of the South and the Advancement of the Race, 1895-1925* (Knoxville, Tennessee: University of Tennessee Press,1989) pp. 7-8

[4] Patricia Hill Collins, *Black Feminist Thought: Knowledge Consciousness and the Politics of Empowerment* (New York: Routledge, 1991) p. 140

[5] Ibid., p. 23

[6] Katie G. Canon, "The Emergence of Black Feminist Consciousness," in *Womanism and the Soul of the Black Community* (New York: The Continuum Publishing Co, 1995) p. 47; also cited in Collins, *Black Feminist Thought,* p. 22

[7] Collins, *Black Feminist Thought,* p. 22

[8] Ibid., p. 141

[9] Ibid., p. 146

[10] Ibid.

[11] Ibid., p. 141

[12] Ibid., p. 154

[13] See Angela Davis, "Black Women and the Club Movement," in *Women, Race and Class* (New York: Random House, 1981) pp. 127-136; also see Stephanie J. Shaw, "Black Club Women and the Creation of the National Association of Colored Women," in Darlene Clark Hine, ed., *We Specialize in the Wholly Impossible: A Reader in Black Women's History* (Brooklyn, New York: Carlson Publishing, 1995) pp. 433-448

[14] For information on Black women's organization of the past, see Paul Philips Cooke, ed., *Black Women of America: A Rose by Any Other Name, The 71st National Celebration of Afro-American History, African American Women:*

*Yesterday, Today, and Tomorrow* (Washington, D. C.: Associated Publishers, Inc., 1996); also see Jaime Hart et al, "Black Women in the United States:" *A Chronology in Black Women in America: An Historical Encyclopedia*, vols. 1 & 2 (Brooklyn, New York: Carlson Publishing Co., 1993)

[15] Shaw, "Black Club Women," p. 435

[16] Dorothy Salem, "National Association of Colored Women," in Darlene Clark Hine, ed., *Black Women in America: An Historical Encyclopedia*, vol. 2 (Bloomington, Indiana: Indiana University Press, 1993) p. 842

[17] Shaw, "Black Club Women," p. 435

[18] Salem, "National Association of Colored Women," p. 842

[19] See Davis, "Black Women and the Club Movement," pp.127-136

[20] See Shaw, "Black Club Women," pp. 433-448

[21] William E. B. Du Bois, *Dark Waters: Voices from Within the Veil* (New York: Schocken Books, 1969) p. 178

[22] Evelyn Higginbotham, *Righteous Discontent: The Women's Movement in the Black Baptist Church, 1880-1920* (Cambridge, Massachusetts: Harvard University Press, 1993) p. 185; also Neverdon-Morton, *Afro-American Women*, pp. 8-9

[23] Higginbotham, *Righteous Discontent*, p. 185

[24] Beverly Guy-Sheftall, *Daughters of Sorrow: Attitudes Toward Black Women: 1890-1929* (Ph.D. dissertation, Emory University, 1984) p. 38

[25] Neverdon-Morton, *Afro-American Women*, p. 9

[26] Kevin K. Gaines, *Uplifting the Race: Black Middle-Class Ideology in the Era of the New Negro:1890-1935* (Ph.D. dissertation, Brown University, 1991) p. 24

[27] Ibid., 31

[28] Susan Smith, "Social Welfare Movement," in Darlene Clark Hine, ed., *Black Women in American History: An Historical Encyclopedia*, vol. 2 (Bloomington, Indiana: Indiana University Press, 1993) p. 1088; Linda Gordon, "Black and White Visions of Welfare: Women's Welfare Activism, 1890-1945," in Darlene Clark Hine, ed., *We Specialize in the Wholly Impossible* (Brooklyn, New York: Carlson Publishing, 1995) pp. 449-489

[29] Smith, "Social Welfare Movement," p. 1086

[30] Gordon, "Black and White Visions of Welfare," p. 454

[31] Smith, "Social Welfare Movement," p.1087

[32] Gordon, "Black and White Visions," p. 454

[33] Ibid.

[34] Mary Church Terrell, "The History of the Women's Club Movement," in Beverly Jones, ed., *Quest for Equality: The Life and Writings of Mary Eliza Church Terrell, 1863-1954* (1940 reprinted: Brooklyn, New York: Carlson Publishing, 1990) p. 316

[35] Louise D. Hutchinson, *Anna J. Cooper: A Voice from the South* (Washington, D. C.: Smithsonian Institution, 1981) p. 93

[36] See Sharon Harley, (1988) "Beyond the Classroom: The Organizational Lives of Black Female Educators in the District of Columbia, 1890-1930," *Journal of Negro Education*, vol. 51, no. 3, pp. 254-265

[37] Terrell, "The History of the Women's Club Movement," p. 319

[38] Hutchinson, *Anna J. Cooper: A Voice from the South*, p. 93

[39] Ibid.

[40] Harley, "Beyond the Classroom," p. 256

[41] Ibid., p. 257

[42] Mary Church Terrell, "What Role is the Educated Negro Woman to Play in the Uplifting of her Race?" in Beverly Jones, ed., *Quest For Equality: The Life and Writings of Mary Eliza Church Terrell, 1863-1954* (Brooklyn, New York: Carlson Publishing, 1990) pp. 154-156

[43] Paula Giddings, *When and Where I Enter: The Impact of Black Women on Race and Sex in America* (New York: William Morrow, 1984) p. 95

[44] Harley, "Beyond the Classroom," p. 258

[45] Gaines, *Uplifting the Race*, p. 25

[46] Darlene Clark Hine, "We Specialize in the Wholly Impossible:" The Philanthropic Work of Black Women, in K. K. McCarthy, ed., *Lady Bountiful Revisited: Women, Philanthropy and Power* (Brunswick: Rutgers University Press, 1990) p. 71

[47] Harley, "Beyond the Classroom," p. 258

[48] Ibid.

[49] Ibid., p. 260

[50] Canon, "The Emergence of Black Feminist Thought," p. 52

[51] Ibid.

[52] Emilie M. Townes, *Womanist Justice, Womanist Hope* (Atlanta, Georgia: Scholars Press,1993) pp. 81- 82

[53] Evelyn Higginbotham, *Righteous Discontent*, p. 143

[54] Ibid.

[55] Ibid.

[56] Ibid., pp. 173-174

[57] Canon, "The Emergence of Black Feminist Consciousness," p. 56

[58] Giddings, *When and Where I Enter*, p. 82

[59] Ibid.

[60] Guy-Sheftall, *Daughters of Sorrow*, p. 43

[61] See Angela Davis 1981 "Rape, Racism and the Myth of the Black Rapist," in *Women, Race and Class*, (New York: Random House) pp. 172-201

[62] Guy-Sheftall, *Daughters of Sorrow*, p. 43

[63] Ibid.

[64] Davis, *Women, Race and Class*, p. 133

[65] Giddings, *When and Where I Enter*, p. 83

[66] Guy-Sheftall, *Daughters of Sorrow*, p. 44

[67] Hutchinson, *Anna J. Cooper, A Voice*, p. 94

[68] Ibid., p. 95-96

[69] Ibid., p. 94

[70] Neverdon-Morton, *Afro-American Women*, p. 6

[71] Giddings, *When and Where I Enter*, p. 95

[72] Beverly Jones, *Quest for Equality: The Life and Writing of Mary Eliza Church Terrell, 1863-1954* (Brooklyn, New York: Carlson Publishing,1990) p. 20

[73] Giddings, *When and Where I Enter*, p. 85

[74] Cooper, *A Voice from the South*, p. 134

[75] Ibid., p. 142

[76] Hutchinson, *Anna J. Cooper, A Voice*, p. 151

[77] Francis E. Harper is quoted in Bert Loewenberg & Ruth Bogin, *Black Women in Nineteenth Century American Life: Their Words, Their Thoughts, Their Feelings* (London: Pennsylvania State University Press, 1976) p. 244

[78] Cooper, *A Voice from the South*, pp. 143-145

[79] Cooper is quoted in Loewenberg & Bogin, *Black Women in Nineteenth Century American Life*, pp. 330-331

[80] Giddings, *When and Where I Enter*, p. 95

[81] Neverdon-Morton, *Afro-American Women*, p. 193

[82] Mary Church Terrell, "The History of the Women's Club," p. 144

[83] Neverdon-Morton, *Afro-American Women*, p. 193; Terrell, "The History of the Women's Club," p. 140

[84] Salem, "National Association of Colored Women," p. 845

[85] Davis, *Women, Race and Class*, p. 144

[86] Nannie Helen Burroughs, (August, 1915) "Votes for Women," The Crisis, vol. 10, no. 4, p. 187

[87] Giddings, *When and Where I Enter*, p. 120

[88] W. E. B. Du Bois quoted in Angela Davis, *Women, Race and Class*, p. 146

[89] Davis, *Women, Race and Class*, p. 144

[90] Jones, *Quest*, p. 24

[91] Ibid.

[92] Giddings, *When and Where I Enter*, p. 95

[93] Guy-Sheftall, *Daughters of Sorrow*, p. 42

[94] Cooper, *A Voice from the South*, p. 143

[95] See Shaw, "Black Club Women," pp. 433-448

[96] Regina Smith, (n.d.) "Anna Julia Cooper," Unpublished paper, n. d. lent to this author courtesy of Dr. Paul Philips Cooke (Private Collection). Ms Smith is the great-great-great niece of Anna J. Cooper.

[97] Harley, "Beyond the Classroom," p. 262

[98] Anna Julia Cooper, *The Social Settlement: What it is and What it does.* (Washington, D. C.: Murray Brothers Press, 1913) p. 3; Harley, "Beyond the Classroom," p. 262

[99] Cooper, *The Social Settlement*, pp. 7-8

[100] Ibid., p. 4

[101] Ibid., p. 7

[102] Ibid., p. 5

[103] Hutchinson, *Anna J. Cooper, A Voice*, p. 123

[104] Ibid., p.124

[105] Ibid., p. 125

[106] Harley, "Beyond the Classroom," p. 263

[107] Kevin K. Gaines, *Uplifting the Race: Black Leadership, Politics, and Culture in the Twentieth Century* (Chapel Hill, North Carolina: University of North Carolina Press, 1996) p. 132

[108] Louise D. Hutchinson, "Anna J. Cooper," in Darlene Clark Hine, ed., *Black Women in America: An Historical Encyclopedia* (Bloomington, Indiana: Indiana University Press, 1993) p. 278

[109] Beverly Guy-Sheftall, ed., *Words of Fire: An Anthology of African American Thought* (New York: The New Press, 1995) p. 9

[110] Opal V. Easter, *Nannie Helen Burroughs and Her Contribution to the Adult Education of African American Women* (New York: Garland Publishing, 1995) p. 75

[111] Earl L. Harrison, *The Dream and The Dreamer: An Abbreviated Story of The Life of Dr. Nannie Helen Burroughs and Nannie Helen Burroughs School* (Washington, D. C.: Nannie H. Burroughs Literature Foundation Publisher, 1956) p. 11

[112] Easter, *Nannie Helen Burroughs*, p. 75

[113] Ibid.

[114] William Pickens, *Nannie Helen Burroughs and the School of the Three B's* (New York: n. p., 1921) pp. 17-18

[115] Easter, *Nannie Helen Burroughs*, p. 37

[116] Ibid., pp. 37-38

[117] Hutchinson, "Anna Julia Cooper," 1993, p. 182

[118] Evelyn Brooks, (Winter/Spring, 1988) "Religion, Politics, and Gender: The Leadership of Nannie Helen Burroughs," *Journal of Religious Thought*, vol. 44, p. 9

[119] Ibid.

[120] Higginbotham, *Righteous Discontent*, p. 150

[121] Ibid.

[122] Brooks, "Religion, Politics and Gender," p. 10

[123] Easter, *Nannie Helen Burroughs*, p. 42

[124] Brooks, "Religion, Politics, and Gender," p. 12

[125] Ibid., p. 17

[126] National Baptist Convention, 19th Annual Session Assembly of the Women's Convention, 1919, p. 232

[127] Easter, *Nannie Helen Burroughs* , p. 130

[128] Ibid., p. 131

[129] National Association of Wage Earners, Incorporated, n. d., pp. 5-6. This booklet contains the Constitution of the organization, NHB papers, courtesy of LC

[130] Harley, "Beyond the Classroom," p. 264

[131] Easter, *Nannie Helen Burroughs*, p. 138

[132] Harley, "Beyond the Classroom," p. 265

[133] "Colored Women in Politics," n. d., n. p., NHB papers, courtesy of LC

[134] Easter, *Nannie Helen Burroughs*, p. 130

[135] Burroughs quoted in Brooks, "Religion, Politics and Gender," p. 21

[136] Guy-Sheftall, *Words of Fire*, p. 10

[137] "International Council of Women of the Darker Races of the World." n. d., pp. 2-3, NHB papers courtesy of LC

# Conclusion
## Lives of Service

> *Better to light a candle than curse the darkness.*
> *It has been my aim and hope to light candles*
> *that may carry on lighting others in God's own*
> *way of good will & helpful living.*
>
> —ANNA JULIA COOPER[1]

> *There is a divinity that makes us brothers, none*
> *goes his way alone. All that we send into the*
> *lives of others comes back into our own. The*
> *first quality of greatness is service. It is the*
> *beginning and end of real worth.*
>
> —NANNIE HELEN BURROUGHS[2]

In 1832, twenty-six years and forty-seven years before Anna Julia Cooper and Nannie Helen Burroughs were born respectively, Maria Miller Stewart, a free Black woman from Connecticut, urged and beckoned African American women to develop their intellects, become teachers, combine family and work outside the home, and to commit themselves to a life of service in all aspects of community building.[3] She cried out:

> O, ye daughters of Africa, Awake! Awake! Arise! No longer sleep nor slumber, but distinguish yourselves, show forth to the world that ye are endowed with noble and exalted faculties. O, ye daughters of Africa! What have ye done to immortalize your names beyond the grave? What examples have ye set before the rising generations? What foundation have ye laid for generations yet unborn?[4]

Decades later after this speech, Cooper and Burroughs would emerge on the scene as educators, administrators and school founders— picking up the torch that Black women like Stewart laid before them, not

so much to "immortalize their names beyond the grave," but in an effort to "set examples before the rising generation" and to lay a foundation for "generations yet unborn."

Cooper and Burroughs were the fortunate ones who were given a "chance to learn," during the Reconstruction and post-Reconstruction era, respectively. They recognized, along with their families and communities, that it was their duty and obligation to use their skills to liberate, empower and improve the lives of their people. Hence, in response to the Black community's needs, aspirations and expectations; a pedagogy rooted in Eurocentric patriarchal hegemony; and a sincere compassion and concern for a better world for all of humanity, Cooper and Burroughs committed themselves to a life of service. They embarked on a life-long mission of self-help, racial uplift, and institution building.

Like many African Americans and women during their era, Cooper and Burroughs were encumbered by the interlocking structures of domination. To be poor, Black and female in the late nineteenth and early twentieth century America, was to experience multiple forms of oppression.

Refusing to succumb to the yoke of oppression imposed upon them by virtue of their race, class and gender, both educators became social activists in the struggle to eradicate the oppressive and exploitative structures of the American social order. They forged alliances with other educated Black women in a collective struggle that would attempt to transform their communities and the overall larger society.

A central theme that emerges from this study is that Anna Julia Cooper and Nannie Helen Burroughs, like other Black women educators of their era, did not separate their roles as educators from their civic and political advocacies. They saw the activist potential of education and skillfully used this "female sphere" of influence to foster a definition of education as a cornerstone of racial "uplift," community development and institutional transformation.[5] They firmly believed that education was the fulcrum for social change, and the role of the educator was one of social and moral change agent. Educating Black youth, females and adults to be productive citizens and social activists, involved in the struggle against race and gender oppression and economic subordination, defined Cooper's and Burroughs' educational philosophies.

Anna Julia Cooper and Nannie Helen Burroughs involved themselves in an ongoing collective fight for racial, sexual and social justice. Their commitment to the movement for justice and equality discloses continuity in the pattern of social and political activism on

the part of African American women, in particularly Black women educators. Their clubs, organizations, schools, and numerous other institutions they established were the epitome of Black women's long tradition of social activism, Black female achievement, fortitude and resiliency.

The study also reveals that Cooper and Burroughs possessed a race, class and gender consciousness, which was manifested in the self-help activities, clubs and various other women-centered organizations they created or participated in. They clearly understood that Black women had no choice but to struggle for the rights of women and African Americans simultaneously. Cooper argued that "the white woman could at least plead for her own emancipation; the black woman, doubly enslaved, could but suffer and struggle and be silent."

Thus, the clubs and organizations Cooper and Burroughs founded or participated in, during the period under consideration, were distinctive from those of White women's clubs. White women's clubs, which failed to address issues of race, also failed to embrace and address issues pertaining to White working class women.

Black women's clubs dealt with issues that were broader in scope—issues that were particular to the Black and female experience and the "underclass." Through their clubs and other organizations, they were able to mobilize against segregation, lynching and the attacks on Black women's morality. They boycotted public transportation and other public institutions that discriminated against African Americans. Black women's clubs also addressed issues relating to workers' rights of Black women. In a similar vein as White women's clubs, Black women's clubs promoted education, healthcare, childcare, temperance, suffrage and morality. Their clubs provided the social services that the state, at that time, was not providing and it set a standard for the present day welfare social service system.

The study also shows that like White club women, Black club women internalized and promoted the prevailing ideas of the Protestant Christian doctrine of bourgeois morality, and the "cult of true womanhood"—ideals which, however, were only applicable to native born White women—as values that would ensure the survival of the Black community as well as gain acceptance in the White community. Black women club members, such as Cooper and Burroughs, truly believed that women were by nature morally superior to men and that it was their duty and responsibility as women to play influential roles in the home and family, the "microcosm and cornerstone of society."[6] Before a group of Black clergy men, Cooper declared,

Only the BLACK WOMAN [emphasis in text] can say when and where I enter, in the quiet, undisputed dignity of my womanhood, without violence and without suing or special patronage, then and there the whole Negro race enters with me.[7]

Burroughs believed that her school was a "a symbol of sacrifice—a sacrifice that I consider my moral and spiritual responsibility."[8]

Indeed, Cooper and Burroughs and other Black club women perceived themselves as the leaders and voices of the African American masses and did not challenge or critique the racist, sexist or classist middle-class ideology they were upholding. Be that as it may, Cooper and Burroughs and other Black club women's commitment to the liberation of Blacks and women were profoundly rooted in their lived experiences as Blacks and women. Their experiences with various forms of oppression propelled them to embark on reform crusades that would bring to the Black community, liberty, equality and social advancement. Their hard-fought battles made a significant impact on the Black community and have laid a foundation upon which to build a more just and humane society.

This study provides insight into the fact that the clubs that Cooper and Burroughs belonged to forged a sisterhood amongst Black women and fostered the growth and development of a Black female leadership determined to be heard, make an impact and be a part of the "public sphere," a domain reserved for men. There is also evidence that a noticeable amount of African American men, although not all, encouraged and supported Black women's participation in the "public sphere" because they understood that Black women's activism contributed to the betterment of the overall Black community.

The study also shed light on the fact that Cooper and Burroughs shared a concern of people of color in the Black Diaspora. They linked their struggle for racial uplift and social equality with the struggles that Africans were waging against European colonialism and American imperialism. In the article titled "What the Belgians Did to the Negro," published in *The Worker*, (a magazine started by Burroughs), the author drew parallels between the burning of "our villages" in the Congo and the lynching of African Americans in the United States.[9]

The International Council started by Burroughs and others was established to study the people of color worldwide and to infuse this information in the school curriculum at Black institutions and the segregated "Colored" public schools.

The Pan-African consciousness of Cooper and Burroughs reflect a distinctive pattern of Black female activism that links them to present day Black feminists and activists who are forging intrinsic links with "Third World" women in an effort to struggle to eradicate sexism, racism, neo-colonialism and imperialism globally. The study has shown that not all African American educators/activists were involved in the secular club movement. Some became involved in the battle for moral and social reform activities solely through the church. Others were involved through both the church and secular clubs. This was the case with Burroughs.

The Black church historically has served as the bulwark against the interlocking forces of oppression that the Black community has experienced. In the vanguard of the struggle against oppression have been the women of the church—such as Burroughs. Burroughs' strong biblical faith grounded in the prophetic tradition gave her the fortitude and resiliency to devise strategies and tactics that would counter-act the indignities and abuses Black folks experienced in the American social order. Burroughs work and efforts through the church resulted in the establishment of her school. Numerous other Black churches were also able to establish health clinics, relief for the needy, job placement and a variety of other services because of the hard work and efforts of activism on part of the female members of the church.

The motto or motivations which guided the actions and accomplishments of Anna Julia Cooper and Nannie Helen Burroughs varied as did each of their personal attributes. Burroughs' motto of "We Specialize in the Wholly Impossible," reflected her belief that it was her moral and spiritual responsibility to successfully "carve the destiny of a race" of Black women to do God's work as well as to carry on the struggle for social justice. Burroughs' strong faith and deep love for God gave her the impetus to establish the National Trade and Professional School for Women and Girls (NTPS). In her school, Burroughs instilled into her students concepts of moral rectitude and strong faith and belief in the Lord. She felt that these were important tools, which would not only defeat human frailties but would also give her students the base to lead lives of worth. She also idealistically believed that if society as a whole were exposed to moral religious teachings then racism and discrimination would be eradicated.

Cooper did not adhere to any one particular motto, but she strongly was motivated by her concern for rights of Black women to receive an education equitable to that of men and Whites. She certainly believed

that to educate a woman was to educate a nation, and a society that presented the "world of thought ... with one face, the man's face," stifled the growth and progress of a civilization."[10]

In this study, we have seen that all of their lives, Cooper and Burroughs voiced strong concerns for the education of African American women. They shared the belief that Black women's education should prepare them for their messianic purpose—the fight for a just and equitable society. The discourse of the Victorian "cult of true womanhood" is embodied in their beliefs of the education of Black women. However, it was redefined so as to speak to the concrete experiences of African American.

Cooper's and Burroughs' struggle for Black women's education, took them on different paths. Cooper passionately championed the cause of higher education for women—i.e. the training of the "Talented Tenth" who would not only embark on the mission of "uplifting" the race but would act as a civilizing force in the Western world to counterbalance the hegemonic masculinist ideals—the "apotheosis of greed and cruelty."[11]

In contrast, realizing that the vast majority of African American women had very limited access to educational and employment opportunities, Burroughs created an industrial arts school to meet the needs of the unskilled Black woman. In addition to being trained as skilled workers, Burroughs wanted her students to "take the struggles, the handicaps and the hardships of this civilization and turn them into stepping-stones."[12]

Both women, a widower who never remarried and one who never married at all, viewed marriage as an institution that stifled the personal and professional growth of women. Cooper urged married women to seek employment outside the home and develop their intellects because she believed that marriage was not the only route to self-actualization.[13] In a similar tone, Burroughs vowed early in life to "free her sisters from ignorance ... and the domination of men."[14] She hoped her school would serve as the vehicle toward that freedom. It is important to note that during Cooper's and Burroughs' era, marriage for women, especially for female educators was an instrument of social oppression. If either of them had gotten married or remarried, more than likely their goals and dreams to committing their lives to a life of service would have been deferred. Hence, their decision to remain spinster schoolteachers allows one to see Cooper's and Burroughs' true devotion and commitment to serving their students and community.

A close examination of the careers and educational philosophies of

Cooper and Burroughs reveals that each educator made a significant impact in the field of education. As principal of M Street High School and president of Frelinghuysen University, Cooper implemented pioneering educational reforms. Burroughs established a "viable educational institution, which was the only one in the United States founded by African American women, for Black women, and funded primarily through contributions of the African American community."[15]

Their educational institutions were not only milieus where the learning of practical and academic skills were imparted, they also were centers where these two educators attempted to transform the lives of their students. They critiqued and challenged the dominant pedagogical perspectives and provided a counter-hegemonic view of educating Black students. Their educational perspectives were anti-racist and anti-sexist.

Like other Black female educators of their time, and unlike W. E. B. Du Bois and Booker T. Washington, Cooper and Burroughs believed that the best education was one that combined classical liberal arts with industrial vocational education. This combination of the two reflected a pragmatic/idealistic approach to teaching Black students.[16] Both educators believed that the combination of the two would provide "a train hand in the trades, and a cultured brain in liberal education." The combined educational programs would produce educated well-rounded students and citizens who would become, according to Cooper, "a beneficent force in the service of the world."[17]

The theme of an ethic of caring resonated throughout Cooper's and Burroughs' philosophies. The study has presented examples of stories from students and co-workers of how Cooper and Burroughs committed and dedicated themselves to nurturing the intellect, empowering the "voices," and validating the experiences of their students. The result of their efforts gave rise to an educated group of students who in turn sought to take their rightful place in this world, engaging in "uplift" activities.

The legacy that Anna Julia Cooper and Nannie Helen Burroughs leave to American education is that education should be about the "practice of freedom," to use bell hooks' terms, not only freedom for self-actualization or individual intellectual pursuits, but freedom that would empower the oppressed to challenge and resist hegemonic domination.

Cooper and Burroughs believed educators and administrators played a key role in the struggle for a better world for their students. Both women held themselves personally accountable to the education of their students as well as the community and overall society from which their

students hailed. They clearly understood that the progress and success of their lives and the lives of their students and the Black community were all interrelated. They not only distinguished themselves professionally in the field of education, they also contributed significantly to the development and advancement of the Black community.

As we rapidly approach the 21st Century, the struggle for an education that would ensure the "practice of freedom" is an area in which contemporary educators need to involve themselves. The picture in urban American public schools today reveals there is a crisis. Students of color at every level are turning off to education in epidemic numbers. In school districts across the country, African American males in the main are either failing or are over-represented in special education classes, low-track classes, and are disproportionately suspended or expelled from school.[18] The dire statistics on the experience of school failure for students of color in urban settings are historically linked to disparities in educational expenditures and other structural inequalities and institutionalized racism that permeates throughout the American public school system. These institutionalized patterns have effectively denied students of color equal access to educational opportunities.

As educators, we are faced with a crisis of epidemic proportions. If we are to rescue a generation of urban school youth from their downward spiral of doom and despair, we need to explore a different, more proactive approach to educating urban school youth. Urban school students need educators and administrators, like Cooper and Burroughs, who are caring, dedicated, willing to make a great impact on their lives, and willing to inspire them to appreciate their own worth and to achieve. We need educators who are committed to teaching in the urban school settings, implementing a curricular that is inclusive and reflective of culturally, linguistically, racially diverse urban school populations. Finally, but most importantly, we need educators and administrators who will continue the tradition that Cooper and Burroughs started—the tradition of tearing down the walls of race, class and gender oppression and building institutions and supporting philosophies and pedagogical practices that are non-oppressive and inclusive of the experiences and perspectives of the diverse racial, ethnic groups in the United States.

In order for African American students to be successful and productive we must implement and implore pedagogical methods that will "ensure the practice of freedom," and believe in the possibility of the transformation of the world.

Anna Julia Cooper's and Nannie Helen Burroughs' philosophies

embodied these concepts and as a result, they were successful in educating generations of students who in turn committed themselves to fighting for a better world.

Further historical research and analysis into the lives, works and educational philosophies of African American female educators needs to be examined, in order to provide insight into their philosophies and pedagogical practices, as well as to include their voices and perspectives into the canon of educational history and discourse. Hopefully, this study may encourage additional investigation into the philosophies of past and present African American educators.

## NOTES

[1] Undated document by Anna J. Cooper, AJC papers, courtesy of MSRC

[2] Document by Nannie Helen Burroughs, NHB papers, courtesy of LC

[3] Beverly Guy-Sheftall, ed., *Words of Fire: An Anthology of African American Feminist Thought*, (New York: The New Press, 1995) p. 25

[4] Maria Miller Stewart quoted in Beverly Guy-Sheftall, *Words of Fire*, p. 27

[5] See Patricia Hill Collins, "Rethinking Black Women's Activism," in *Black Feminist Thought: Knowledge, Consciousness, and the Politics of Empowerment* (New York: Routledge, 1991)

[6] Paula Giddings, *When and Where I Enter: The Impact of Black Women on Sex and Race in America* (New York: William Morrow, 1984) p. 95

[7] Anna J. Cooper, *A Voice from the South: By a Black Woman of the South* (Xenia, Ohio: Aldine Printing House, 1892) p. 31

[8] Letter from Burroughs to D. V. Jemison, April 11, 1947, NHB papers, courtesy of LC

[9] Evelyn Brooks-Barnett, "Nannie Helen Burroughs and the Education of Black Women," in Harley and Terborg-Penn, eds., *The Afro-American Woman: Struggles and Images* (Port Washington, New York: Kennikat Press, 1978) p. 107

[10] Cooper, *A Voice from the South*, p. 56, 63

[11] Ibid., p. 51

[12] This was a speech given by Burroughs and printed in the *Tuskegee Messenger*, June 1943, p. 11, NHB papers, courtesy of LC

[13] Cooper, *A Voice from the South*, pp. 70-71

[14] Earl L. Harrison, *The Dream and the Dreamer: An Abbreviated Story of the Life of Dr. Nannie Helen Burroughs and Nannie Helen Burroughs School* (Washington, D. C.: Nannie H. Burroughs Literature Foundation Publisher, 1956) p. 10

[15] Opal V. Easter, *Nannie Helen Burroughs and Her Contributions to the*

*Adult Education of African American Women* (Ed.D. dissertation, Northern Illinois University, 1992) p. 147

[16] See Carol O. Perkins, *Pragmatic Idealism: Industrial Training, Liberal Education Women's Special Needs, Conflict and Continuity in the Experience of Mary McLeod Bethune and Other Black Women Educators* (Ph.D. dissertation, Claremont Graduate School and San Diego State University,1986) p. iv

[17] Anna Cooper, "On Education," AJC papers courtesy of MSRC

[18] See Jonathan Kozol, Savage Inequalities: Children in America's Schools (New York: Harper Perennial, 1991); C. Bennett & J. J. Harris, "Suspensions and Expulsions of Male and Black Students: A Study of the Causes of Disproportionality," *Urban Education*, vol. 16, no. 4 (1982): 399-423; Jeannie Oakes, *Keeping Track: How Schools Structure Inequality* (New Haven: Yale University Press, 1985)

# Selected Bibliography

**PRIMARY SOURCES**

**Manuscript Collections**

Nannie Helen Burroughs Papers. Manuscript Division Library of Congress, Washington, D. C.

Nannie Helen Burroughs Vertical Files. Moorland-Spingarn Research Center, Howard University, Washington, D. C.

Nannie Helen Burroughs Vertical Files. Washingtonian Division, Washington, D. C. Public Library.

Nannie Helen Burroughs Vertical Files. Historical Society, Orange County, Virginia.

Nannie Helen Burroughs Correspondences. Mary McLeod Bethune Archives and Black Women's History Museum, Washington, D. C.

Anna Julia Cooper Papers. Manuscript Division, Moorland-Spingarn Research Center, Washington, D. C.

Anna Julia Cooper Vertical Files. Moorland-Spingarn Research Center, Washington, D. C.

Anna Julia Cooper Vertical Files. Washingtonian Division, Washington, D. C. Public Library.

**Interviews**

Cooke, Paul Philips. Washington, D. C. 23 & 26 October 1996.

Haynes, Shirley. Washington, D. C. 28 October 1996.

Smith, Sterling. Washington, D. C. 19 & 25 1996.

**Newspapers and Magazines**

"Colored High School." September 19, 1905, *Washington Post.*
"Negro Educator Sees Life's Meaning at 100." August 10, 1958 *Washington Post.*
"Congressional Library Honors Black Educator Orange Native, Dr. Nannie H. Burroughs." September 30, 1976, *Orange County Review.*

## SECONDARY SOURCES

**Books**

Anderson, J. D. *The Education of Blacks in the South, 1860-1935.* (Chapel Hill, North Carolina: University of North Carolina Press, 1988).

Andolsen, B. H. *Daughters of Jefferson, Daughters of Bootblack? Racism and American Feminism.* (Macon, Georgia: Mercer University Press, 1986).

Bailey, K. D. *Methods of Social Research.* (London: The Free Press, 1994).

Baker-Fletcher, K. *A Singing Something: Womanist Reflections on Anna Julia Cooper.* (New York: Crossroad, 1994).

Barnett, E. B. "Nannie Burroughs and the Education of Black Women." In S. Harley & R. Terborg-Penn, eds., *The Afro-American Woman : Struggles and Images.* (Port Washington, New York: Kennikat Press, 1978), pp. 97-108

Bigglestone, W. E. *Oberlin From War to Jubilee, 1866-1883.* (Oberlin, Ohio: Grady Publishing Co., 1983).

Brundage, A. *Going to the Sources: A Guide to Historical Research and Writing.* (Arlington Heights, Illinois: Harlan Davidson Inc., 1989).

Bullock, H. A. *A History of Negro Education in the South, from 1619 to the Present.* (Cambridge, Massachusetts: Harvard University Press, 1967).

Burroughs, N. H. *Think on These Things.* (Washington, D. C.: Nannie H. Burroughs Publications, 1982).

Burroughs, N. H. *Making Your Community Christian.* (Washington, D. C: Nannie H. Burroughs Publications, 1975).

Canon, K. G. *Womanism and the Soul of the Black Community.* (New York: The Continuum Publishing Co., 1995).

Chateuvert, M. "The Third Step: Anna Julia Cooper and Black Education in the District of Columbia, 1910-1960." In D. C. Hine, eds., *Black Women in United States History*, vol. 5, (Brooklyn, New York: Carlson Publishing, 1990), pp. 261-276

Collins, P. H. *Black Feminist Thought: Knowledge, Consciousness, and the Politics of Empowerment.* (New York: Routledge, 1991).

Cooper, A. J. *A Voice from the South.* In the Schomburg Library of Nineteenth

Century Black Women Writers, eds., (1892 reprinted: New York: Oxford University Press, 1988).

_____. *L'Attitude de la France a L'Egard de L'Esclavage Pendant La Revolution.* (Paris, France: Imprimerie de la Cour D'Appel, 1925).

_____. *Le Pelerinage de Charlelmagne.* (Paris, France: A Lahure, Imprimeur Editeur, 1925).

_____. *Personal Recollections of the Grimke Family & The Life and Writings of Charlotte Forten Grimke.* 2 vols. (Privately Printed, 1951).

_____. *The Third Step.* (Privately Printed, 1951).

_____. *The Social Settlement: What it is and What it Does.* (Washington, D. C.: Murray Brothers Press, 1913).

Davis, A. *Women, Race and Class.* (New York: Random House, 1981).

Delaney S. & Delaney E. & Hearth, A. H. *Having Our Say: The Delaney Sisters' First 100 Years.* (New York: Kodansha International, 1993).

Delpit, L. *Other People's Children: Cultural Conflict in the Classroom.* (New York: The New Press, 1995).

Downey, A. R. *A Tale of Three Women: God's Call and Their Response.* (Brentwood, Maryland: International Graphics, 1993).

Du Bois, W. E. B. *Black Reconstruction in America, 1860-1880.* (Cleveland: World Publishing Co., 1962).

_____. *The Education of Black People.* (Amherst, Massachusetts: University of Massachusetts Press, 1963).

_____. "Of Mr. Booker T. Washington and Others." In J. Lester *The Seventh Son,* 2 vols. (New York: Vantage Books).

_____. *Darkwater: Voices from Within the Veil.* (New York: Schocken Books, 1969).

Easter, O. V. *Nannie Helen Burroughs and Her Contributions to the Adult Education of African American Women.* (New York: Garland Publishing, 1995).

Fairchild, J. H. *Oberlin: The Colony and the College, 1833-1883.* (Oberlin, Ohio: E. J. Goodrich, 1883).

Fletcher, R. S. *A History of Oberlin College: From its Foundation Through the Civil War,* 2 vols. (Oberlin, Ohio: Oberlin College, 1943).

Franklin, J. H. *Reconstruction After the Civil War.* (Chicago: University of Chicago Press, 1994).

Gabel, L. *From Slavery to the Sorbonne and Beyond: The Life and Writings of Anna Julia Cooper.* (Northampton, Massachusetts: Smith College Studies in History, 1982).

Gaines, K. K. *Uplifting the Race: Black Leadership, Politics, and Culture in the Twentieth Century.* (Chapel Hill, North Carolina: University of North Carolina Press, 1996).

Gatewood, W. B. *Aristocrats of Color: The Black Elite, 1880-1920.* (Blooming-
ton, Indiana: Indiana University Press, 1990).

Giddings, P. *When and Where I Enter: The Impact of Black Women on Race and
Sex in America.* (New York: William Morrow, 1984).

Gilligan, C. *In a Different Voice.* (Cambridge, Massachusetts: Harvard Univer-
sity Press, 1982).

Gordon, B. "The Fringe Dwellers: African American Women Scholars in the
Postmodern Era." In B. Kanpol & P. McLaren, ed., *Critical Multicultural-
ism: Uncommon Voices in a Common Struggle.* (Westport, Connecticut:
Bergin & Garvey, 1995), pp. 59-88.

Gordon, L. "Black and White Visions of Welfare: Women's Welfare Activism,
1890-1945." In D. C. Hine, eds., *We Specialize in the Wholly Impossible: A
Reader in Black Women's History.* (Brooklyn, New York: Carlson Publish-
ing, 1995), pp. 449-486.

Green, C. M. *The Secret City: A History of Race Relations in the Nation's Capi-
tal.* (Princeton, New Jersey: Princeton University Press, 1967).

Gutek, G. L. ed., "The Civil War, Reconstruction, and the Education of Black
Americans." In *Education in the United States: An Historical Perspective.*
(Englewood Cliffs: Prentice Hall, 1986), pp. 150-172.

Guy-Sheftall, B. *Daughters of Sorrow: Attitudes Towards Black Women, 1880-
1920.* (Brooklyn, New York: Carlson Publishing, 1990).

_____. "Anna Julia Cooper." In M. S. Seller, eds., *Women Educators in the
United States, 1820-1993: A Bio-Bibliographical Sourcebook.* (London:
Green Wood Press, 1994), pp. 161-167.

_____. ed., *Words of Fire: An Anthology of African American Feminist Thought.*
(New York: The New Press, 1995).

Hammond, L. H. *In the Vanguard of a Race.* (New York: Council of Women for
Home Missions, 1923).

Hansot, E. "Historical and Contemporary Views of Gender and Education." In S.
K. Bilken & D. Pollard, eds., *Gender and Education.* (Chicago: University
of Chicago Press, 1993), pp.12-24.

Harding, S. & Hintikka, M. B. *Discovering Reality: Feminist Perspectives on
Epistemology, Metaphysics, Methodology, and Philosophy of Science.*
(London: D. Reidel Publishing Co., 1983).

Harding, S. *The Science Question in Feminism.* (London: Cornell University
Press, 1986).

_____. ed.,"Is there a Feminist Method?" In *Feminism & Methodology: Social Sci-
ence Issues.* (Bloomington, Indiana: Indiana University Press, 1987), pp. 1-13

Harley, S. "For the Good of the Family and Race: Gender, Work and Domestic
Roles in the Black Community, 1880-1930." In M. Malson, ed., *Black*

*Women in America: Social Science Perspectives.* (Chicago: University of Chicago Press, 1988), pp.159-172.

_____. "Black Women in a Southern City: Washington, D. C., 1890-1920." In D. C. Hine, eds., *Black Women in American History*, 2 vols. (Brooklyn, New York: Carlson Publishing), pp. 487-506.

Harrison, E. L. *The Dream and the Dreamer: An Abbreviated Story of the Life of Dr. Nannie Helen Burroughs and Nannie Helen Burroughs' School.* (Washington, D. C.: Nannie H. Burroughs Literature Foundation, 1956).

Higginbotham, E. B. "Nannie Helen Burroughs." In D. C. Hine, ed., *Black Women in America: An Historical Encyclopedia*, 2 vols. (Bloomington, Indiana: Indiana University Press, 1993), pp. 201-205

_____. *Righteous Discontent: The Women's Movement in the Black Baptist Church, 1880-1920.* (Cambridge, Massachusetts: Harvard University Press, 1993).

Hill, M. R. *Archival Strategies and Techniques: Qualitative Research Methods*, Series 31. (Newbury Park, California: Sage Publications, 1993).

Hine, D. C. "We Specialize in the Wholly Impossible: The Philanthropic Work of Black Women." In K. K. McCarthy, eds., *Lady Bountiful Revisted: Women, Philanthropy and Power.* (New Brunswick, New Jersey: Rutgers University Press, 1990).

hooks, bell. *Feminist Theory: From Margin to Center.* (Boston: South End Press, 1984).

_____. *Teaching to Transgress: Education as the Practice of Freedom.* (New York: Routlege, 1994).

Hundley, M. G. *The Dunbar Story, 1870-1955.* (New York: Vantage Press, 1965).

Hutchinson, L. D. "Anna Julia Cooper." In D. C. Hine, eds., *Black Women in America: An Historical Encyclopedia.* (Bloomington, Indiana: Indiana University Press, 1993), pp. 275-281

_____. *Anna J. Cooper: A Voice from the South.* (Washington, D. C.: Smithsonian Institution Press, 1981).

Jones, J. *Labor of Love, Labor of Sorrow: Black Women, Work and the Family: From Slavery to the Present.* (New York: Vintage Press, 1986).

Keller, F. R. *Slavery and the French Revolutionist, 1788-1805, by Anna Julia Cooper.* (Lewiston, New York: The Edwin Mellen Press, 1988).

Klein, A. F. *In the Land of the Strenuous Life.* (Chicago: A. C. McClurg & Co., 1905).

Ladson-Billings, G. *The Dreamkeepers: Successful Teachers of African American Children.* (San Francisco: Jossey-Bass Publishers, 1994).

Lerner, G. *Black Women in White America: A Documentary History.* (New York: Vintage Press, 1973).

Logan, R. *The Negro in American Life and Thought: The Nadir, 1877-1901.* (New York: Dial Press, 1954).

Loewenberg, B. J. & Bogin, R. *Black Women in Nineteenth Century American Life: Their Words, Their Thoughts, Their Feelings.* (University Park, Pennsylvania: Pennsylvania State University Press, 1976).

McLaren, P. *Life in Schools: An Introduction to Critical Pedagogy in the Foundations of Education.* (New York: Longman Publishers, 1994).

Neverdon-Morton, C. *Afro-American Women of the South and the Advancement of the Race, 1895-1925.* (Knoxville, Tennessee: University of Tennessee Press, 1989).

Noddings, Nel *Caring: Feminine Approach to Ethics and Moral Education.* (Berkeley: University of California Press, 1984).

Patton, M. Q. *Qualitative Evaluation and Research Methods.* (Newbury Park, California: Sage Publications, 1990).

Perkins, L. *Fanny Jackson Coppin and the Institute for Colored Youth, 1865-1902.* (New York: Garland Publishing, 1987).

Perkins, L. "Black Women and Racial Uplift Prior to Emancipation." In F. C. Steady, ed., *Black Women Cross Culturally.* (Rochester, Vermont: Schenkman Books, 1981), pp. 317-334.

Pickens, W. *Nannie Burroughs and the School of the Three B's.* (New York: n. p., 1923).

Salem, D. "National Association of Colored Women." In D. C. Hine, eds., *Black Women in America: An Historical Encyclopedia.* (Bloomington, Indiana: Indiana University Press, 1993), pp. 842-851.

Seller, M. S. ed., *Women Educators in the United States, 1820-1993: A Bio-Bibliographical Sourcebook.* (London: Green Wood Press, 1994).

Shaw, S. J. "Black Club Women and the Creation of the National Association of Colored Women." In D. C. Hine, eds., *We Specialize in the Wholly Impossible: A Reader in Black Women's History.* (Brooklyn, New York: Carlson Publishing, 1995), pp. 433-448

Smith, S. "Social Welfare Movement." In D. C. Hine, eds., *Black Women in America: An Historical Encyclopedia*, 2 vols. (Bloomington, Indiana: Indiana University Press, 1993), pp.1068-1088

Sterling, D. *We Are Your Sister: Black Women in the 19th Century.* (New York: W. W. Norton, 1984).

Stevenson, B. E. "Slavery." In D. C. Hine, eds., *Black Women in America: An Historical Encyclopedia*, 2 vols. (Bloomington, Indiana: Indiana University Press, 1993), pp.1045-1070

Terrell, M. C. "The History of the Women's Club Movement." In B. Jones, ed., *Quest for Equality: The Life and Writings of Mary Eliza Church Terrell,*

*1863-1954.* (Brooklyn, New York: Carlson Publishing, 1940, reprinted in1990), pp. 315-325.

———. "What Role is the Educated Negro Woman to Play in the Uplifting of her Race?" In B. Jones, ed., *Quest for Equality: The Life and Writings of Mary Eliza Church Terrell, 1863-1954.* (Brooklyn, New York: Carlson Publishing, 1990), pp. 151-158.

Thompson, P. J. "Beyond Gender: Equity Issues for Home Economics Education." In L. Stone, ed., *The Education Feminism Reader.* (New York: Routledge, 1994), pp.184-194.

Townes, E. M. *Womanist Justice, Womanist Hope.* (Atlanta, Georgia: Scholars Press, 1993).

Tyack, D. *The One Best System: A History of American Urban Education.* (Cambridge, Massachusetts: Harvard University Press, 1974).

Tyack, D. & Hansot, E. *Learning Together: A History of Coeducation in American Public Schools.* (New York: Russell Sage Foundation, 1992).

Washington, M. H. Introduction to *Anna Julia Cooper: A Voice from the South.* In the Schomburg Library of Nineteenth Century Black Women Writers, eds., (New York: Oxford University Press, 1988).

Weinberg, M. *A Chance to Learn: A History of Race and Education in the United States.* (London: Cambridge University Press, 1977).

White, D. G. *Ar'nt I a Woman?: Female Slaves in the Plantation South.* (New York: W. W. & Norton Co., 1985).

Wolcott, V. "The National Training School for Women and Girls." In D. C. Hine, eds., *Black Women in America: An Historical Encyclopedia*, 2 vols. (Bloomington, Indiana: Indiana University Press, 1993), pp. 868-869.

Woodson, C. G. *The Education of the Negro Prior to 1861.* (New York: Arno Press, 1968).

Woodward, C. V. *The Strange Career of Jim Crow.* (New York: Oxford University Press, 1974).

Woody, T. *A History of Women's Education in the United States*, 2 vols. (New York: The Science Press, 1929).

## Unpublished dissertations, theses and papers

Chitty, A. B. (1981). "The Life and Works of Anna Haywood Cooper, 1858-1964." Unpublished paper presented at Saint Augustine's College Library, Raleigh, North Carolina. This paper was lent to this author courtesy of Dr. Paul Philips Cooke. (Private Collection).

Cooke, P. P. (1981). "Ann J. Cooper." Unpublished paper. This paper was lent to this author courtesy of Dr. Paul Philips Cooke. (Private Collection)

Dabney, L. G. *The History of Schools for Negroes in the District of Columbia, 1807-1947.* (Ph.D. dissertation, Catholic University, 1949).

Easter, O. V. *Nannie Helen Burroughs and Her Contributions to the Adult Education of African American Women.* (Ed.D. dissertation, Northern Illinois University, 1992).

Gaines, K. K. *Uplifting the Race: Black Middle-Class Ideology in the Era of the New Negro, 1890-1935.* (Ph.D. dissertation, Brown University, 1991).

Guy-Sheftall. *Daughters of Sorrow: Attitudes Toward Black Women, 1880-1929.* (Ph.D. dissertation, Emory University, 1984).

Keller, F. R. (1979). "Historian-Innovator. Comments on the Life and Thoughts of Anna Julia Cooper." Unpublished paper delivered at the opening of the National Archives-National Council of Negro Women in Washington, D. C., courtesy of the National Archives for Black Women's History & National Council of Negro Women, Washington, D. C.

Perkins, C. O. *Pragmatic Idealism: Industrial Training, Liberal Education, Women's Special Needs. Conflict and Continuity in the Experience of Mary McLeod Bethune and Other Black Women Educators, 1900-1930.* (Ph.D. dissertation, Claremont Graduate School and San Diego State University, 1986).

Robinson, H. S. (1980) "The M Street High School, 1891-1916." Unpublished paper. This paper was lent to this author courtesy of Dr. Paul Philips Cooke. (Private Collection).

Skorapa, O. *Feminist Theory and the Educational Endeavors of Mary McLeod Bethune.* (Ph.D. dissertation, Georgia State University, 1989).

Slovick, L. *Nannie Helen Burroughs: The Role of Religion and Education in the Improvement of her Race.* (M.A. thesis, George Washington University, 1992).

Smith, R. (n. d.). "Anna Julia Cooper." Unpublished paper. This paper was lent to this author courtesy of Dr. Paul Philips Cooke. (Private Collection).

## Articles

Bigglestone, W. E. (1971). "Oberlin College and the Negro Student, 1865-1940." *Journal of Negro History*, vol. 56, pp.198-219.

Brooks, E. (Winter/Spring 1988). "Religion, Politics, and Gender: The Leadership of Nannie Helen Burroughs." *Journal of Religious Thought*, vol. 44.

Colliver-Thomas, B. (1982). "The Impact of Black Women in Education: An Historical Overview." *Journal of Negro Education*, vol. 51, no. 3, pp. 172-182.

Franklin, V. P. (1990). "They Rose and Fell Together: African American Educa-

tors and Community Leadership, 1795-1954." *Journal of Education*, vol. 172, no. 3, pp. 39-64.

Gordon, B. M. (1990). "The Necessity of an African American Epistemology for Educational Theory and Practice." *Journal of Education*, vol. 172, no. 3, pp. 88-107.

Harley, Sharon. (1982). "Beyond the Classroom: The Organizational Lives of Black Female Educators in the District Columbia, 1890-1930." *Journal of Negro Education*, vol. 51, no. 3, pp. 254-265.

Hogeland, R. W. (1972-73). "Coeducation of the Sexes at Oberlin: A Study of Social Ideas in the Mid-Nineteenth Century America." *Journal of Social History*, no. 6, pp. 160-76.

Lerner, G. (1974). "Early Community Work of Black Club Women." *Journal of Negro History*, vol. 59, no. 2, pp. 158-167.

McCluskey, A. T. (1993). "The Historical Context of the Single-Sex Schooling Debate among African Americans." *The Western Journal of Black Studies*, vol. 17, no. 4, pp. 193-201.

Mohr, F., ed., (1977). "Francis L. Cardozo Papers." *Quarterly Journal of the Library of Congress*, vol. 34, no. 4, pp. 354-55.

_____. (1977). "Nannie Helen Burroughs Papers." *Quarterly Journal of the Library of Congress*, vol. 34, no. 4, pp. 356-359.

Neverdon-Morton, C. (1982). "Self-Help Programs As Educative Activities of Black Women in the South, 1895-1925." *Journal of Negro Education*, vol. 51, no. 3, pp. 207-222.

Perkins, L. (1983). "The Impact of the Cult of True Womanhood on the Education of Black Women." *Journal of Social Issues*, vol. 39, no. 3, pp. 17-28.

Slater, R. B. (1995). "American Colleges that Led the Abolition Movement." *Journal of Blacks in Higher Education*, no. 9, pp. 95-97.

Terrell, M. C. (1917). "History of the High School for Negroes in Washington." *Journal of Negro History*, no. 2, pp. 255-257.

Wormley, G. S. (1932). "Educators of the Public Schools of the District of Columbia." *Journal of Negro History*, vol. 17, no. 2, pp. 124-140.

# Index

African American scholars, on educational research, 1–2
African American women. *See* Black women
African Methodist Episcopal Church (AME), 18
African Dorcas Association, 133
Afrocentric consciousness, 5
Allen, Rev. Richard, 18
American Missionary Association, 21
   establishment of Black schools, 21
Anna Julia Cooper Memorial Circle, 90
Armstrong Manual High School, 53, 79
Armstrong, Samuel Chapman, 24
Association of the Study of Negro Life, 93
Avery Normal Institute, 53

Benevolent organizations, established by Black women, xxv, 133–135
Bethel African Methodist Episcopal Church, 18
Bethune, Mary McLeod, 150, 151

black churches, 138–139, 148
   churchwomen's activism, 139
   churchwomen's beliefs, 139, 142
   establishment of schools and, 139
Black clubwomen
   anti-lynching activities, 149
   beliefs, 142, 161
   establishment of schools and, 25, 135
   ideological differences with White clubwomen, 139, 141
   racial uplift ideology, 134–135, 137, 143
   social concerns and projects, 135
   and women's suffrage, 143–144
Black education
   Black female colleges, 24, 96–97
   historical overview, 15–28
   in the North, 18
   separate and unequal, 20
   in the South, 17, 18–22
   struggle for, 17, 19, 38
Black feminism. *See* Black feminist theory
Black feminist analysis of Black motherhood, 35
   "other mothers," 36

Black feminist theory
  Afrocentric perspective on, 4, 5
  alternative epistemological frame-
    work, 3
  core themes, 3
  definition of, 2, 3–4
  dimensions of, 3–5
  and "ethic of accountability," 4
  and "ethic of caring," 4
  and "outsider-within" stance, 4
Black migration, 134
  of Black women, 50, 96–97
Blacks, in free territories, 18
Black women, xxi, xxii
  and activism, defined, 132
  benevolent organizations and, xxv,
    133, 135
  churchwomen, 138, 139, 142
  clubwork, 135–137, 140–145
  education, 22–25
  and historical overview of ac-
    tivism, 133
  and home economics training,
    98–99
  involved in social reform move-
    ment, 136
  and women's suffrage, 143–144
  work options, 49, 96–97
Black women's activism. *See* Black
  women
Black women educators, xxii
  on classical and industrial educa-
    tion, 110
  concept of "ideal" Black woman,
    26–27, 103–104
  educational beliefs, xxvii, 25–28,
    105
  establishment of schools and other
    social service institutions,
    xxv, 25, 26, 133, 135
  establishment of women's clubs,
    27, 136

Bond, Horace Mann, 1–2, 82
Bronson, Regina, 81
Brooks, Walter H., 148
Bureau of Refugees, Freedmen, and
    Abandoned Lands, 17
  and the establishment of schools,
    19, 20
Burroughs, Nannie Helen, xxiv, 69
  activism, xxvii, 147–152
  birth, xxvii, 47, 48
  churchwork. *See* Burroughs and
    activism
  clubwork. *See* Burroughs and
    activism
  compared with Anna Julia Cooper,
    104, 105, 106, 107, 108, 110
  compared with Booker T. Wash-
    ington, 111–112
  criticism of clubwomen, 138
  death, 102
  education, xxvii, 51, 52, 54
  educational views, 26, 103–115
    and Black women's education,
      164
    on Christian education, 110
    on classical and industrial edu-
      cation, xxiv, 110
    and an ethic of caring, 95, 106
  formation of the Women's Con-
    vention, xxvii
  founder of International Council of
    Women of the Darker Races,
    151–152
  founder of National Association of
    Wage Earners, 150
  founder of National Training
    School for Women and Girls,
    xxvii
  and National Advancement Asso-
    ciation of Colored People,
    151
  and National Urban League, 151

president of National League of
Republican Colored Women,
150
regional president of NACW, 150
as social change agent, xxiii, xxiv,
104, 105
Busbee, Charles, 34

Cardozo, Francis L., 53, 68, 71
principal of M Street High School,
71
Churchill, Charles Henry, 46
Civil Rights Act of 1875, 66
Classical education, xxiv, 25, 45, 54
Colored Social Settlement House,
145–146
*Colored Woman in a White World, A*
(Terrell), 45
Colored Young Women's Association
(CYWCA), 146–147
Colored Women's League, 136
Comer, James P., 73
compulsory ignorance law, 15–16
Cook, George F. T., 50, 55, 67–68,
70, 71, 75
Cooper, Anna Julia, xxiv, xxvii
activism and member of, 141,
142–143, 143–144, 145–147
birth, xxvi, 33–34
clubwork, 145. *See also* Cooper
and activism
and Colored Social Settlement
House, 145–146
compared with Burroughs, 104,
105, 106, 107, 108, 110
compared with W. E. B. Du Bois,
112–113
death, 90
educational philosophy, 26,
103–115
and black women's education,
xxvi, 104, 164

and Christian education, 109
and classical and industrial
education, xxiv, 110, 113
and an ethic of accountability,
36
and an ethic of care, 106
marriage, 42
and M Street High School contro-
versy, 82–83
presidency at Frelinghuysen Uni-
versity, 86–89
principal at M Street High School,
75–84
schooling experiences
at Oberlin College, 43–47
at St. Augustine College, 38–42
at the Université de Paris Sor-
bonne, 85
as social change agent, xxiii, xxiv,
104, 105
teaching experiences, 39, 41, 47,
66, 69, 74
Cooper, George Christopher, 42
Coppin, Francis (Fanny) Jackson, 45
cult of true womanhood, 22, 103
and female education, 22–23
impact on black females, 22, 49
redefined as "ideal Black women,"
103, 104, 105

Daughters of Africa, 133
Delany, Elizabeth (Bessie), 39
Delany, Henry B., 40
Delany, Nancy Logan, 40
Delany, Sadie, 39
District of Columbia Board of Edu-
cation, 75, 81
District of Columbia Colored Public
Schools, 70
elementary courses during the
1880s, 51
formation of, 50

District of Columbia Colored Public
    Schools (*cont.*)
  hiring practices, 55–56
  policies on martial status of
      women, 69
  salaries in 1890s, 68–69
  for African Americans, 69
  segregation of, 50
domestic science, 98
Douglass, Frederick, on women's
    rights, 144
Du Bois, W. E. B.
  birth, 25
  on Black women's education,
      25
  compared to Anna Julia Cooper,
      112–113
  critic of Booker T. Washington, 25,
      79
  education, 25
  educational ideals, xxiv, 25, 79,
      80, 104
  on women's rights, 144
*Dunbar Story, The* (Hundley), 71

Epistemology
  in Black feminist theory, 2, 3
  defined, 2
ethic of caring, 3, 4, 36, 106, 107,
    165
ethic of personal accountability, 3, 4,
    36
Europe, Mary L., 74

Fairchild, James, 42
Female education
  and Black women, 23, 24
    and nineteenth-century beliefs
        of, 22–23
  seminaries, 23
Fifteenth Street Presbyterian Church,
    51, 70

Freedmen and women
  and the establishment of schools in
      the North, 18
  and the struggle for universal
      public schools in the South,
      19, 20, 38
Free Northern Blacks, and establish-
    ment of schools, 18
Frelinghuysen University
  under Anna Julia Cooper's admin-
      istration, 86–89
  courses, 86–87
  formation of, 86
  goals and objectives, 88
  students, 88

Gender oppression, xxii
  intersection with race, xxii–xxiii;
      67
  nineteenth-century school board
      policies and, 69
  and Victorian social doctrines,
      81
General Federation of Women's
    Clubs (GFWC), 134, 141
Gibbs, Ida Hunt, 44, 67
Giles, Harriet, 24
Grimke, Rev. Francis J., 70, 87

Hampton Institute, 24
Hannah Stanley Opportunity School,
    36–37, 87
Harrison, Earl L., 48
*Having Our Say* (Delany and De-
    lany), 38
Hayford, Adelaide Casely, 152
Haywood, Anna Julia (Cooper). *See*
    Cooper, Anna Julia
Haywood, George Washington, 34
Haywood, Hannah Stanley, 34
Haywood, Rufus, 34, 66
hooks, bell, 72, 90

home economics
  and immigrant women's educa-
    tion, 98
  and the intersection of race,
    gender, class and education,
    97–99
  and professionalization of the
    field, 97–98
  and women of color education, 98
Howard, General Oliver, 19
Howard University, 50
Hughes, Percy M., 75, 79, 80, 83

Industrial education, xxiv, 21, 22, 24,
  25
International Council of Women of
  the Darker Races, 151–152

Jim Crow laws, 138. *See also* segre-
  gation

Klein, Father Felix, 76–78, 85

Ladson-Billings, Gloria, 72, 89
*L'Attitude de la France* (Cooper)
  85
Lawson, Jesse, 86
"Lifting as We Climb" (NACW
  motto), 143
Logan, Rayford, xxii
Love, John, 36, 67, 80, 81
Love, Lula Emma, 36, 67
lynching, 48, 137
  Burroughs' response to, xxvii
  NAACP response to, 149
  NACW response to, 149
  WC response to, 149
Lyon, Mary, 68

M Street High School, 51–52, 106,
  108
  communal attributes of, 73

curriculum, 53–54
  under Anna Julia Cooper, 76
faculty and administration of, 52,
  68, 71, 72, 73
graduates of, 52
name change to, 71
methodological perspective, 7
Miner, Myrtilla, 23, 51
Mount Holyoke Seminary, 68

Nannie Helen Burroughs Avenue, 101
Nannie Helen Burroughs Day, 102
Nannie Helen Burroughs School, 102
National Association for the Ad-
  vancement of Colored Peo-
  ple, 145, 149
National Association of Colored
  Women, 141, 143
  class issues and beliefs, 136–138,
    142, 144
  first conference, 140
  formation of, 141
  members' class status, 136
  motto, 143
  projects, 135, 143–145
  similarities with and differences
    from GFWC, 141
National Baptist Convention, 91,
  148–149
  controversy with Burroughs and,
    101–102
National League of Colored Republi-
  can Women, 150
National Trade and Professional
  School for Women and Girls.
  *See* National Training School
  for Women and Girls
National Training School for Women
  and Girls
  aim and objectives, 94
  compared with Tuskegee Institute,
    112

National Training School for Women and Girls (*cont.*)
  controversy with, 101
  curriculum, 92–93
  domestic science training, 98–99
  faculty, 95
  financial support, 99–101
  motto, 93
  name change 94, 102
  opened, 92
National Urban League, 151
Nineteenth Street Baptist Church, 148

Oberlin College, 42, 43
  and African American students, 43–44
  and anti-slavery, 43
  founded, 43
  "gentlemen's course of study," 45
  "ladies course of study," p. 45
  policies toward female students, 45
  "outsider-within" standpoint, 4

Packard, Sophia, 24
Paul Laurence Dunbar High School, 74, 106
  discipline record during Anna Julia Cooper's administration, 77
Patterson, Mary Jane, 44–45, 68, 69
Pelerinage de Charlemagne, Le (Cooper), 46, 85
Phelp-Stokes, 101
Plessy v. Ferguson, 20
post-Reconstruction, 48–49
  and educational ideologies, 21
Progressive Movement, 134

race
  and Black women's labor, 66, 67
  pseudoscientific theories on, xxii, 20, 49
  racial oppression, xxii, 20

racial segregation, 20–21, 66, 67
racial terror, 48, 137
racist images, 49, 139–140
Racial uplift, 134–135, 137
Rockefeller, John D., 99–100
Ruffin, Josephine St. Pierre, 142

Saint Augustine's Normal School and Collegiate Institute, 38–40
Segregation, xxii, 20–21, 66, 67, 72, 138
  labor for Black women under, 66–67
  separate and unequal education, 20–21
Slater foundation, 101
Slater, John, 21
slavery
  clandestine schooling during, 16–17
  slave codes, 34
  slave family, 35
  slave mothers, 35–36
  tasks performed by slaves, 16
Shipherd, John J., 43
Socially constructed images of Black womanhood, 139–140
Social Darwinism, xxii, 20
Spelman College, 24
Stewart, Maria Miller, 159
Stewart, Philip P., 43
Stuart, Alexander T., 75, 79
Sumner, Charles, 50

Talbert, Mary, 150
Teutonic theory, xxii
  "talented tenth," 25
Terrell, Mary Church, xxvii, 44, 45–46, 68, 69, 136, 150, 152
  founding member of International Council of the Darker Races, 152

president of NACW, 141
treasurer of National League of
    Republican Colored Women,
    150
Terrell, Robert, 68, 69, 75
Tuskegee Institute, 25, 78, 79, 80

*Voice from the South, A* (Cooper),
    147

Walker, Maggie Lena, 91
Washington, Booker T., 100, 104,
    111–112
  birth, 24
  education, 24
  education beliefs, xxiv, 22, 78–79
  and Tuskegee Institute, 25, 78, 79,
    80
Washington, D.C., 50, 96–97
Washington, Margaret Murray, 144,
    152
*Washington Bee,* 55, 82
Washington Colored High School,
    51, 67, 70. *See also* M Street
    High School

Washington Preparatory High
    School, 51
Western Anglo Masculinist perspec-
    tive, 7
Woman's Era, The, 142
Woman's Convention,
  activism, 149
  and anti-lynching projects, 149
  auxiliary to National Baptist Con-
    vention, 149
  controversy over National Trade
    and Professional School, 101
  educational objectives, 149
  establishment of National Training
    School of Women and Girls,
  financial support of National
    Training School of Women
    and Girls, 100
  formation of, 91
  and NAACP and NACW, 149
Women's Industrial Club, 148
Women's standpoint theory, 6
Woodson, Carter G., 1, 17, 89, 93
*Worker, The* (Women Convention)
    101